Writing Mothers

Narrative Acts of Care, Redemption, and Transformation

Edited by BettyAnn Martin and Michelann Parr

DEMETER

Writing Mothers
Narrative Acts of Care, Redemption, and Transformation
Edited by BettyAnn Martin and Michelann Parr

Demeter Press
2546 10th Line
Bradford, Ontario
Canada, L3Z 3L3
Tel: 289-383-0134
Email: info@demeterpress.org
Website: www.demeterpress.org

Demeter Press logo based on the sculpture "Demeter" by Maria-Luise Bodirsky www.keramik-atelier.bodirsky.de

Printed and Bound in Canada

Cover artwork: Irena Zenewych in collaboration with Heather Vollans
Movement title pages artwork: Dara Herman Zierlein
Cover design and typesetting: Michelle Pirovich

Library and Archives Canada Cataloguing in Publication
Title: Writing mothers : narrative acts of care, redemption, and transformation/edited by BettyAnn Martin and Michelann Parr.
Names: Martin, BettyAnn, 1971- editor. | Parr, Michelann, 1964- editor.
Description: Includes bibliographical references.
Identifiers: Canadiana 20200154125 | ISBN 9781772582239 (softcover)
Subjects: LCSH: Motherhood. | LCSH: Motherhood—Anecdotes. |
LCSH: Mothers. | LCSH: Mothers—Anecdotes.
Classification: LCC HQ759.W75 2020 | DDC 306.874/3—dc23

to my children
whose intellect, creativity, humour, and humanity are humbling
sources of inspiration and joy. For your many challenges to
my learning edge, and a sustaining ebb and flow of love given
and received, I am ever grateful.

—BettyAnn

to my mom
for it is only in being a mom that I have truly come to understand
all that means. You are truly an unsung hero. Never doubt that I see
you and give thanks for your resilience, your selflessness, and your
unconditional acceptance. Thank you for all that you are and all that
you have challenged me to be. My success is indeed your success.

—Michelann

Acknowledgments

We express a deep sense of gratitude to Andrea O'Reilly and Demeter Press for creating a space for continued dialogue for women and mothers to write about motherhood and the multitude of social and emotional intersections women experience through mothering. In an era of disconnection and alienation, it makes sense to return to the maternal bond as a starting point for redefining strength as a function of compassion and for rediscovering the inherent possibilities of empathy. Through the study and experience of mothering, we learn that it is possible to be selfless without a loss of self—that is, through empathy, there is an opportunity for expansiveness in our understanding of humanity that takes us beyond the limitations of our individual consciousness. Sharing stories of mothering extends this opportunity as an invitation to both experience and feel motherhood through various perspectives, and sometimes a renewed perspective is all that is required to initiate meaningful change.

We acknowledge the power of our writers and their stories to stir our empathy and contribute to this movement of increased understanding and connection. Their stories are the inspiration for this collection and our continued inspiration as both mothers and writers. Through the documentation of maternal experience, women are encouraged to understand their stories as part of a collective and cultural negotiation of what it means to be a mother as well as the empowering prospects that lie beyond absolute definitions. It is within their stories that we find both a sense of community and support.

We would also like to thank our close friends, families and children for their encouragement and support in the writing of this book and for the many relational opportunities they provide to know ourselves through motherhood; in our encounters with mothering and being

mothered, we find the possibility for personal and communal transformation and healing.

Finally, we acknowledge mothers whose stories are as yet untold—silenced out of fear or oppression—whose worth is not diminished by this silence. We see you and acknowledge your experience, and we hope that collections such as these create space and provide courage for you to come into your voice.

Cover Artist's Statement

My mother was moving into a personal care home; her apartment needed to be liquidated. As the only child, that responsibility fell on me. In the process of liquidation, I distributed many things to people and places I thought would appreciate and/or use them. And, of course, I kept some things for myself. But there was this set of tea cups and saucers that nagged at me. Pure white porcelain. Rich purple and gold leaf designs. Overwhelmingly beautiful, but not my style. I would never use them. On the second last day of cleaning, my cousin asked me, "So, is there anything special that you would like to keep?" I thought of the tea set and my friend, Heather Vollans, a mosaic artist. And in that moment, I decided that my mother's tea set was coming home with me.

Irena Zenewych

Foreword

Kate Hopper

For almost two decades, motherhood has been the primary focus of both my writing and my teaching. In 2004, when my older daughter, Stella, was five months old, I began work on what would become *Ready for Air*, a memoir about my daughter's premature birth and my first year of motherhood. In those early days, I was writing to make sense of the trauma that we had experienced, and I also knew that I wanted to write against the myths of motherhood. My experience becoming a mother didn't seem to fit into an acceptable narrative of motherhood, so I sat down and wrote my way into understanding—one scene, one image at a time.

It is challenging to really lay yourself bare and write the hard parts of life. But it was important to me to write as honestly as possible and to not sugarcoat anything or make myself into a hero. I wrote the difficult moments, including the moment when I thought Stella might die. I wrote into my confusion and anger, straight into my own vulnerability. Some days, I sat in the coffee shop with tears streaming down my face. Some days, I needed to step away from the work and go for a walk. But even when it was hard, the more I wrote, the less alone and more grounded I felt.

In his research, Dr. James Pennebaker has found that writing about traumatic events has many physical and emotional benefits; it can lower your blood pressure, strengthen your immune system, reduce stress, and help you gain perspective and improve your outlook on life. This was so true for me that I began to create spaces where other women could come together and explore writing about motherhood—the gritty parts, the beautiful parts, and everything in between. Through readings, classes, retreats, and a blog I began to create a community of mother writers who could encourage each other to put their words out into the world even when those words didn't fit into tidy narrative boxes.

Over the years, I have watched countless women heal, grow, and transform through the process of writing and sharing their mother stories, as is evident in this collection. Again and again, I have witnessed exactly what Marjorie Jolles writes in her chapter "Slow Motherhood: Utopian Narratives of Time Lost and Found in the Slow Parenting Movement": "the very act of narration—the imposition of narrative order on somewhat inchoate experience—preserves precious memory and can ease suffering and confusion."

Writing offers us a way to connect to each other and also more deeply to ourselves, as many of the authors in this collection note. In "The Possibility of Everything," Michelann Parr writes, "Throughout the retelling and the writing, and the living, I was challenged to show up, with all of my vulnerability, my imperfection, my anger, and my shame. This is something I've not done well in the past, but I'm learning to do now."

There is no question that writing about motherhood and other aspects of our lives empowers and transforms us, but reading about other women's experiences does, too. I loved the pieces in this anthology in which authors describe how they were changed when they engaged with the stories of other women writers. In "Narrating an Open Future: Blogs by Mothers of Autistic Children," Daena Goldsmith writes, "Reading these blogs changed my understanding of autism and my ideas about mothering. I began to see why some scholars celebrated blogs as 'radical feminist acts.'" And Cassandra Hall writes how the work of Alison Bechdel and Leah Lakshmi Piepzna-Samarasinha has allowed her to reflect on the lack of care she received in childhood and has helped her move towards a new kind of care for herself and her children.

Showing up and fully engaging as readers also provide opportunities to challenge our assumptions and beliefs. I am always grateful when I can walk in someone else's shoes and leave their story with a more open mind and greater empathy. This was the case when I read Lianne C. Leddy's "The Mum with the Dark Hair: Indigenous Motherhood and the NICU." I know firsthand the difficulties of mothering in the NICU, and Leddy's piece showed me once again how much more challenging that experience is for women beyond the comfort of white privilege, who must navigate an already difficult situation with the added layer of racism.

This powerful collection of personal narratives and academic inquiries offers multiple views of motherhood and the role and power of writing in our lives. In these pages you will find women grappling with their roles as mothers and how they were mothered, and also writing about the ways they have transformed how they see themselves, their pasts and other mothers through the very act of writing.

I love what editors BettyAnn Martin and Michelann Parr write in their introduction: "We explore the power of maternal narrative to create a space for resonance to grow empathy and community, and to grow in ourselves and others the freedom to re-imagine and re-story our lives."

Empathy. Community. Reimagine. Restory.

That is exactly what happens when women and mothers have the space to write their truths. Whether you are absorbed in the pages of a book like this one or sitting in a room full of other mothers sharing your words aloud, this important work creates community and plants the seeds of real change. Not only does it challenges the way we see mothers, ourselves, and our pasts, but it also challenges the very idea of "normative motherhood," as Andrea O'Reilly writes in her chapter "Redemptive Mothering: Reclamation, Absolution, and Deliverance in Emma Donoghue's *Room* and *The Wonder.*"

Ultimately, this collection is a call to action. Listen deeply to the stories that other mothers tell. Listen, reflect, write, reimagine and rewrite your own stories. Your perspective will shift, your empathy will grow, you will be changed, and slowly, one story at a time, the world will be changed, too.

Works Cited

Hopper, Kate. *Use Your Words: A Writing Guide for Mothers.* Berkeley: Viva Editions, 2012.

Hopper, Kate. *Ready for Air: A Journey Through Premature Motherhood.* Minnesota: University of Minnesota Press, 2013.

Pennebaker, James W. *Writing to Heal: A Guided Journal for Recovering from Trauma and Emotional Upheaval.* New Harbinger Publications, 2004.

Contents

An Introduction and an Invitation to Story
BettyAnn Martin and Michelann Parr
17

Movement One
Reflecting: A Way In
33

A Consciousness of Time

Chapter One
Motherhood In Medias Res
BettyAnn Martin
37

Chapter Two
Slow Motherhood: Utopian Narratives of Time Lost
and Found in the Slow Parenting Movement
Marjorie Jolles
53

Bearing Witness to Trauma

Chapter Three
The Mum with the Dark Hair:
Indigenous Motherhood and the NICU
Lianne C. Leddy
65

Chapter Four

A Cold Death: Storying Loss and Writing towards Forgiveness

Mandy Fessenden Brauer

79

Movement Two

Reimagining: A Way Through

91

The Question of Care

Chapter Five

Raising Ourselves: Engendering Maternal Narrative
through (Un)remembering Childhood Trauma

Cassandra Hall

95

Chapter Six

Narrating an Open Future:
Blogs by Mothers of Autistic Children

Daena J. Goldsmith

109

Chapter Seven

Distressed Caregivers or Criminals?
Stories of Precarity and Perceived Maternal Neglect in Chile

Michelle Sadler and Alejandra Carreño

127

Reclaiming Motherhood as Readers and Writers

Chapter Eight

Redemptive Mothering: Reclamation, Absolution, and
Deliverance in Emma Donoghue's *Room* and *The Wonder*

Andrea O'Reilly

141

Chapter Nine
Killing the Angel in the Ether
Victoria Bailey
167

Chapter Ten
Mommas Who Brunch: Is Soup on the Menu?
Hinda Mandell
179

Movement Three
Rewriting: A Way of Becoming
187

Rewriting the Self: Acts of Transformation

Chapter Eleven
Grandmothering in Remission
Michelle Hughes Miller
191

Chapter Twelve
The Possibility of Everything: A Mother's Story of Transformation
Michelann Parr
205

Conclusion
Mapping Motherhood: Where Do We Go from Here?
Michelann Parr and BettyAnn Martin
235

Appendix
A Travel Guide for Your Journey
245

Notes on Contributors
249

An Introduction and an Invitation to Story

BettyAnn Martin and Michelann Parr

"We are, all of us, living stories, eager to find
our own voices by which we can be known to others."
—Robert Atkinson (3)

Take a moment to consider the most powerful story you've ever encountered. Was it a novel you were forced to read in high school but eventually couldn't put down? Was it a firsthand narrative of survival? Perhaps it was an historical account of an early explorer? Or maybe it was an Indigenous history of first contact? Was it your grandmother's telling of her parents' immigration and early years in Canada? Or maybe it was a story read to you by your mother or father as a child. Whatever the narrative, remember how it held your attention and how it stayed with you long after its conclusion. Perhaps this story continues to inspire you, to influence the shape of your own life—the story you are currently living.

Stories have the power to transform our lives; the stories we tell become the narratives that shape perception and action. The stories we love, and the stories we share, reflect the meaning we are making of our experiences. We make sense of the past through narrative, and through conscious acts of creativity and imagination, we create futures of possibility. The gift and power of stories are their resonance; it is through individual and collective aspects of sense-making that we come to understand what it means to be human. In many ways, story fulfills our need for connection and support found in community with others.

Through the sharing of stories, we create a space of reciprocity—a space of giving and receiving—as well as a site of intimacy and vulnerability that allows for both personal and social change. In surrendering to this process, we embrace the true power of narrative—to bear witness, to redeem, to care, to heal, and to transform.

Mary Catherine Bateson posits that transformation is possible through the creativity enacted as we compose our daily lives, in the same way that one creates art or music. She suggests that we employ the narrative acts of interpretation and composition when we attempt to understand the meaning of experience in context. She refers to "the freedom that comes not only from owning your memory and your life story but also from knowing that you make creative choices in how you look at your life" (41). The ability to find continuity—to bridge the gaps between seemingly disparate aspects of our personal narrative—is an act of creativity that calls on our powers as creators to reflect, reimagine, and often rewrite the experiences that form the very fabric of our lives. Indeed, for narrative researchers, "experience *is* the stories people live. ... and in the telling of them reaffirm them, modify them, and create new ones" (Clandinin and Connelly 415).

Reflections on mothering heighten awareness of the complex interaction of possible mental, social, emotional, and cultural responses to maternal experience. We are all at different stages in our awareness of the interplay of these responses. Our writers have bravely engaged the process of putting pen to paper—or fingers to keyboard—to begin the process of discovering how these pieces fit in their own lives and through their own experience. The act of reimagining involves narrative inquiry, whereby the imagination is liberated to explore the interplay of words, which calls new perspectives into being. In this way, imperfect lives become the foundation of imperfect art, and it is through this imperfection—and our willingness to share our selves in process—that others find their resonance with writings on motherhood. These stories are at various stages of development because we, as mothers, are all living these stories in real time—in medias res. As editors, we understand that the work of rewriting both personal experience, as well as the very construction of motherhood, begins with sharing diverse stories: the happy and sad, the poetic and chaotic, the polished and the raw. In keeping with this principle, we have limited our role to that of guide. We want these stories—the well-crafted yarns, brief snapshots, as well

as the stories evolving through continued research on mothering—to speak to you in their own voices. In the stories, we hope you witness the struggle of every mother to find their footing in a landscape replete with faultlines. The hope is that in every crack, you will find a bit of light.

Acknowledging the freedom to consciously create stories and embody change, this collection is dedicated to the experience of mothering and the potential inherent in the storying of motherhood. We explore the power of maternal narrative to create a space for resonance to grow empathy and community as well as to grow in ourselves and others the freedom to reimagine and restory our lives. Our hope for every mother and reader who bears witness to these narrative acts—these conscious, imperfect, and diverse reflections on the beauty and emotion implied by our humanity—is that you may be both inspired and empowered to seek your own voice and confidently compose your own life story.

As editors, we have been privileged to read, engage, and be transformed by the stories gathered in this collection. We found resonance with our authors' experiences of motherhood: we felt our way through these stories with tears, outrage, and laughter. We have been moved to reflect on their reflections and to think and imagine from their perspective, and, in so doing, our lives' trajectories have been forever altered. For the gift of these stories, we extend our most sincere gratitude.

Many use story as a means of escape, but we would like to offer another perspective: story here is explored as a way *in* and *through* experience that culminates in new, creative ways of being in the world. Narrative heightens awareness of artistic choice; when this awareness is combined with encouragement to create and engage possible worlds, imagination and intuition are liberated in the quest for becoming.

When honoured with the task of composing a collective story from these authors' experiences, we gestured towards the function and power of story to transform. We have organized the collection in three movements, which mirror the interdependent narrative acts of *reflecting, reimagining,* and *rewriting.* By reflecting, we refer to conscious engagement with experience that makes meaningful connections between past, present, and potential futures; provides context for who we understand ourselves to be; and guides our awareness of the narratives shaping our lives. Only after we become conscious of tired narratives and ontological frameworks that no longer serve us, can we be free to reimagine our experiences—that is, to recreate and reconstruct the very foundations

of meaning on which the emplotment of our lives is based. Finally, by reimagining, we create opportunities to rewrite all dimensions of experience (temporal, personal, and cultural) in ways that reclaim and redeem the narrative composition of our lives. When these narrative acts are engaged, we write alternate realities and open futures into existence.

Each narrative act is illustrated in the collection by stories that most exemplify its function and power. Stories in the first movement, demonstrate the authors' engagement with the process of reflecting through memory and over time to make sense of experience, in particular, the reality of change or revisiting trauma. In the second movement, the act of reimagining is illustrated, as the writers challenge limited definitions of care and explore futures beyond convention. Finally, the third movement is dedicated to the act of rewriting, in which the authors demonstrate how changes in perspective, and faith in possibility, can be written into our being in ways that transform both the meaning of experience and the evolution of self.

Reflecting: A Way In

In composing our lives, one of the most powerful tools we have at our disposal is the process of reflection. To reflect and create through a process informed by narrative is to recollect in an effort to come to terms with our past and to enhance the meaning of experience in the present while shaping possible futures. Outward, inward, forward, and backward movements through experience are critical to narrative inquiry (Clandinin and Connelly 417). The first movement, then, speaks to the transformative power of this reflective process. The first two chapters reflect a conscious journey through time and memory, and the latter two contain reflections on trauma.

A Consciousness of Time

Motherhood in Medias Res" by BettyAnn Martin is a love letter of sorts—a reflection upon and recollection of memories of her children's young lives and how their relationships in the present moment find meaning through these recollections. It is a personal portrait of the ebb and flow of relationship and the way in which motherhood shapes both knowledge of other and experience of self. The chapter is intended as a reflection on the growth of her children as well as her understanding

of that growth through the empathy and longing of a mother's perspective. Throughout the piece, she wonders if she has loved them enough, a question that continues to challenge her lived experience of mothering and her uneasy relationship with the expectations of motherhood. In composing this collection, Martin now reflects on a potentially greater question: Have I been open enough to the love of others or to the idea of loving myself? Through experience, and the wisdom of these texts, she has come to know that the real gift of motherhood is a reciprocity of care—a shared responsibility of nurture—which evolves between mother and child to meet the change that comes with the passage of time.

In "Slow Motherhood: Utopian Narratives of Time Lost and Found in the Slow Parenting Movement," Marjorie Jolles reflects on her own child's growth by exploring the way in which time is asynchronously measured throughout the experience of pregnancy and mothering. She explores how this disconnect leads many to a dichotomous sense of motherhood as both the "shortest and the longest time." Jolles examines the political investments in the spending of maternal time—how nostalgia has the potential to alter reality—and suggests that the slow parenting movement, with its implied leisure and gendering of domestic labour, is perhaps more suspect than imagined at first glance. The narrative encourages dialogue, including our own as editors, about whether slow motherhood is a seductive red herring or a genuine oasis. Are domestic acts and spaces a threat to feminism or is the "homeplace," as bell hooks suggests, a site of potential power (389), which allows for orientation to self and greater authenticity?

Narrative is Jolles' answer to the question of time, and although it cannot close the gap between then and now, its reflective function offers a bridge and a way home. Finally, Jolles suggests that she is less looking for answers than for witnesses and connection. Her inquiry is a call to action through its invitation to consciously examine how maternal experience has been culturally mediated, shaped, and potentially distorted. But more importantly, perhaps, she invites us to engage the narrative process through the words of poet Mary Oliver: "Pay attention, be astonished, tell about it" (37)

Bearing Witness to Trauma

In "The Mum with the Dark Hair: Indigenous Motherhood and the NICU," Lianne Leddy shares the experience of her daughter's premature birth. Although the birth itself was traumatic, equally devastating was her postpartum experience. The surveillance Leddy endures in a Westernized medical context forces her to balance self-advocacy with deference in fear of reprisal; it is a position of precarity that she acknowledges may be even more tenuous for Indigenous women of less privileged circumstances. Leddy laments her introduction to motherhood and breastfeeding in a Westernized space, where the bond between mother and child is often compromised by intervention and separation. For Indigenous people, this bond is sacred; breastfeeding—fulfillment of "the first treaty"—is an act which heralds the promise of life sealed at the time of creation, as told in the story of Wenonah's nourishing of her people. The inability to perform the sacred act of breastfeeding is a source of deep sadness for Leddy that finds little empathy in the NICU.

Although the chapter is a reflection on personal trauma and the racism she encountered in her vulnerability as a new mother, her writing and sharing not only bear witness to this experience but also reclaim the power of her own cultural heritage. In the end, Leddy regards "Mothering and restoration [as] community practices" and recalls the resilience that Indigenous women embody in communal acts, such as the sharing of stories and laughter. Leddy welcomes us into this space of sharing and restoration and invites us to bear witness to her pride in Indigenous tradition, her community, and her daughter.

In "A Cold Death: Storying Loss and Writing towards Forgiveness," Mandy Brauer comes to terms with the trauma of a mother's suicide and the long-term effects of her mother's mental illness. The shared love of story and writing is one of their only points of connection, and it is through this connection that Brauer is able to find a way in—to reconcile the pain of her loss, especially her conflicting feelings of grief and reluctance to say goodbye. The author struggles with the image of motherhood and expectations of maternity, which often obscure the reality of an imperfect person who also happens to be a mother. In moving through time and memory, between her experience of trauma and loss as a child and an adult, Brauer experiences healing as an evolution in understanding; she finds peace, if not forgiveness, through

a conscious process of reflection that allows for a reinterpretation of past experience and recovery of lost innocence. In the end, Brauer comes to the pragmatic realization that "we all do the best we can under the circumstances, whatever those may be."

Reimagining: A Way Through

Narrative inquiry examines the lived experience of individuals but also "the social, cultural, and institutional narratives within which individual experiences [are] constituted, shaped, expressed, and enacted" (Clandinin and Rosiek 42). The project of reimagining our story, the story of our lives as mothers, continues with the act of reimagining our role in light of the lived contexts of our maternal experience. Through this process of contextualization and creative reimagination, our stories take on a more authentic shape, as is poignantly addressed in this movement. The first three chapters interrogate the cultural contexts in which notions of maternal care and responsibility are defined, and the latter three look to the role of reading, writing, and venting as individual and collective acts of maternal empowerment, reclamation, and redemption.

The Question of Care

How do we learn, embody, and enact care? How is the provision of care culturally scripted, controlled, and used to exploit or evaluate maternal practice? These questions are interrogated and explored throughout these writings that reimagine care and futures beyond such controls.

"Raising Ourselves: Engendering Maternal Narrative through (Un) remembering Childhood Trauma" is a reparative analysis that seeks to undo the shame attached to notions of care informed by hegemonic ideologies. In this process, Cassandra Hall reimagines care as a process beyond the "genealogies of abuse and neglect" that characterized her childhood experience. She argues that "the transformative act of (un) remembering memoir creates ruptures in the past, enacted in the present, that move us towards novel, perhaps queer futures." For Hall, who identifies as a "crip femme," care cannot be one sided, as it is so often constructed in normative culture. Hall advocates that through acts of reimagining care and the provision of care (beyond shame), there is power to resist "normative futures that profess to be inevitable." With every act of (un)remembering, a new reality is created. And in the act of

choosing to (un)remember and disentangling associations with care forged in memory, Hall clears a space for reimagining and, in turn, birthing an open future. She welcomes the promise of this uncertainty for her own child with the query: "What becomings will (my) care enable in you?" For Hall, birthing identity and raising oneself is a conscious act of restorying, in which the archive of the body is repaired and liberated from painful histories. Change is possible through new narratives—creative acts that begin with a process of re-imagining and a vision of the possibility of restoration.

In "Narrating an Open Future: Blogs by Mothers of Autistic Children," Daena Goldsmith likewise interrogates cultural investments in care and the trajectories of care in the lives of children whose futures are, for the most part, uncertain. She explores this uncertainty through the blogs of mothers whose lives have been shaped by the experience of caring for a child on the autism spectrum. These mothers narrate their daily experience and share their frustrations as well as their proudest moments with other moms seeking both to be supported and to offer support. The blog format, as Goldsmith observes, is analogous to the experience of raising a child with autism; it meanders, pausing on the minutiae, and often moves in unpredictable directions, with disregard for plotlines. There is a communal synergy and political impetus for such sharing, as mothers advocate for enhanced social support systems and challenge notions of maternal care that burden mothers with responsibility beyond reasonable expectations. Goldsmith compassionately argues that mothers of autistic children invest care without any promise of return—a concept that runs contrary to notions of investment of time and attention in the construction of intensive motherhood and its perceived benefits. The product, in their case, is, at best, an uncertain future. Although this uncertainty is the source of genuine apprehension for these mothers, it is through the act of sharing stories that many have come to reimagine these uncertain futures as open sites of possibility.

When mothers are powerless to define the conditions of their own mothering, and the performance of their own care, the consequences can be devastating. The impact of intrusive institutional mandates that seek to govern maternal responsibility is painfully evident in "Distressed Caregivers or Criminals? Stories of Precarity and Perceived Maternal Neglect in Chile." Recounting the stories of Gabriela and Joane, Michelle Sadler and Alejandra Carreño explore the acute vulnerability

of marginalized mothers, whose caregiving practices are heavily scrutinized outside of their cultural context. Gabriela, an indigenous Aymara shepherdess, faces criminal charges of abandonment and murder when she is forced to leave her son and pursue animals that have left the herd. The landscape, her actions, and even her emotions are deemed suspect in the context of contemporary Chilean policies on maternal responsibility, which are steeped in paternalistic and Westernized notions of care. Similarly, a Haitian immigrant by the name of Joane is accused of neglect when she leaves her child with a local authority while searching for a translator. For Joane, this is not a criminal act, but a gesture of good faith, in keeping with the *lakou* system, in which Haitian women place their trust in public spaces and communal childrearing practice. In Chile, her gesture is misread, and Joane's daughter is taken into protective custody; Joane languishes in prison and dies shortly after her incarceration. The story is a devastating testament to the power of cultural narratives that seek to define and surveil the provision of mothers' care. The chapter bears witness to women's vulnerability when their maternal subjectivities are "tested in public and political contexts." Systems of power that threaten to challenge or even criminalize maternal practice create the conditions of precarity that alienate Gabriela, Joane, and countless other unnamed mothers from their culture, their children, and the authenticity of their own experience.

Whether mothers are made vulnerable through the failure of a social safety net or oppression based on race, class, gender, and/or non-normative expressions of sexuality or family, mothers' lives and their stories become tenuous. It is in the act of reimagining notions of care and motherhood that mothers redress limitations and, in so doing, reclaim experience and create space for a world in which cultural difference is celebrated and empowering futures may be realized.

Reclaiming Motherhood as Readers and Writers

Reimagining motherhood with sensitivity to the contextual narratives that seek to define its meaning and evolution, as well as reimagining the significance of our own experience in context, is a critical step in liberating the idea of "mother" (as well as women) from its oppressive legacy. We need to read and write mothers with more compassion. We must make a concerted effort to understand mothering that resists normative definitions. We must seek the solidarity of women whose

perspectives resist the limitations of dominant constructions of what it means to be both woman and mother.

In "Redemptive Mothering: Reclamation, Absolution, and Deliverance in Emma Donoghue's *Room* and *The Wonder*," Andrea O'Reilly enacts this liberation by exploring maternal redemption in Donoghue's *Room* and *The Wonder*. O'Reilly artfully reimagines and, thereby, reclaims the actions of two mothers whose behaviour could potentially be deemed suspect. In *Room*, Ma's seemingly codependent relationship with her son is taken out of context once she escapes confinement. Late breastfeeding and her general obsessiveness in his care and protection are viewed as perverse and, subsequently, are implicated in his emasculation. However, O'Reilly suggests that in Donoghue's works "mothering emerges as empowered practice of resistance and salvation for children and mothers." Ma, she argues, is an attentive mother whose care of her son is reciprocal and redemptive. In *The Wonder*, suspicion and judgment are compounded by the limited perspective of the narrator. O'Reilly argues that Rosaleen's complicity with her daughter's will to starvation is potentially redemptive, given that her actions are informed by the religious belief that she can save her daughter from mortal sin through fasting and prayer. She shows how perspective is all, since Lib (both nurse and narrator) is unable to reconcile her own scientific knowing with the mother's actions. O'Reilly's insights challenge the reader to inquire how many mothers' stories are misread. How do we as mothers, writers, and readers reclaim these narratives? Through O'Reilly's redemptive act of reading and reinterpreting the maternal figures of Ma and Rosaleen, the answer seems to lie in the will to see with compassion.

In her chapter, "Killing the Angel in the Ether," Victoria Bailey both reimagines and liberates creativity from traditional and worn narratives. With the realization that the collective weight of past expectations on women (as both mothers and writers) has done her a disservice, she works diligently to undo the damage through a creative and evocative plot to "Kill the Angel in the Ether." Bailey's writing explores notions of freedom and privilege by interrogating the idea of space. The reader is encouraged to question how women will come to know themselves as writers or mothers if there are no safe spaces (never mind the proverbial "room of one's own") where a woman may be at peace with her thoughts. As a mother, Bailey reflects on space as a treasured and finite commodity, with many demands on time, attention, and bandwidth. So when does

empowerment happen if there are meals to make, kids to transport, and the ghosts of past female writers to slay? Ultimately, Bailey reimagines space itself:

> A room is not enough ... we need more space. We need a new space. We need an open, inviting, inclusive, safe, supportive, communal space. We need a limitless space of our own. The time for safe enclosures is past; we must think beyond the constructed ether to which we are given limited access. As mothers, we must nurture each other and other writers similarly misguidedly locked away in their own room or echoing in the void without traditionalist acknowledgement ... the most important story is (y) our own.

Bailey's argument for communal space is taken up in the reimagining of motherhood as enacted by Hinda Mandell in "Mommas Who Brunch: Is 'Soup' on the Menu?" The collective support offered in sharing stories at brunch dates and via digital communication through text messaging is the subject of Mandell's humorous exploration of the manner in which "venting" is understood as an act of reciprocity between moms that allows for debriefing, validation, and, ultimately, the determination of a husband's soup worthiness (where soup is a euphemism for sex). Mandell's piece celebrates the reciprocal "sharing ritual that so many women have mastered with their closest female friends: If you bare your secrets to me, I'll bare mine to you." Through this chapter, this ritual and these secrets move beyond the realm of the private and occupy an open space within this collection. Humour aside, Mandell openly acknowledges that in these acts of sharing, "We feel supported, loved, validated." And it is in this admission that Mandell's chapter inspires us, as readers and mothers, to reflect on the meaning and value of communal rituals of sharing and support in our own lives.

As mothers, we are able to glimpse our power (beyond the slights of our partners or children) when others share the gift of their empathy in response to our stories. Resonance offers a way through experience; in community and through story, women and mothers collectively engage the project of deconstructing and reimagining experience from the perspective of another's wisdom, which offers a way through our "problem(s) du jour" and the places where we may get stuck in our own story.

Rewriting: An Act of Transformation

> "What lies behind us and what lies before us are tiny matters compared to what lies within us."
>
> —Author unknown

Movements of reflecting and reimagining offer the tools to work our way through experience and engage alternative futures and realities lightened by the promise of transformation. In reimagining our stories and the contexts in which they are lived, we are free to rescript our experience and, thereby, plot otherwise inaccessible trajectories for becoming.

The ideas of self-care and self-help are implicitly predicated on an absence of reciprocity. O'Reilly suggests that the same is true of traditional notions of maternal care as sacrificial—something that is given rather than shared and inherently powerful in its potential to redeem both child and mother. If mothering is, by its very nature, redemptive, we would do well to look to relationships of reciprocity as the inspiration for our own transformation as mothers. There is a balance in this: maternal practice is both sacrificial and restorative; it is our greatest vulnerability but also a gift of connectivity through which we are able to access higher levels of our own consciousness and being. The power of reciprocity is storied in this collection through touching narratives of trial and transformation by Michelle Hughes Miller and Michelann Parr.

In "Grandmothering in Remission," Hughes Miller describes her experience of grandmothering through the lens of her experience as a cancer survivor. She laments the uncertainty of the future; her altered reality and body; as well as the limitations that now exist on the care she is able to give. The terrain of Hughes Miller's beginning shifts through a friend's lesson on the importance of remaining "aggressively optimistic" and her own refusal to save energy for the journey back since that place of being. Self is inevitably changed through experience, and although we might look back, through memory, there is no return; hope, however, lies in the promise of transformation. Through experiences that have shaped us, and which we have shaped through writing, there are new beginnings and becomings, which ultimately mark the evolution of our consciousness.

The reader empathizes with Hughes Miller's quest for faith amid uncertainty; hope is evident in the love this author bestows and garners through relation with her children, partner, and her grandson. In the weaving of her tale, we recall the intergenerational connections and universal desire to be known that bind us all. In her writing, the seeds of possibility are sown and we are, likewise, transformed by the rewriting of trauma towards a vision of a forward journey that is fuelled by loving (if not aggressive) optimism.

Hughes Miller's gesture of hope is taken up by Parr in "The Possibility of Everything: A Mother's Story of Transformation." In this chapter, Parr's rewriting of experience allows for a reawakening to the possibility implied by motherhood as explored through the birth and illness of her oldest child. Parr shares her vulnerability to personal investments in the idea of motherhood and the manner in which these investments (challenged in the experience of caring for her daughter and family) took her from herself, until a storytelling retreat brought her through disenchantment to a place of personal transformation. Ultimately, a rewriting of faith and relationship are required for Parr to move through—and forgive—herself. Her growth is guided by faith in simple pleasures, presence, and a knowledge of peace, which are rooted not in the absence of hardship but in an authentic, grounded vision of self that remains open to the possibilities implied by change. Ultimately, Parr invites all mothers, regardless of circumstance, to confront their mother stories with the same empathy and compassion they bring to the task of mothering, to seek peace and inspiration in their lived experiences, and, to embrace the countless possibilities accessible to all mothers through the reflective, creative practice of both mothering and writing.

Story validates wisdom gained through experience. The writing and sharing of narrative affirm trust in personal ways of knowing as well as our right to creative control of the stories that shape our lives. When the meaning of motherhood is culturally mediated, mothers engage storied lives with traditional plotlines and closed endings. When stories—such as the ones in this collection—embolden women and mothers to look beyond convention for stories of adventure and potentiality, those narratives become available to us. In other words, if we dare to imagine and inhabit open futures, we create space for the possibility of everything.

Space for Connection and Creativity: The Promise of a Pause

As writing mothers and editors, our academic lives are punctuated with pauses from our reading and writing; it is in these pauses that we are able to ground ourselves through processes of reflection and creative engagement that allow for transformation. It is in these found spaces that we often seek communion with fellow mothers. There was a time when we might have rushed these encounters, distracted by thoughts or looming deadlines. We're learning, however, to celebrate and surrender to the beauty of these pauses—those spaces in which we connect with others to tell of our lived experience and to share our stories.

We hope that you, as mothers and readers, are able to find pause—time to feel your way through these stories. Get comfortable and dwell in them. Let them ignite your own powers of empathy and creativity. Be guided by them to bear witness. Be inspired by them to access your own voice and share your story.

These Stories, Our Gift

This collection is very much a love letter to you, our dear writers and readers: it is a celebration of your limitless potential and your power to craft stories that model authenticity—a knowledge that we, as readers, can only attain by taking up the call to consciously compose our lives. In the journey towards understanding, we learn first and foremost through experience; we then share experience in an effort to make sense and to make ourselves known. We tell stories so people will come to know us, but it is in the telling that we also come to know ourselves. Mothers who write explore self and other simultaneously; they write as they love, in the spirit of reciprocity, and it is in this spirit that we lovingly invite you to be acquainted with the prospect of your own evolution through the care, community, solidarity, and healing reflected in these stories.

In truth, it is human to resist change and to follow a linear and familiar trajectory. It is, often, a rupture, imperfection, or disruption in the fabric of our experience—or in our perception of that experience—that allows for change. As Leonard Cohen suggests, "there's a crack in everything; that is how the light gets in." Perhaps this crack can be found in time—through a moment of conscious reflection and a subsequent reimagining of experience that allows for a process of reseeing

and reconstruction of self. When we are empowered to revisit and revise the past, rewrite our present, and create our future, we surrender to change—to an evolution of our own design—which makes both redemption and transformation possible. Given that the imperfect arts of mothering and writing are conduits for both, the choice and the power to restory our lives are ever present. Whether the change we invite through our narrative acts is personal, social, or both, we are liberated by the opportunity they create to move in and through our stories to a place that feels both like home and an undiscovered country.

Endnotes

1. Authorship is contested. With varying frequency, this quote has been attributed to Ralph Waldo Emerson, Oliver Wendell Holmes, Albert Jay Nock, Henry David Thoreau, Henry Stanley Haskins, and William Morrow.

Works Cited

Atkinson, Robert. *The Gift of Stories: Practical and Spiritual Applications of Autobiography, Life Stories, and Personal Mythmaking.* Bergin & Garvey, 1995.

Bateson, Mary Catherine. "Composing a Life." *Sacred Stories: A Celebration of the Power of Story to Transform and Heal,* edited by C.H. Simpkinson & A. Simpkinson, Harper One, 1993, pp. 39-52.

Clandinin, D. Jean and F. Michael Connelly. "Personal Experience Methods." Handbook of Qualitative Research, edited by N. K. Denzin and Y. S. Lincoln, Sage, 1994, pp. 413-427.

Clandinin, D. Jean, and Jerry Rosiek. "Mapping a Landscape of Narrative Inquiry: Borderland Spaces and Tensions." *Handbook of Narrative Inquiry: Mapping a Methodology,* edited by D. Jean Clandinin, Sage, 2007, pp. 35-75.

Cohen, Leonard. "Anthem." *The Future,* Columbia Records, 1992. CD.

hooks, bell. "Homeplace (a site of Resistance)." *Yearning: Race, Gender, and Cultural Politics,* South End Press, 1990, pp. 41-49.

Oliver, Mary. "Sometimes." *Red Bird: Poems.* Beacon Press, 2008, pp. 35-38.

Movement One
Reflecting: A Way In

By "reflecting," we refer to conscious engagement with experience that makes meaningful connections between past, present, and potential futures, provides context for who we understand ourselves to be, and guides our awareness of the narratives shaping our lives.

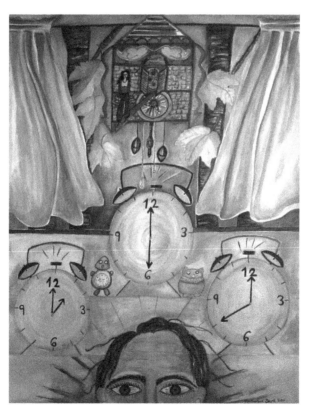

Alarm Clocks and Bells

A Consciousness
of Time

Chapter One

Motherhood in Medias Res[1]

BettyAnn Martin

"Every story is a threshold to a new understanding.
I am remade through these collected memories,
through these acts of recollection and creation."

When we are living amid the drama (mothering in medias res), it is difficult to savour time spent with our children. Like tiny paparazzi, kids overwhelm our senses: sights, sounds, and an assemblage of still images all flash into recognition to form a temporal collage that chronicles the progress of our days. The recollection of many of these moments will fade like a trove of colour-worn photos, but some will make their way into more permanent memory—those indelible pictures that unexpectedly flicker into future thought, making us instantly present to our past.

Images of you ...

Bathed in light;
Shirtless in the sun,
Afloat on a sea of magnolia blossoms.

> *With a DIY haircut and lost tooth*
> *Flying your kite;*
> *Defying gravity—*
> *And me.*

A mop of dark curls, dancing;
Warm in snowman pajamas,
Stretched over toddler belly.

> *Lying in a patch of daisies;*
> *Plucking petals ...*
> *I love you.*

Wading through rivers,
Fearlessly feral.
Serene.

Images of the five of you
Now woven
Into a patchwork of memory.

As mothers endeavour to remain present in the moment, there is little time to process events—to decipher the daily onslaught of images and interactions towards an understanding of both our experiences and ourselves ... until we find pause to reflect and tell our story.

<div align="center">*</div>

"It is cold outside, but it is warm inside." I read in hushed tones as you listen, your eyes wide in anticipation of the story yet to unfold. Your fingers edge ever so slowly towards the corner of the book, as you endeavour to sneak a peek at the following page. "You'll have to wait," I say.

I am conscious of the preciousness of our time together, in this moment, in every moment. We are huddled close, and it is warm.

A wish, a prayer for my children, spills into this warmth we're sharing:

May you always be safe
May you be happy
May you be strong
May you live with ease.[2]

Where to begin is always the question. In reaching back, I may lose something of the moment that lies before me. Torn, I look for landmarks: memories that mark my place of beginning, the origin of my being and my becoming.

What now?

Begin.

Again.

*

How do we make story from memory in the soft afterglow of elapsed time? How do we reconstruct those "memorybank movies" (Laurence)—those weightless yet precious possessions that we carry from our past into the future? I play them often, especially when I want to feel closer to you or when I consider how much we have grown. I watch the scenes play out before me: delightful vignettes, comedic missteps, dramatic plotlines. Creative licence and a healthy resignation to the reality of imperfection have long ago softened any lingering feelings of regret.

"This parenting gig is pretty fucking hard," I tell myself most days, especially on those days when the lunches aren't made; when the report card still hasn't been signed and the teacher has already sent three reminders; or when picture day comes and goes without notice, and the arrival of the proofs reveals that my daughter's lack of grooming is now documented for future generations.

"Why can't I get my shit together," I ask myself.

"Well, you could start by not using the word 'shit,' and by resisting the temptation to chastise yourself in tones loud enough for others to hear."

And so the dialogue between my aspiring best self and my oft-defeated mother self continues.

Labour was difficult, don't get me wrong, but the work involved in managing everyday relationships with my children is more than I could have ever imagined. I make every effort to share mealtimes, to ask about their day, and to understand what is really going on in their lives. *Harry Potter* with herbal tea finishes our days; my kids and I have regular "life chats," as my daughter calls them; I tuck them in and kiss them goodnight.

It is like fucking *Little House on the Prairie*—until it's not.

Banana Bread and Vinyl

Since my second oldest daughter left for university, I have had to relearn the art of communication—when to call, when to pry, and when to accept long silences and not knowing. She is an artist. She thinks in pictures more than words and with steady hand gives form to thought.

I putter in the kitchen in anticipation of her coming home; I bake for her, and sometimes we will bake together. I love her with all my heart, but lately every conversation deteriorates into my pleading with her to be more responsible and her exerting independence through quiet (and not so quiet) acts of rebellion. The nose ring, the tattoos, and the five-minute haircut with kitchen scissors are some of her most recent volleys in this sport of provocation.

Little does she know how much I respect her tenacity, her will to be different and daring: I love when she wears Blundstones with a cocktail dress.

She talks about feminism, politics, identity, and the anxiety she feels about not having a clear vision of her future. And so she sketches and draws herself to the bone. Sometimes I recognize these images, but often I do not. She is both exhilarated and terrified by every untouched canvas. When her spirit settles a little, the silence breaks; colour and form find expression, and I am in awe.

I wish she knew how much I want to know her, this woman she is becoming. She is far more principled and nuanced than I was at her age. I tell her this, but she does not believe me.

She demands little these days, basking in her independence and the angst of life's uncertainty. Coffee shops and climbing gyms are her refuge. She only ever asks that I make banana bread. I don't know whether her needing me or not needing me is more difficult. And so I bake.

4 bananas
2 eggs
½ cup apple sauce
1 tsp vanilla
3 tbsp plain Greek yogurt

2 cups of oat flour
¾ cup quick oats
¼ cup ground flax seed

1 tsp baking soda
½ tsp salt
1 tsp cinnamon
½ cup chocolate chips

And then we wait.

Few words are exchanged. She cuts the bread, piping hot, and enjoys a generous slice. I smile, happy to contribute in a small way to her present joy.

Her phone signals a new message, and within seconds, her fingers issue seemingly critical missives to a friend? a lover? And still I wait. I wait for her to enter into this moment with me. I realize, however, that long histories sometimes breed complacency. Perhaps she believes that, when the need arises, the words will be there like warm banana bread.

Her passion for nostalgia inspires her fondness for handwritten letters and vinyl. Like the scent of baking, music often fills the space between us—the sound of every scratch signals authenticity and the beauty of imperfection.

In turning this table,
You stir
Emotion and memory;
Restore my will.

Distant child,
Drifting;
Holding you is like
Embracing water.

I used to think wisdom was my domain,
But your depth humbles me.
Perhaps we both have something to learn.

Your music
Fills the space,
The silence between you and me;
These vinyl circuits have lessened the gap:
We know the words;

There are no surprises.

The comfort is all.

Beyond this moment,
Your life beckons.
Mine is here
Waiting ...
For your return.

For the journey,
I give you this offering—
These words—
As gratitude for all the lyrics
That have us singing of goodbyes
And future moments of togetherness.

Buses and Microbiology

She has lived away from home long enough to know longing for a sense of place and family. She makes an effort to call me when travelling to and from class on the city bus. Our conversations are often interrupted by the brief, polite exchanges she has with the driver and other passengers. The sounds of the bus as it negotiates traffic, stops, and starts again have become ambient noise for these dialogues in transit.

She has just come out of a long relationship and finds solace in simple reassurances: "I just don't know how I could give so much and still have it not work," she muses. I empathize. "I understand" is all she needs me to say. I once said more, filling conversations with what I thought was wisdom. I've since learned how silence can work to build closeness.

Gentle child;
Self-proclaimed nerd;
Proud lover of all things animal.
You dwell in fantasy:
Superheroes, vampires, and avatars—
Comfort when reality is unkind.
I'm sorry
I did not intuit
The depth of your need.

From other worlds to microcosms;
Through imagination and magnification,
You mark
Seemingly imperceptible change.
Perhaps one day
You will see,
I too have changed.

I wish the love I feel for you
Could manifest a world,
A refuge;
Your avatar gifted
With all the power
You are reluctant to claim
In this life.

A student of microbiology, she informs me that she has just grown resistant bacteria. "Why would you do that?" I ask. She laughs, as if I had intentionally made a joke. It is ironic that she wants to be a scientist. In high school, she loathed the humanities with its unresolved questions and messy grey areas, and now she places her faith in scientific theory and hypothesizes the behaviour of microscopic organisms. How should I tell her that she is as much a storyteller and creator as any author?

She likes genetics and germs but hasn't decided how inspiration will translate into prospects for a career. We chat about the possibilities—fertility, gene therapy.

She likes the lab; it is quiet. She lives alone, but would like a sugar glider. I laugh. I hadn't even heard of such a creature before our conversation. She informs me that if you don't love them enough they get lonely and start to pull out their fur. As she explains in detail the peculiarities of these tiny but fiercely bonded creatures, I wonder: "Have I loved them enough?"

She doesn't know how proud I am of her. She is a brilliant young woman and endures the grind of student life with a tempered enthusiasm. After all of these years, she is still studying, going to the lab, and taking the bus. I am thankful for the bus because it gives us a space in time to chat that otherwise wouldn't exist—a time to catch up on her life, her dreams for the future, and her pet musings.

I wish she had more time to come home, or a longer bus ride.

She Who Intoxicates

My middle child is a scene stealer, an unadulterated ham with just a hint of sass. She has a mess of dark curls and a palpable glow, accentuated by honey-coloured eyes. She was nicknamed "Boo" by her daycare provider because she bore a striking resemblance to the character of the same name from *Monsters Inc.*

FACT: She watched this movie so many times as a toddler that her siblings refuse to watch it to this day.

Her spirit is unburdened by pettiness. Lightness and humour are her domain.

This child—
First breath of spring.
Pure joy.
Wild auburn tresses;
Hints of red—
subdued fire.
Well, almost subdued.
Her irrepressible spirit,
A Beacon.

Awake before dawn,
She speaks her truth—
Endless anecdotes of excitement.
Her voice, a balm against darkness.
To hear her sing
off key,
A melody.

She is now sixteen. The mother-daughter madness of the teen years is upon us. Every time I want to scream in absolute frustration, she thanks me for making dinner or tidies a room without prompting. In so many ways, she is already an adult. She understands the value of family and responsibility.

At times, her childhood has been obscured by her sense of obligation and will to lead. As a toddler, she always wanted to be the mommy. She could often be found rummaging through the closet for a pair of high heels and then shuffling along with a doll in tow. On occasion, I still have to remind her that I am the mom. Despite her adult aspirations,

she is still a child. I see glimpses of her—the exuberant toddler—when she excitedly shares the details of her day or tells me about a compliment received from a friend or admirer. Her smile and humour are infectious. She draws others to her with a gravitational force that is not difficult to understand. Her admirers are many, mostly because she makes people laugh. I tell her this is a gift.

Recently, she has been distant. Tears begin to well as she speaks: "High school has made me realize that I am average."

I tell her, "You are a lot of things, but average isn't one of them. People are drawn to you. You are a leader. That isn't something that can be taught; it has to do with your character, your creativity, and how you take advantage of the influence you have and the opportunities you are given."

My zeal is lost on her. I'm her mother, of course; I think she's special. She says as much to me. How can I tell her that she is amazing and have her believe me? That is the bind of a mother's opinion; it is always suspect, presumed to be biased. Perhaps it is, but this kid is the real deal.

Sometimes I can feel the tide turning. I feel my influence waning, as she becomes ever more mature. Determination is her essence. She is driven. Middle child ennui be damned.

I flashback to her toddler resolve: "Tie it tighter mommy." I try. "Sorry, honey, I can't tie it any tighter." She pleads. "Okay. There." (I'm satisfied with the increased tension on her dress sash). "No mommy, tie it tighter!"

Again and again, she pleads, and every failed attempt results in a flood of tears and all round misery.

Later that day, while she naps, I take the scissors and cut the ties without regret. There is now no sash, ergo no opportunity for disagreement.

I wish it were that easy now, but the out of sight, out of mind hypothesis doesn't apply to anxiety-fuelled teen musings. In fact, it is the nebulous, not the real, that incites panic: "Why didn't they invite me? Don't they like me? Why can't I have a phone? When will I have a phone? I don't have a social life; no one invites me anywhere because I don't have a phone. Why are you being so unreasonable? You just don't understand."

How can I make her understand that all I want is for her to stay connected with our family just a little while longer?

The time of a child's attention, the time of loving notes and countless

stick figure families drawn under yellow ball suns and arching rainbows is fleeting. Our circle of influence is diminished; and, sometimes we find ourselves on the outside, looking in and back on moments we neglected, at the time, to recognize as precious.

Bows and Beats

And now for something completely different.

I was raising three girls. I knew what "girl" meant, or so I thought at the time. I didn't understand "boy." It was a terrain that I wasn't really keen on tackling. My enthusiasm for newness as a parent had long since been replaced by the comfort of known entities. With the birth of my son, the adage about best laid plans was called into play. He weighed a painful 9 lbs. and 13 oz. and cried long hours into the night, but from the very beginning, his big blue eyes and open smile made me forget that "boy" was not part of the original game plan.

With three sisters, my son became enamoured with hair clips and nail polish. He liked cars, but he also liked Barbies (which he mostly wielded as weapons). He grew with a flair for fashion, and to this day, he remains my most intuitive shopping companion. Funny how things work out: The daughter I always wanted, a close companion and confidante, turned out to be my son.

When he was little, I would not allow toy guns in the house. All of my son's friends had numerous plastic weapons with diverse firing capabilities. My son's envy was palpable, but I held firm in my conviction. Years passed, and I was certain that the thirst for fire power was behind us. It was during our foray into homeschooling that my son found time to pursue his interest in weaponry as well as a budding interest in replica construction. For months, my lawn was littered with homemade wooden swords, shields, crossbows, pistols, bayonets, and rifles. He regularly took to the shed to modify my drainpipes to make triggers. I do see the irony. Did censure breed this fetish? I choose to repress that possibility. I did take solace in the fact that he was learning a trade, and that his woodworking might come in handy if directed toward more functional projects. The jury is still out.

My son is now thirteen. He wears his hair long on top and short at the sides, in a style we affectionately call "the full Kramer." Having hit puberty at barely eleven, he reminds me of Tom Hanks in the movie

Big—he looks like a full-grown man but still hunts for Easter eggs, plays wormy wars (a game of full-body combat played while zipped into a sleeping bag), and jumps on trampolines.

Research suggests that the prefrontal cortex in males isn't fully developed until approximately age twenty-four. Why, then, does nature fuel accident-prone adolescents with testosterone before this critical age of rational decision-making? Needless to say, the disconnect between his appearance and level of maturity continues to pose certain challenges for both of us.

Your smile
Opens and lightens my heart.
With a hug,
All is right with the world.

Now taller and stronger than me,
I feel like a child, in your embrace;
Then I remember that you are still my boy:
You still build Lego,
Still pout,
Still plead with the intensity of a child.

I remember your pride
When your homemade arrow
Flew straight and steady,
Made contact with your target.
I remember also how your enthusiasm waned;
And you devised a moving target,
By making your little sister
Wear it ...
Like a sandwich board.

All those years I tucked you in, we'd talk.
I wondered if it meant as much to you.
You speak now of honouring that time in
Matching tattoos—
I would have said, "Never," a lifetime ago,
But now I am moved by your suggestion.

Lately, your Beats signal inattention

To our time together.
Music is your passion.
I watch you dance while unloading dishes,
Your mind and body in constant motion.

I wish I could settle your spirit.
I wish we could slow this process
Of you growing up and away from me ...

I would like to stop the music,
Or share in it, at least.

Palindromes and Pollywogs

My nine-year-old thinks and writes in reverse. Initially, it was just letters, but as her familiarity with language progressed, whole words and phrases were reproduced in mirror image. Perhaps she will always struggle to grasp the orientation of words, which seem to move and slip their sense. Through her struggle to find expression, she has taught me the value of alternate perspectives: the ability and, sometimes, the will to see things differently.

She peels her bananas from the bottom up and eats them like corn on the cob. Her reality has become a metaphor. She does things in her own way and gets to where she needs to go ... eventually. I am ashamed to admit that early on, I discouraged her unabashed independence, misinterpreting it as a petulant streak of rebellion. I somehow took it personally that she refused to wear socks with shoes, that she removed both every time she travelled, that she climbed trees and jumped fences, and that she would never wear matching outfits or let me brush her hair. Now, I realize that many people spend the majority of their lives searching for even a hint of the kind of freedom that my daughter inspires. She is at peace with her being in the world, unfettered by custom and conformity. She regularly defies fences and other boundaries that seek to define her space of becoming.

Her liberated will sometimes complicates our relationship— depending on how rebellious she's feeling on a given day and how exhausted I'm feeling on that same day. I regularly ask myself: Is my mission to guide or simply enjoy this child? Am I to be her mentor or friend? There are few definitive answers.

At some point, for the sake of sanity mostly, I abandoned the idea that I am intended to shape my daughter to reflect the image of a child that someone (in some imagined future) may reward and validate for good behaviour. My child is a good and thoughtful friend to others, so I have come to overlook the fact that she is usually dirty and somewhat unkempt.

I have accepted that dirt comes with her callings as a naturalist, a garbage artist, and an engineer. Her most recent project is a humane mousetrap. I have twenty failed prototypes adorning my yard that bear witness to her dedication. Water bottles, cardboard boxes, elastics, pencils, paperclips, and string are all collected and customized with care. She works with a feverish intensity that makes her oblivious to any form of distraction, including calls for meals and bedtime.

She wears Converse or goes barefoot; she often draws diagrams of skunk anatomy in her love notes to me; she incubates fallen bird eggs, dissects frogs on her iPad, and snacks on sriracha seaweed. She regularly wears a t-shirt made by her sister that says, "Do art. Stay weird." I would have to say that there are worse imperatives than these. My daughter is clearly determined to do both, and for that, I have learned to be grateful.

A whirling dervish;
You keep me on my toes.
"Esio Trot is tortoise spelled backward,"
You inform me.
You have found a kindred spirit in Roald Dahl;
Both quirky and off-beat,
Finding delight in reversal
And irreverence.

You spend summer in the garden,
Lost in planting and dreams of harvest.
You would like a chicken named Gloria,
And a pet rat.
I will consider the chicken ...
Compromise is challenging.

We sometimes take long bike rides.
You wheel the trail with purpose,
Often with a bottle in your backpack,

Intent on hunting tadpoles.
We find the spot—
Our path to the river.
Your shoes and socks disappear.
You are quiet in the water,
Still as the river's surface—
Waiting.

Pollywogs are quick creatures,
But you are determined.
Satisfied with your catch,
We begin our journey back
Through trees
And slices of the day's fading light.

At home you make a habitat,
Filled with river water, rocks, and grass.
That night you dream ...
Amphibious dreams,
Filled with hope and transformation.

Reflections in Real Time

Can a child be a poem? Atwood says, "No."[3] Yet as I make sense of these stories—my relationships with these children—poetry is the only language that rises to my need. In the telling and retelling, every story is a threshold to a new understanding. I am remade through these collected memories, through these acts of recollection and creation.

These lives, including my own, are stories in process, intersecting and unfolding, even as I write. They are pieces of a portrait that inform my knowledge of the world: my experience of the past as well as my perception of both present and future. I share these precious fragments— my memories, thoughts, and insights—knowing that the potential for empathy and community is abundant in those places where story finds resonance.

*

She listens, as I read. I ask her to move over so that I can cuddle her in bed. Tonight's story is *Fanny and Blue*. I sing the lyrical verse. She loves animals and delights in knowing that she has two fawning white canines, like those in the story.

I feel her warmth against me. She is almost as tall as me now—this little girl who still pounces like a puppy and sets booby traps for unsuspecting parents who enter her room at bedtime. I am filled with the tenderness of our time together, conscious that it will soften into memory.

These intimacies we share,
Forge mind and soul,
Change life's direction,
Without question.

Well, maybe there are a few questions ...

Time and story unfold.
We struggle to find our bearings;
So many skins we shed.
Through experience, we are remade.

Like the phoenix, rising;
Taking comfort in ash—
Birth from ruin;
Finding wisdom in silence;
Loving the child,
In our growing children,
And ourselves;
Dwelling in possibility;
And embracing the change that must be.

Endnotes

1. A Latin term meaning "into the midst of things;" it is often used in literature to denote a narrative or drama that begins in the middle of the action.

2. My version of a loving kindness meditation.

3. See the poem "Spelling" by Margaret Atwood.

Works Cited

"In medias res." *Britannica*, 2020, www.britannica.com/art/in-medias-res-literature.

Atwood, Margaret. "Spelling." *True Stories*. Oxford University Press, 1981.

Laurence, Margaret. *The Diviners*. Bantam Books, 1975.

Chapter Two

Slow Motherhood: Utopian Narratives of Time Lost and Found in the Slow Parenting Movement

Marjorie Jolles

"Maternal time, it turns out, isn't only personal; it's political."

N arratives of motherhood are stories of time: the long days and short years, as well as the experience of twenty-four hours divided into "naptime," "tummy time," "time out," "after school," "bedtime," and, of course, "quality time." Time dominates our understanding of life before pregnancy—we hear the ticking of biological clocks—and despite remarkable technological advances, time, in the form of maternal age, remains the defining feature of motherhood's start, whether biological or not. Pregnancy, too, is defined by time; whether measured in forty weeks or three trimesters, time captures the duration of gestation. Mothers employed in the workforce quickly learn the difference between "paid time" and "unpaid time"— the rather bloodless language of human resources for describing a culture's variable economic investments in maternal work. Time is a central concern in parenting books, parent-teacher conferences, and at the paediatrician's office, where mothers are encouraged to understand their maternal work as both a quantitative and qualitative investment in the present that pays returns in the future.

Narratives of maternal time vary. Motherhood passes too quickly for some and too slowly for others. And then there are those—like me—who experience maternal time as at once too fast and too slow, simultaneously longing for time to both hurry up and slow down. I see my experience vividly mirrored in *A Life's Work,* Rachel Cusk's memoir of her first year of motherhood, a year characterized by slow time, waiting, and tedium. At the same time, I am attracted to the maternal voices of the slow parenting movement, who advocate strategies for putting the brakes on the speed of modern living to better bask in maternal time. Ultimately disappointed by slow parenting's failures to reckon with feminist motherhood, I find that narrative itself is my richest resource as a feminist mother.

Maternal Time

When my daughter Eliza was born, a friend with grown children wistfully warned me: "The days are long, but the years are short." Sometime around Eliza's third year, another friend—also a mother—recommended I listen to the podcast, "The Longest Shortest Time," an uncanny echo of the earlier message I received about motherhood's temporal paradoxes. And lately, Eliza—now six—asks to look at photos and videos of herself as a baby, and, together, we marvel at the passage of time, which my maternal self experiences at warp speed. Her babyhood feels simultaneously like yesterday and a lifetime ago. "That's you," I whisper to Eliza as we watch her baby self in motion picture. Eliza looks in awe, and despite knowing it's a video of her as a baby, she refers to the person on the screen as "her," not "me." In this way, Eliza reveals her awareness that she and the baby are not the same person.

The baby I once carried is gone. She has been replaced by a child who bears little trace of that baby: she has literacy, social identity, and a sense of bodily autonomy. In becoming less baby and more human, Eliza leaves behind a chapter of our prelinguistic life—a precious chapter of my life but a forgotten one of hers—in a profound maternal experience of differentiation that Cusk describes as "draw[ing] a veil over the murky history of my care for her" (92). My only access to my baby is through memory, and this fact—that a treasured phase of my life is locked in my subjective memory alone—creates an acute anxiety about losing the past. What confounds me most about Eliza's transformation is the way

staggering change occurred simply by living one day after the next. Day by day and moving through a sometimes dull and nearly invariant routine, incremental and barely perceptible change amassed to produce a new person. In my maternal time, each day is nearly identical to the last, yet a stunning metamorphosis occurred between birth and age six. This experience requires a reckoning with an illogical sense of time as both dynamic and inert, which, for me, is a peculiar feature of maternal subjectivity.

Motherhood does feel like "the longest, shortest time." Although I am so grateful to have left behind me the monotony and burden of caring for a young child, the sight of a small toddler takes my breath away, and I yearn to travel back in time. I know I am idealizing a time that was no more precious than the present moment, in which I am just as besotted with my kindergartner as I was with my toddler. The past was certainly different, but it was not more perfect or happy or abundant than the present; yet I can't quite shake the feeling that motherhood operates according to a temporal logic whereby my child's development is outpacing my capacity to savour it. The utopian impulse at work here suggests that if I could just slow it down, I would arrive at a state of motherhood where nothing, and no one, is lost. I, and she, would be present for all of it. Present for the present. I am curious about this utopian impulse and my relation to it. Do I try to capture time, or do I accept its passage? How can I simultaneously experience the present and be at peace with its inevitable disappearance?

Yet maternal time goes too slowly. I commonly experience an hour as lasting the length of a full day. Nothing seems to get done on these endlessly long days; occasionally, I struggle to believe the day will ever end at all. Describing a morning at home with her baby, Cusk somewhat dreadfully anticipates a day that "lies ahead empty of landmarks, like a prairie, like an untraversable plain" (63) and observes that "time hangs heavy on us and I find that I am waiting, waiting for her days to pass, trying to meet the bare qualification of life which is for her to have existed in time" (138). Time is no longer measured by life's metrics before motherhood, but by her daughter's needs that have their own temporal rhythm: "The days pass slowly. Their accustomed structure, the architecture of the past, has gone. Feeds mark them like stakes driven into virgin soil. By the time my daughter is three weeks old I have discerned in them a pattern. She cries with mysterious punctuality every

three hours" (102). My early life with Eliza felt this way: time was slow and lethargic, the stillness interrupted only by routine feedings and naps.

My experience of maternal time is not unique. The experience of motherhood as too slow yet too fast, I suspect, has been felt in times and places other than early twenty-first-century life in the postindustrial West. But how some mothers in contemporary, accelerated Western life rhetorically name this malaise characterizes it not as a fact of maternal life, however bittersweet, but as a problem to be solved. A range of solutions have emerged in tandem with the diagnosis. One solution to the perceived problem of motherhood's fast pace is the slow parenting movement, which circulates in the form of maternal narratives of time lost and found.

Slow Parenting

An extension of the larger "slow" movement—including slow food, slow schooling, slow work, and more—that has emerged in response to the frantic pace of modern life, slow parenting rejects the typically overscheduled (American) childhood and instead celebrates unsched-uled time and encourages resistance to the speed of contemporary life in ways that highlight domesticity, nature, as well as mindfulness, and encourage a withdrawal from technology.[1] Like many polemics of mo-dernity, slow parenting posits mainstream culture as an assault on our creative and affective energies and a threat to the quality of our lives—taking specific aim at the hypercompetitive and consumerist dimen-sions of our late capitalist era and its normative expectations of achieve-ment. This spirit comes through clearly in the work of Carl Honore, a leading figure of the slow movement, whose book titles highlight the pressures of modern life: *In Praise of Slowness: Challenging the Cult of Speed* and, more recently, *Under Pressure: Rescuing our Children from the Culture of Hyper-Parenting*. In a 2009 *New York Times* interview, Honore claims that "slow parents ... accept that bending over backwards to give children the best of everything may not always be the best policy" and observes that "slow parents understand that childrearing should not be a cross between a competitive sport and product-development" (qtd. in Belkin). Honore isn't wrong: I am often exhausted by the de-mands of motherhood when I allow myself to be susceptible to an anx-

iety that tells me Eliza will thrive only if she does more, has more. I lose hours combing the Internet for music lessons and language classes to add to our already busy days, motivated by wanting the best for Eliza. And then I am frustrated to be so busy and long for slower time.

Time is money, so the cliché goes, and that is certainly true of the overscheduled, middle-class childhood. It is not surprising, then, that the slow parenting discourse circulated so strongly in the years during and immediately following the Great Recession. The cost-saving benefits of slow parenting are emphasized in "New-Age Trend: Slow Parenting," a mini-feature in *Ebony* magazine, also from 2009. It describes "forego[ing] ... tennis lessons... and shopping binges at the mall" and looking for cost-free activities for children and families instead ("New-Age Trend"). But my desire to slow down the pace of life with Eliza is rooted more palpably in emotional vulnerability than in economic insecurity, and here the white, middle-class specificity of my longing becomes clear. *Ebony* characterizes slow parenting as primarily an economic strategy and a "new-age trend," which indicates that slow parenting may belong to—or at least originate in—some novel context other than that of the *Ebony* reader, which suggests the racial dimensions of slow motherhood. The slow movement has been rightly criticized for its inaccessibility to those families who lack sufficient class privilege to afford to slow down—in that there is no reckoning with the fact that working less, or less hard, is a luxury out of reach for many. If slow parenting's anxious narratives of too-fast motherhood appeal to white, middle-class mothers like me, it is likely because class not only structures our consumption habits but our psychic lives as well: I uncritically understand success for Eliza to mean success by white, middle-class standards. The pace of her childhood, and of my maternal life, is a direct reflection of our classed and raced family.

Despite my ambivalence about slow time, dreams of my own slower childhood infuse my current maternal life, and I find this same dream animating the maternal narratives of slow parenting advocates. In a 2012 interview with *Time* magazine, slow parenting advocate Susan Sachs Lipman, author of *Fed Up with Frenzy: Slow Parenting in a Fast-Moving World*, gives an example of how to "embrace ... downtime": "There's something to doing wonderful activities that are simple and don't require equipment, like how to show an outdoor movie. Every summer we set up an outdoor movie in our driveway, have the neighbours over and

make some popcorn. It's a little old-fashioned and takes us away from the everyday" (qtd. in Rochman). Or if an outdoor movie isn't your thing, Lipman advises other activities: "Make boats from newspapers, an idea from *Curious George Rides a Bike*. Or play classic playground games like Kick the Can or Capture the Flag and Red Rover. A lot of kids don't know how to play these anymore" (qtd. in Rochman). The desire to slow down gets conflated with a desire to return to an earlier era, idealizing its old-fashioned activities. I find this same appeal to recapturing the past in *The Abundant Mama's Guide to Savoring Slow,* when self-described slow mother Shawn Fink writes the following:

> It's so easy to go to the store to buy laundry detergent. One-two and done. So why do I keep making our own every year? Because it feels slower. It feels fresher. It feels simpler.... I encourage you to try doing things differently, too. Hang your laundry outside. Bake your own bread. Unplug the TVs and video games and play a board game. Make jam. (105-6)

Nostalgia, the achy longing for the past, is a strong affective presence in these maternal narratives and undergirds the slow parenting ethic. References to such outdated activities and the escape they afford from contemporary technological culture positions slow parenting as an idyllic anachronism—indeed, idyllic because it's an anachronism. In these slow maternal narratives, multiple modalities of time—not just slowing down in the present but bringing back a past that is superior to the present while imagining a utopian future—do much of the work of responding to maternal experiences of time. Slow parenting employs not only temporal but generational references in its efforts to persuade, which suggests that its narratives enable some working out of maternal longing for our own lost pasts, our own lost selves.

Feminist Dilemmas

At first, I am seduced by the narratives and prescriptions of slow parenting granting me permission to let go of the hurry that comes with the striving and competition so familiar to the middle class. In slow parenting's maternal aspirations towards mindfulness and abundance, I am encouraged to see that gifts I can give Eliza—gifts of time and

attention—are already right here, and in that awareness, the mythical "out there" of success and achievement loosens its grip. In its rejection of disciplinary norms and capitalist imperatives that enslave us to ideals of perfection, and in its valorizing of maternal wisdom and women's work, the utopian narratives of slow parenting are vaguely feminist. I begin to feel that my longing for slower maternal time has found its answer.

But nostalgia has its own politics. Kate Eichhorn notes the feminist attraction and revulsion towards nostalgia, and notes that for many feminist thinkers, "nostalgia abuses individual and collective memory. It sets objects, figures and even entire eras adrift in new economies. Nostalgia distorts reality while claiming a historical real … there is always the risk of getting stuck—of being held back in the past" (256-7). For these reasons, I am wary of slow parenting—with its distortions and idealizations of a complicated past and its imperatives of slow domestic labour, and whose privileged site is the home, the same site of all the oppressive stasis that Cusk narrates so powerfully. The home, the family, and the private sphere: these institutions are uncritically embraced as the primary spaces of maternal fulfillment, and in this, slow parenting seems more a subtle backlash, not the advancement of feminist values. Although slow parenting promises the mother suffering from modern frenzy a rescue and a return, I can only respond to this promise with feminist ambivalence. For in its marriage of nostalgia and retreatist domesticity, slow parenting levels criticism at the modern Western world, a world changed, in part, by feminism. My life—with its competing pleasures and demands of work, motherhood, community, solitude, love, and rest—is made possible by those feminist interventions that have released mothers from a compulsory destiny of a life spent making their own laundry detergent and jam. In prioritizing the home and its gendered labours, the narratives animating slow motherhood assume and enforce an explicit public-private duality (and implicit gender assignments to these spheres)—a duality feminists have sought both in theory and practice to productively blur, thereby permitting the emergence of new and potentially more liberatory modes of work and kinship. The maternal longings motivating slow parenting imply that the heteronormative bourgeois nuclear family is life's central institution, which subsidizes, with its old-fashioned gender roles, slow motherhood and its utopias (Lipman).

The same feminist interventions that may have released me from a primarily domestic destiny have also made possible the fast—sometimes too fast—pace of my life, raised as I was on "have it all" American feminism. Conveniences of consumerism and technology that emerged in those cultural shifts are not necessarily liberating for mothers: they may get us out of the kitchen, but they create in us new relationships of dependence and constraint. They save us time in one arena only to rob us of time in another. In an observation that captures these vexing contradictions of maternal time, Andrea O'Reilly claims that "though they have fewer children and more labour-saving devices—from microwaves to take-out food—today's mothers spend more time and energy (and I may add money) on their children than their mothers did in the 1960s. And the majority of mothers today, unlike forty years ago, practice intensive mothering while engaged in full-time employment" (242). In other words, time is not strictly mathematical; it is ideologically defined, valued, and experienced. Mothers are ambivalently positioned for both gain and loss within the institutions of family, work, production, and consumption. The resource perhaps most precious in each is time. Maternal time, it turns out, isn't only personal; it's political.

The Narrative Impulse

I am not a slow mother. I am alienated by slow parenting's naïve nostalgia and unconvinced its prescriptions will cure my agitated consciousness in which maternal time is both too fast and too slow. What I'm working out is not primarily a critique of modernity but an affective state of loss and longing, which is linked, perhaps, to modern life but not reducible to it. This subtle grief is nearly impossible to metabolize because it occurs in the same moment as abundant gain: I cannot fully reckon with the loss of Eliza's sweet babyhood when the thrilling girl she has become is right here. When Eliza and I look at photos of her babyhood, I don't want to time travel so much as to say to her: "See us here? This is what that time was like, felt like. Do you remember? Do you feel it?" She asks me to tell her the story of a particular moment captured in the photo, and I revel in her invitation to narrative. The dissonant gap between then and now is not closed, but gently bridged, in telling her a story of our time together. In narration, I exert some small measure of control and clarity over my jarring experience of maternal time.

In fact, I am a mother nearly addicted to narrative. I seek out the stories mothers tell of their experience of time and how they negotiate its passage. I have a compulsive tendency to describe my experience of maternal time to others, including Eliza and her father but especially other mothers. I find I'm not looking for solutions but rather looking for a witness, repeatedly describing what it's like to watch Eliza change before my eyes, as if through narration I can dwell in memory and know it won't be lost, convey what I find so baffling about maternal time, or unravel its mystery. I find deep identification in knowing other mothers have managed this perplexing subjective experience: watching our children's transformations unfolding before us. I am reminded of Mary Oliver's simple "Instructions for living a life: Pay attention./Be astonished./Tell about it" (37). I feel compelled to "tell about it," which reveals something important about narrative's power to make "astonishing" experience less shocking and more integrated. More than wanting time to slow down, I want to tell about this longing and be understood in it.

I know I cannot stop time. I don't want to. I want Eliza to grow, and I want to be there for all of it. What I seek is the solace and community that narration offers. Narration does not necessarily resolve conflicts or tensions, but the very act of narration—the imposition of narrative order on somewhat inchoate experience—preserves precious memory and can ease suffering and confusion. Maternal narrative is a vital sense-making practice for an astonishing experience.

Endnotes

1. One cannot fail to notice that much slow parenting rhetoric circulates through digital spaces reliant on modern technologies, which are often the very target of slow parenting's criticism. This reliance on technological culture is an unresolved contradiction within the slow movement more generally.

Works Cited

Belkin, Lisa. "What is Slow Parenting?" *The New York Times,* 8 Apr. 2009, parenting.blogs.nytimes.com/2009/04/08/what-is-slow-parenting/. Accessed 12 Aug. 2018.

Cusk, Rachel. *A Life's Work: On Becoming a Mother.* Picador, 2001.

Eichhorn, Kate. "Feminism's *There:* On Post-ness and Nostalgia." Feminist Theory, vol. 16, no. 3, 2015, pp. 251-64.

Fink, Shawn. *The Abundant Mama's Guide to Savoring Slow.* CreateSpace Independent Publishing Platform, 2015.

Honore, Carl. *In Praise of Slowness: Challenging the Cult of Speed.* Harper-One, 2005.

Honore, Carl. *Under Pressure: Rescuing our Children from the Culture of Hyper-Parenting.* HarperOne, 2009.

Lipman, Susan Sachs. *Fed Up with Frenzy: Slow Parenting in a Fast-Moving World.* Sourcebooks, 2012.

"Manifesto." *Slow Family Living, slowfamilyliving.com/manifesto/.* Accessed 12 Aug. 2018.

Oliver, Mary. "Sometimes." *Red Bird:* Poems. Beacon Press, 2008, pp. 35-38.

O'Reilly, Andrea. "The Motherhood Memoir and the 'New Momism': Biting the Hand that Feeds You." *From the Personal to the Political: Toward a New Theory of Maternal Narrative,* edited by Andrea O'Reilly and Silvia Caporale Bizzini, Susquehanna University Press, 2009, pp. 238-48.

"New-Age Trend: Slow Parenting." *Ebony,* Oct. 2009, p. 100.

Rochman, Bonnie. "'Slow Parenting': Why a Mom is 'Fed Up with Frenzy.'" Time, 14 Aug. 2018.

2012. healthland.time.com/2012/08/14/slow-parenting-why-a-mom-is-fed-up-with-frenzy/. Accessed 12 Aug. 2018.

Bearing Witness
to Trauma

Chapter Three

The Mum with the Dark Hair: Indigenous Motherhood and the NICU

Lianne C. Leddy

"... we learn that our moon time and our
ability to give life are sacred.*"*

As *Anishinaabe kwewag* (women), we learn that our moon time[1] and our ability to give life are sacred. Traditionally, our communities had gifted women who caught babies, and, more recently, there have been attempts to celebrate Indigenous motherhood and reclaim birth practices. Indigenous female scholars have been active in emphasizing the importance of Indigenous motherhood and are telling stories of empowerment, tradition, and reclamation.[2] My passage into this new stage of life did not take either a traditional or a new decolonized shape. This chapter is a personal reflection in which I explore ideas around what it means to be an *Anishinaabe* mother with a baby in the neonatal intensive care unit (NICU); how Indigenous women are a particular and visible target of mother-blaming; and, finally, the challenges of breastfeeding. This chapter will expand our knowledge of Indigenous motherhood and the ways in which it is affected and limited by Western views of medicine and parenting.

Dreaming My Daughter into Being

When I became pregnant at the age of thirty-three, I was overjoyed. Like a lot of things in my life, it was carefully planned. Not long before, I had experienced a very early miscarriage, and my partner and I were both hopeful about this pregnancy and looked to our future as a family as we built our life in Southern Ontario. I was overjoyed when my daughter introduced herself to me in a dream at twenty weeks gestation. She had bright blue eyes and a tuft of reddish hair, and she was very sweaty. In a little voice, she asked me to feed her and told me she was thirsty. When the twenty-week ultrasound showed that everything seemed to be progressing well, I chalked the dream up to my fears about motherhood and my anxiety regarding a lack of preparedness. Judging from the plethora of parenting and pregnancy blogs, I was not alone in this kind of self-doubt, so I tried not to think about it. The rest of the pregnancy was fairly typical—food aversions, morning sickness, and gradually moving slower as my body grew to make room for her. When I try to remember this transformative stage, I was happily looking forward and relishing the feeling as faint butterflies turned to strong kicks. Her personality started to emerge as well: she moved when she heard specific voices, punched her father when he leaned in too closely to say hello, and woke regularly at 1:00 a.m. and 4:00 a.m. (which carried on into infancy). She reacted to music, and Skynyrd's "Free Bird" was her favourite. I gained weight as expected, and my belly measured normally as she grew.

Paige Enters the World with a Fierce Howl

Late in my pregnancy, I was given an ultrasound requisition to check the fetal size and position, as my doctor was concerned that she was breech. I didn't know that the appointment was going to lead directly to the next stage of my life. I had attended the birth classes, had eagerly practiced prenatal yoga, and had a birth plan set out. Life had other plans. My birth experience started terrifyingly with a panicked ultrasound technician and ended less than 48 hours later with the caesarean section birth of my 3 lbs., 13 oz. daughter. At thirty-seven weeks' gestation, I was told she had severe intrauterine growth restriction (IUGR), the cause of which is still unclear. My partner and I learned that IUGR is normally caused by external factors like maternal

smoking or drug use, malnutrition, high blood pressure, problems with the placenta, or genetic syndromes. Normally, it is identified earlier in the pregnancy, and undiagnosed cases like ours are a significant cause of full-term stillbirths (Mandruzzato et al. 277). None of the normal causes applied in our situation. At birth, the umbilical cord, the literal tie between mother and baby, was unusually twisted like a telephone cord. Cords are sacred, and, as Kim Anderson (*Life Stages* 50-52) and Carrie Bourassa (49) remind us, there are traditions to follow with umbilical cords, which, ideally, I should have followed, but, instead, our cord was sent to pathology for examination because of its deformity. The doctors in the room thought that it may have played a role in restricting nutrients and, therefore, my baby's size. Despite her size, which was smaller than even that panic-inducing ultrasound had shown, Paige entered the world with a fierce howl. Pinned to the operating table, I moved my head to watch as my tiny shrieking purple baby was carried across the room and disappeared behind a wall of yellow robed nurses and the paediatrician who examined her. I remember the paediatrician telling my partner to take a picture, and then she was placed on my chest. I couldn't move my arms to hold her properly, but I welcomed her as best I could.

I held my daughter for a few brief moments before she was taken to the NICU. It would be seven hours before I saw her next, as hospitals treat maternal health as separate from that of the baby. Mothers with healthy babies can have them in bassinets in their rooms, but mine was down the hall, around the corner, through two separate sets of locked doors that I needed permission to access. I could not take her out of the NICU, and I couldn't go visit her unattended until I could walk again. Given that I had just had surgery, my physical recovery demanded that I quickly learn how to walk independently. The promise of reunion with my daughter was, however, little comfort when a doctor on rounds came to my maternity ward room and asked me where my baby was. That simple question forced me to say out loud that she couldn't be with me and to acknowledge the trauma of this experience that had been so totally bewildering.

Navigating the NICU

Ultimately, Paige spent fifteen days in the NICU. Before I continue, I want to emphasize that she received excellent treatment, and both the nurses and doctors were attentive regarding her physical health and development. The hospital had a program to allow mothers to live in dormitory-style accommodations at a much reduced cost (even for free if it presented a financial burden to families). After I was discharged, I was able to secure a room in the unit and had greater proximity to my baby. This was part of a program that allowed mothers (fathers were not permitted in the rooms) to stay close by, which also facilitated breastfeeding.

My partner and I were introduced to a clinical research program designed to promote greater family responsibility in caring for their newborns. We learned practical skills that helped to ensure that when the time came, we left with the confidence to care for her independently at home. At the same time, however, it presented several challenges: the intake paperwork for this program contained no trigger warnings but asked very specific sensory and emotional questions about what had been a very difficult experience. I found this puzzling, as a university researcher myself, since we are expected in the historical discipline to be sensitive to our participants if we can reasonably anticipate that a situation may cause pain to resurface. Nevertheless, my partner and I decided to continue our participation and worked with nurses and lactation consultants, who had been specially trained to assist in the program.

At the same time, it was jarring to be required to ask nurses for permission to feed my baby. Because of her size, breastfeeding was a challenge. Her mouth was too small, and she was too weak overall to latch effectively, so although I continued to encourage her to breastfeed, I still pumped milk to feed her with a bottle. Even then, it was recommended that my milk be supplemented until she reached four pounds, so I had to wait patiently while the powdered supplement, which was strictly controlled by staff members, was added to my milk and then brought to me under careful supervision. Trying to breastfeed, pump, and ask permission to prepare a bottle while also adhering to the principles of cue-based feeding was, as can be imagined, incredibly difficult and frustrating.

Being constantly reminded that I didn't have care and control of my own child was also frightening. Although staff members would not have known the unique discomfort Indigenous mothers feel when their parenting is overseen by doctors, nurses, lactation consultants, physiotherapists, social workers, and dieticians, my terror was sometimes overwhelming. As both an *Anishinaabe kwe* and a professor of Indigenous studies, I am keenly aware of the shocking apprehension rates of Indigenous children and of the sharp reality that although Indigenous children comprise only 7.7 per cent of the child population of Canada, more than half the children in foster care are Indigenous (Indigenous Services Canada). This rate is a distressing 90 per cent in Manitoba (Malone). I was also reminded of the history and contemporary reality of forced sterilizations of Indigenous women in this country and how it is tied to settler colonialism's continued denial of our humanity and our sovereignty (Stote). All of this informed who I am as an Indigenous mother: the fear but also the pride, determination, and joy.

Until the birth and the discovery of Paige's condition, I had felt comfortable with my prenatal care and how I was treated. Perhaps my new socioeconomic class was a balm: I had a PhD in history, a fulltime job as a university professor, and a supportive partner and family. I was, overall, in good health. But in the hospital, I found that "the mum with the dark hair," as I was known, was perceived as neither intelligent nor capable. If I picked my baby up to feed her, I was sometimes told in an authoritative voice to put her down. One nurse looked over her glasses at me and condescendingly told me that if I encouraged her too much to eat, she would refuse it (which she never did). Even something as simple as treating a diaper rash was controversial, and when we followed the advice of one nurse, the next one told us we were wrong. Overall, my will was usually disregarded.

Mothers staying in the ward were "encouraged" to attend seminars that promoted breastfeeding, answered questions to assist in the transition home, and urged mothers to engage in self-care to ensure that the baby was safe. Sometimes the expectation of attendance felt coercive. On a few occasions, I found the time to attend seminars between breastfeeding, pumping, bottle feeding, and trying to find time to feed myself. Sometimes staff members provided useful information and I dutifully took notes like the conscientious undergraduate student I once was. Other times, I was sharply reminded of my difference and that my

capability as a mother was suspect. A lactation consultant expressed concern that I was returning to work after seven months and was going to share the parental leave with my partner. Apparently a supportive spouse is desirable but only to a point. At another seminar, a staff member used the word "precocious," hesitated, and then looked at me as she defined it—not the white mother in the room—assuming I wouldn't know what it meant. Another woman found a cigarette lighter at the washing station at the NICU entrance and assumed it was mine.

These racist encounters were compounded by assumptions regarding my daughter's condition. The implications of her diagnosis as an IUGR baby were the foundation of all my interactions with the healthcare team. In the absence of any genetic cause for my daughter's condition, others presumed it originated with me. Whereas the tie between mother and infant was not reflected in the hospital's general organizational structure, the connection was recognized with regard to my culpability for her condition. That cord—our tie together, that tie to her family, ancestors, and homeland—became the source of my implication. Because of this, I felt like my responses to questions on rounds were always suspect. As anyone familiar with hospitals knows, shift work brings new nurses every twelve hours. Some worked with us for only a shift or two and then moved on to work with other babies. This meant regular repetition of relevant information: her birth weight and length, exact age, current measurements, and the condition with which she presented. After the technical conversation came to an end, it was usually followed by the same question from every nurse, "You didn't know?" It was all the more puzzling to people when I insisted that I had no idea there was a problem and that I was more shocked than anyone at her size. Over and over again, I had to tell people that I had been measuring well and gaining weight. Defensively, but carefully, so as not to arouse more suspicion, I had to defend my own position as a new but capable mother.

In addition to inquiries regarding how it was possible that I could not know why she was born the way she was, several people also asked whether or not I smoked. This happened four times in the first week (not including the lighter incident), and one person asked me this twice, the second time adding, "Are you sure?" As we were in a teaching hospital, one of these incidents happened on instructional rounds, when the resident asked me this question in front of medical students. To be clear,

this is not an innocent question: it was meant to assign blame for a situation that otherwise had an unclear cause. I already felt guilt for the way my baby had come into the world, and I became fearful for other women, particularly Indigenous and racialized women, who might have had a different answer. If I had answered yes, would my baby get substandard care? Would it elicit a smug reaction, insinuating that I somehow deserved this? Would the social worker visit my corner of the NICU more often? Mother-blaming is pervasive and can have real implications for child protection cases, as the Motherisk scandal has recently shown (CBC News).[3]

Trying to Fulfill the First Treaty: Breastfeeding

One of the most frustrating, demanding, and maddening parts of the care experience was feeding my baby. This should not be so. As Leanne Betasamosake Simpson so eloquently writes, "breastfeeding is the very first treaty" (106), and it is a relationship that teaches us about sharing, balance, and patience (106-07). She ties this beautiful relationship back to our Creation story:

> Before there were humans on earth, a female spirit being came to the earth. Her name was Wenonah, which means the first breastfeeder—*nonah* is to breastfeed; *we* is "the one who." Wenonah took the responsibility of creating humans on earth. She came to earth, and with struggle, eventually created humans. Nishnaabeg people are her descendants. We exist today because she united with w-bngishmog (the west wind) and created the first humans. She created and then nourished us by nursing us. When women breastfeed they are aligning themselves with this sacred story, engaging in the act of creating a new life. (108)

Indeed, Indigenous women have been at the forefront of reminding us of the importance of breastfeeding. In 1977, Cree musician and activist Buffy Sainte-Marie breastfed her son Cody on *Sesame Street* and explained to Big Bird what it was all about. As Kristy Woudstra has argued, Sainte-Marie's appearance was before its time, but as an historian, I would argue that the scene reflected the 1970s return to recognizing breastfeeding as a normal, healthy, and natural practice. As an *Anishinaabe kwe* wanting to celebrate Indigenous motherhood practices, I

struggled with the incongruity of this message with my own inability to breastfeed my daughter.

The aforementioned television appearance occurred approximately two years after renowned American midwife Ina May Gaskin published *Spiritual Midwifery*, a seminal book in the modern midwifery movement that has undergone several subsequent editions. In Canada, Tasnim Nathoo and Aleck Ostry point to the resurgence of breastfeeding from 1960 to 1980 in the context of widespread social change for women and second-wave feminism:

> The natural childbirth movement emerged strongly in the late 1960s in conjunction with the women's movement ... the forma-tion of the La Leche League, a lay organization supporting breastfeeding, was key to supporting and strengthening breast-feeding the return to breastfeeding in Canada. As well, interna-tional efforts to counter the marketing practices of infant formu-la companies in the developing world found tremendous support among Canadian women in the late 1960s and early 1970s, creating awareness about the potential dangers of infant formula. Finally, by the late 1970s, public health and the scientific com-munity "rediscovered" the value of breastfeeding, and this lent the practice increasing medical authority. (107)

Whereas many Indigenous breastfeeding practices remained common, even during its mainstream suppression in the mid-twentieth-century, there were reported instances where, according to a 1958 study by David Grewar, some Indigenous mothers in Manitoba were choosing to bottle feed using "white man's ways" (qtd. in Nathoo and Ostry 103). Soon researchers identified an increase in infant mortality rates that mirrored those in developing countries and cited unsafe drinking water and unreliable formula supply as contributing factors, which was followed by attempts to promote breastfeeding in Indigenous communities (118-20). So as an historian and Indigenous studies professor, who was also interested in my own personal family history, I was acutely aware that Indigenous women's bodies have consistently been under government and medical surveillance since the nineteenth century and subject to reactionary and changing policies (Brownlie; Juschka; Kelm). Our infant feeding choices were no exception.

It was in the context of both the more recent mainstream and medical

promotion of breastfeeding as well as the celebration of Indigenous motherhood that I felt I had failed, since breastfeeding was a challenge for us. Bottle feeding my baby was not what I had planned to do, although I completely respect the choices of other mothers. Nevertheless, I was confident in my own choice as an Indigenous feminist to breastfeed. I had been breastfed, as had my partner. Breastfeeding is also consistent with Indigenous mothering: it continues the link between mother and child and is known as a proud source of food sovereignty. It felt like the most natural choice for me. But just as I felt the cord had failed me, so too did my body. The shape of my breasts, combined with the size and weakness of my baby—the ability to immediately provide ample nutrition was necessary for my daughter's survival—meant that I was likely not going to achieve exclusive breastfeeding. Health Canada strongly advocates that "breastfeeding is the normal and unequalled method of feeding infants," and it "promotes breastfeeding—exclusively for the first six months, and sustained for up to two years or longer with appropriate complementary feeding—for the nutrition, immunologic protection, growth, and development of infants and toddlers ("Infant Feeding"). That said, the statement does not leave a lot of room for those of us who cannot, or choose not to, breastfeed.

Even Buffy Sainte-Marie provided a more nuanced view of feeding one's baby. In the touching video, Buffy proudly breastfeeds her son, but she also notes that "not all mothers" do. Perhaps this could be seen as a pitch to soften what was a controversial act on television, but it could also be interpreted as a respectful recognition of the agency of mothers to choose how to feed their babies. Although there is widespread public recognition that breastfeeding is, indeed, normal and natural, in recent years, Courtney Jung has argued, "breastfeeding is no longer just a way to feed a baby; it is a moral marker that distinguishes *us* from *them*— good parents from bad" (8). "Lactivism" has caused the pendulum to swing the other way.

Even though it is no longer controversial to choose to breastfeed, there is often a paradoxical expectation that women cover themselves in public. Despite the fear of sexualized women's bodies, it is now considered the norm to breastfeed one's child—so much so that I experienced shaming for bottle feeding. At first, my daughter could only derive nutrients from an IV and a nasal-gastro tube. I immediately tried to breastfeed her (the fact that my body had not been ready to give birth

and she was born via Caesarean section did not help my milk supply), but she was too weak. Paige was fed by the nasal tube until she was twelve days old, supplemented by breastmilk from a bottle while nuzzling (though not drinking) from my breast. When it became clear that I was going to have to supplement with a bottle, hospital staff provided, almost shamefully, an information sheet about formula because my milk still needed to be mixed with a supplement. In fact, the sheet's brevity and lack of clarity meant I had to ask for clarification from the dietician. A kindly nurse recommended the bottle brand we ultimately chose, as this information was also difficult to come by.

Breastfeeding did not improve as time went on, despite my daily regimen of choking down oats and a fenugreek and blessed thistle supplement. Despite my efforts, numerous well-meaning people asked why I didn't try harder, as their kids had no problem breastfeeding, or offered anecdotes of tiny babies who latched with no problem at all, or asked if I was "aware of lactation consultants?" or suggested other related hints and tips. I was the only mother at baby yoga to crack open a bottle of formula, and in restaurants, strangers looked at me like I was feeding her poison (even if the bottle contained expressed milk). Not only did I have to constantly explain my daughter's size, I also had to explain my feeding choice, and because of the intense public pressure from health-care and infant development professionals, I was trying to make clear that it wasn't much of a choice at all. Even my partner was not immune: when he fed Paige a bottle at eight months of age, after her swimming lesson, a woman came up to him and said that breastfeeding was really best and asked whether or not he knew that. Unsurprisingly, racialized and Indigenous women have offered the most support, perhaps because they, too, have experienced this type of surveillance and judgment of their parenting choices.

Restoring My Balance

This reflection has been an attempt not only to explore an Indigenous mothering experience in a Western medical space but also to help me restore balance in this new role. I found my birth and breastfeeding experiences to be unexpectedly incongruous with Indigenous mothering, but at the same time, I was racialized and my efforts were often met with suspicion. I was, however, reminded, through visits with

women both in the hospital and at home—when thoughtful people brought food, laughter, and stories to share—that Indigenous women are resilient. Both mothering and restoration are community practices. As I write this reflection, Paige is a happy, fierce, strong, and inquisitive toddler. With time, her feeding cues have turned to articulate requests. She recently looked at me with her big blue eyes and confidently demanded, "Mama do baba." Reminded of her first introduction to me in my dream, I happily complied.

Endnotes

1. "Moon time" refers to menstruation. As Kim Anderson writes in A Recognition of Being, "traditional understandings of menstruation were central to the understanding of creative female energy, and the power that it carried. As with birth, menstruation was perceived as a spiritually charged occurrence" (74).

2. The list of Indigenous scholars and community members telling their birth and mothering stories is growing (Anderson Life Stages; Recognition of Being; Cook; Lavell-Harvard and Anderson; Lavell-Harvard and Corbiere-Lavell; Neufeld and Cidro).

3. In 2016, The Ontario government established the Motherisk Commission, which examined more than twelve hundred child welfare cases involving "flawed hair-strand drug and alcohol tests from a lab run by the Hospital for Sick Children in Toronto." (CBC News). The Commission's report was released in 2018 (Beaman).

Works Cited

Anderson, Kim. *Life Stages and Native Women: Memory, Teachings, and Story Medicine*. University of Manitoba Press, 2011.

Anderson, Kim. *A Recognition of Being: Reconstructing Native Womanhood*. Sumach Press, 2000.

Beaman, Judith C. *Harmful Impacts: The Reliance on Hair Testing in Child Protection. Report of the Motherisk Commission*. Ministry of the Attorney General, 2018.

Bourassa, Carrie. "Reclaiming Indigenous Practices in a Modern World." *Listening to the Beat of Our Drum: Indigenous Parenting in a*

Contemporary Society, edited by Carrie Bourassa, Elder Betty McKenna, and Darlene Juschka, Demeter Press, 2017, pp. 46-61.

Brownlie, Robin Jarvis. "Intimate Surveillance: Indian Affairs, Colonization, and the Regulation of Aboriginal Women's Sexuality." *Contact Zones: Aboriginal and Settler Women in Canada's Colonial Past*, edited by Katie Pickles and Myra Rutherdale, University of British Columbia Press, 2005, pp. 160-78.

"Buffy Nurses Cody." YouTube, uploaded by NantoVision1, 15 Mar. 2010, www.youtube.com/watch?v=7-L-Fg71WgQ. Accessed 20 Feb. 2020.

Cook, Kasti. "Powerful Like a River: Reweaving the Web of Our Lives in Defence of Environmental and Reproductive Justice." *Original Instructions: Indigenous Teachings for a Sustainable Future*, edited by Melissa K. Nelson. Bear & Company, 2008, pp. 154-67.

"Discredited Hair-Testing Program Harmed Vulnerable Families across Ontario, Report Says," *CBC News*, 26 Feb. 2018, www.cbc.ca/news/health/motherrisk-commission-1.4552160. Accessed 20 Feb. 2020.

Gaskin, Ina May. *Spiritual Midwifery*. 1975. 4th ed. Book Publishing Company, 2002.

Harvard-Lavell, D. Meme, and Kim Anderson, eds. *Mothers of the Nations: Indigenous Mothering as Global Resistance, Reclaiming and Recovery*. Demeter Press, 2014.

Harvard-Lavell, D. Meme, and Jeannette Corbiere Lavell, eds. *"Until our Hearts are on the Ground": Aboriginal Mothering, Oppression, Resistance and Rebirth*. Demeter Press, 2006.

"Infant Feeding." *Health Canada*, 6 July 2015, www.canada.ca/en/health-canada/services/canada-food-guide/resources/infant-feeding.html. Accessed 20 Feb. 2020.

Jung, Courtney. *Lactivism: How Feminists and Fundamentalists, Hippies and Yuppies, and Physicians and Politicians Made Breastfeeding Big Business and Bad Policy*. Basic Books, 2015.

Juschka, Darlene. "Indigenous Women, Reproductive Justice, and Indigenous Feminisms." *Listening to the Beat of our Drum: Indigenous Parenting in Contemporary Society*, edited by Carrie Bourassa, Elder Betty McKenna and Darlene Juschka, Demeter, 2017, pp. 13-45.

Kelm, Mary Ellen. "Diagnosing the Discursive Indian: Medicine, Gender, and the 'Dying Race.'" *Ethnohistory*, vol. 52, no. 2, 2005, pp. 371-406.

Malone, Kelly. "Manitoba's Child Welfare Crisis to Be Tackled through Law, Funding Changes." *CBC News*, 12 Oct. 2017, www.cbc.ca/news /canada/manitoba/manitoba-child-welfare-plan-1.4351637. Accessed 20 Feb. 2020.

Mandruzzato, Giampaolo, et al. "Intrauterine Restriction (IUGR)." *Journal of Perinatal Medicine*, vol. 36, no. 4, 2008, pp. 227-81.

Nathoo, Tasnim and Aleck Ostry. *The One Best Way?: Breastfeeding History, Politics, and Policy in Canada.* Wilfrid Laurier University Press, 2009.

Neufeld, Hannah Tait, and Jaime Cidro, eds. *Indigenous Experiences of Pregnancy and Birth.* Demeter, 2017.

"Reducing the Number of Indigenous Children in Care." Indigenous Services Canada, 20 Feb. 2020, www.sac-isc.gc.ca/eng/154118735 2297/1541187392851. Accessed 24 Feb. 2020.

Simpson, Leanne. *Dancing on Our Turtle's Back: Stories of Nishnaabeg Re-Creation, Resurgence and a New Emergence.* Arbeiter Ring Publishing, 2011.

Stote, Karen. *An Act of Genocide: Colonialism and the Sterilization of Aboriginal Women.* Fernwood, 2015.

Woudstra, Kristy. "Buffy Sainte-Marie Sesame Street: Canadian Icon Breastfed on TV Way Before it was Cool." *Huffington Post Canada*, 27 Jan. 2016, www.huffingtonpost.ca/2016/01/27/buffy-sainte-marie-sesame-street_n_9090090.html. Accessed 20 Feb. 2020.

Chapter Four

A Cold Death:
Storying Loss and Writing towards Forgiveness

Mandy Fessenden Brauer

"Even after all these years ... I wish I could forgive her."

Even after
all these years
I can still hear her
strident, biting voice perfectly enunciating
every tainted syllable spewing forth
from her smoke-ruined voice,
 a ruptured septic line.

*

"Good morning, sis. Are you sitting down?"

"You know I'm not." The phone is hanging on the kitchen wall. Besides which, we were all raised with the egg-timer limit of three minutes for what dad called "the rudest instrument in the world," and I have stuck to that through the years. "Has something happened to dad?"

"It's mother."

"You mean dad." Our father had just had massive throat surgery for

cancer less than two weeks before.

"No, I mean mother. She died."

"What?" Incredulity laces my response.

"They think she killed herself."

"Oh, how horrible. Poor dad, alone in that god-forsaken place in nowhere Maine."

I wished there was somewhere to sit as I began to absorb the news, but no chair or stool was nearby.

"What are the plans? Are you there?"

"Of course not. Just heard about this myself, will be driving up tonight after work. A neighbour agreed to stay with dad until I arrive."

"What about arrangements and all that sort of stuff?"

"I'll know more after I get there. There needs to be an autopsy, since mother died unattended. That will take awhile. Come quickly. We'll make the arrangements together."

And so, at last, our mother had succeeded doing what she had tried so many times before. I wasn't sure what I felt. For some reason, I wanted to laugh, so I did, all alone in that bleak kitchen. There was, however, nothing remotely humorous about the situation.

My life at the time was falling apart: my second husband had recently said he wanted to sleep with anyone and everyone, I had just given notice at a job I hated, and I had two young children (who, fortunately, could stay with friends while I was gone). Aside from how I felt, the idea of buying a ticket from California to Maine was a real stretch financially and would necessitate putting the charge on a credit card, something I hated to do.

The trip across the country was, and remains, a blur. I had shed only a few tears for my mother, someone with whom I had shared a problematic relationship for as long as I could remember. My brilliant, witty, and terribly unhappy mother was a raging alcoholic, in addition to being abusive verbally and physically. She staged constant fights with those she thought of as friends. Before the move to Maine, there was no one in her life except my father and the Episcopalian minister, who was her drinking buddy.

No matter how hard I tried to deny it, the death of my mother evoked certain feelings. I moved from being shocked to saddened, from angry to disgusted, and, then, to feeling relieved.

Years later, I wrote poems about my mother that I shared with no one. I now wonder if they were written in an effort to come to terms with the reality of this person who was the only mother I would ever have. My image of motherhood was confused and laced with disgust. As I reread them, I note the absence of this sense of relief. I can only guess that maybe the thought of relief consumed me with an unrelenting guilt that I had no option but to bury.

(Image of) Motherhood

Craziness spilled like a pitcher of water
dropped, splashing all over the house,
drenching everything while bits of broken
glass glistened, sparking escape; which
to follow became not a game but necessity
soaking into image of motherhood where
safety's not found in insanity
nor comfort in chaos.

To be touched became a constant threat
like a herd of sheared sheep hurrying forward,
pink trim of their cut coats nakedly pristine,
the serenity of pastoral scene deceptive:
peaceful, cloud strewn sky harmonizing with
towering dark mountainside merging into
miniature animals magnified into momentary
annihilation under hurtling, hurting hooves.

Bedtime was another very different painting,
a strangely subtle, secret nocturnal battlefield
where perceptions of unknown intentions
lacked a clarity discomforting, as grin sneered
into grim, with condemnation commonplace,
as smeared smile slid into startling sadness
when that tearful woman bent into a pitiful creature,
whiskey-saturated, smoky breath bleating
what she needed, or thought she did, and to think
about giving that which she could only imagine.

It was late February when my mother died. The year was 1973. There were no cell phones, and, therefore, no easy way to reach anyone. From Logan, I took a bus to Portland where my brother picked me up in his souped-up Chevy. He was his usual efficient, grim self: "Tomorrow, we meet the funeral director. He will discuss the various arrangements we can make. Dad is okay, kind of in neutral gear as always. He can't speak because of the surgery, so he writes little notes. I can't read his horrible handwriting most of the time. Never could. I don't know how he feels but never did. Mother always yelled enough for both of them. Dad never expressed his feelings. Loss of his vocal chords will not be any great loss for him." He chuckled. I sadly agreed. As vividly as it was lived, I recalled the bedtime ordeal characterized by my mother's biting tongue and my father's dispassionate silence punctuated by infrequent utterances.

Childhood Help (excerpt)

... at other times she would grimace and contort her bright
painted mouth
just as she would twist small limbs into unnatural positions
pain and powerlessness feeding fear.
She seemed to relish screams and protests,
which poured forth as my father looked on dispassionately.

"That's my child, defend yourself with words
because it's your only weapon.

"She'd make a good lawyer," my father proclaimed proudly,
as I writhed and fought to escape
the nightly ritual of saying good-night to parents ...

I returned myself to the present scene in Maine. "How's your wife ... and the job?" I asked my brother.

"Same as always. Sue runs everything. She's a good woman, too good for me. The job is the same old, same old, no matter who's in charge. Never should have become a banker. For a while, it was okay. This merger business, though, is destroying me. I hate going to work now. Dad's okay, the same as always. A visiting nurse comes to the house to change his dressings. Now, we have to deal with mother's demise." He laughed as he said demise, perhaps because it was not part of his usual vocabulary.

The next morning, we drove the short distance into town to go to the funeral home. The streets were empty, partly because Kennebunkport had not yet been discovered—as it would with the Bushes—and partly, of course, because it was still winter and there was snow on the ground and icy patches on the streets.

We had summered every year for as long as I could remember in this area, famous as the setting for some of Booth Tarkington's novels and for an old ornate home called "The Wedding Cake House." For me, the most delightful thing of all was going to the bathroom in one of the small restaurants built over the inlet, a shack really, where you could hear your production plop into the water below.

The McMaster Funeral Parlor was a three-story Victorian home with two imposing oak trees in the front yard. It had been a long-standing custom in New England for a husband and wife to plant two trees when they built or bought a home. The enormous trees were a reminder of this custom. My brother and I walked up the curving driveway and climbed the massive granite steps.

Before we could ring the ship's brass bell that was hanging by the door, a middle-aged man wearing a black, three-piece suit stepped outside and greeted us. "You must be the family of the deceased," he said somberly. "I am James McMaster, funeral director. I believe I talked to you," glancing at my brother, "on the phone yesterday. May I ask how you heard about me?"

"The police recommended you," my brother responded.

Police? This was the first I'd heard about their involvement. That was something I would definitely ask about later, but then again, an unattended death, even in this god-forsaken place, probably prompted their involvement.

"Aye-up. Coffee or tea for either of you? I know you probably don't have much of an appetite right now, but Mrs. McMaster can brew up a great cup of Folgers best. She also makes delicious lemon cake, if I do say so myself. I'll have her slice some. Even if you don't want any, I do. Meanwhile, why don't you two come into my parlour and sit." With this invitation, he smiled.

I looked around the room and noticed the incredible carved wood framing the entryways and the shining silver doorknobs and hinges.

"Aye-up, right you are. They are indeed sterling silver. The place was built in the late 1860s by one of those robber barons. Made his fortune

in lumber. Many fortunes were made in this part of the world. People don't remember that these days. Think fortunes are only made out West with the oil boom. When my father bought this place, he saw immediately through the decay and tarnish that had taken over the place. As a kid, I had to remove all the hinges and window openings and then polish 'em until I could see my face, like mirrors they had to be. Now of course, we have someone who comes in and does that hard work. Ah, here's the coffee and the cake. Enjoy. Then let's talk about the deceased. Your mother?"

"Yes." we both answered at the same time.

"Well, as I always tell people, it's proper to consider her wishes. Do you know what she'd have wanted?"

My brother and I exchanged a knowing look, each of us remembering dozens of family discussions about how death was the end and how nothing fancy should be done. In fact, returning home from funerals, our parents would criticize how much money had been spent on a casket that would eventually rot. Then they would reiterate what a horrible thing it was, the way funeral directors took advantage of people's grief, selling them the most expensive caskets that they felt were a waste of money.

"Our parents were very frugal when it came to their wishes about such matters. Everything simple: a plain pine box, no embalming, cremation, and then a hole in the ground." I said.

"Well, that's sure simple. The police probably told you it was a suicide. There were enough pills in her to finish an elephant. Seems to be what she wanted. Sure is a sad thing to have to live with. My condolences. But since it's illegal in the State of Maine, don't worry; it'll be ruled a heart attack. Here, another slice of the cake? Not from a cake mix or the store either. Aye-up, the genuine thing."

"Why is it illegal?" I asked.

"The church, young lady. In fact, no one who commits suicide can be buried in consecrated land. That's why you will see graves just outside the cemetery walls. You wouldn't want your mother out there, would you?"

I knew that no one in our family would care but mumbled some sort of thanks, I then began discussing funeral arrangements.

*

In a sad little Episcopalian church, a minister, who had never met our mother, kept talking about "this wonderful lady who was now in the arms of the Lord." All I remember is how cold it was in that church and how our mother would have criticized the service in her witty, sarcastic way. She would have probably, also, made some mention of the Anglicans not having much influence in an area where many had been viewed as traitors during the Revolutionary War. To New Englanders, that war was not in some distant past but was still influencing the nation.

*

I remained in Maine for a while after the funeral. My brother returned to his normal life, and my father was speechless and busy with his two hounds and crossword puzzles. One day, I called the local police to see what more I could find out about our mother's death.

"So glad you called," said the man who answered the telephone. "Please come to see me as quickly as you can. I really want to talk with you. I'm Chief Gordon."

I asked directions to the police station, which was in Cape Porpoise, a nearby town. I bumped along a road with patches of frozen snow and some slick ice, then pulled into the parking lot and walked to the front of a surprisingly large building.

I opened the door and was met by a huge man in a leather and fur jacket, his somewhat flabby face tense with anger. "These god-damned prisoners want blankets!" he proclaimed, his frigid breath sending up little visible puffs in the freezing room. The same breath could be seen from a few prisoners behind him.

"Well, it is very cold in here," I said. "I can understand their wants."

"What are you, some sort of flaming liberal who feels prisoners deserve the Hilton treatment?"

"No. It is just very cold, and I am not accustomed to it. I'd want a blanket if I had to be here."

"That's right. I forgot. You are the daughter that lives in Califor-ni-ay, right? Probably hang out with those god-damned-hippy Hollywood types. Anyway, I do want to talk to you. Come into my office."

I followed this enormous man away from the jailed inmates and sat in a typically uncomfortable cracked plastic chair while he sat in an ergonomically designed, black leather desk chair. He stared at me and

then began to speak: "There is nothing we can prove, I want to assure you. But me and the others think your father murdered your mother, and we wanted to warn you. You're alone there, and, I don't know, you might just remind him enough of your mother that he would turn on you. You get what I am saying, don't you?"

To say I was shocked would be a gross understatement. My father was Mr. Meek, the most passive man alive. I once wrote a poem that said he had died before I was born, only he hadn't. It had just seemed that way growing up.

"What makes you think that?" I asked, trying to sound calm.

Chief Gordon pulled out a stack of notes, all written on the same small pad. Even from a distance, I recognized my father's handwriting. "Just look at these. This one says, 'If you do that, the kids will think you were crazy.' Or "Okay, if you really want to do it, no one can stop you. It's your life." Or this: 'Now just go to bed and sleep it off.'"

There were others, all in a similar vein. I could see how this one-sided, strange conversation gave the impression that my father had, if not encouraged, at least not discouraged our mother's final escape.

The police had no awareness of her multiple suicide attempts, so I filled him in. He was somewhat puzzled by the fact that my mother had been dead for a few days before the police were alerted. Three days passed before a neighbour noticed that no one had picked up the newspapers. I explained that my father couldn't speak or use the telephone, nor could he go outside because he had to keep warm after his throat cancer surgery. Having interviewed my father, I could not quite figure out exactly what Chief Gordon did not understand.

"It was not a good sign, not a good sign at all," Chief Gordon reiterated, "that poor woman lay in that house dead for so long."

"But I explained why," I said.

"No explanation is sufficient. Don't you see that? As I tried to warn you, you must be very careful, very careful indeed, because I, for one, don't want another murder on my watch."

I knew, unfortunately, what he meant by "another" but saw there was no point in arguing. As Chief Gordon walked me to the door, he grumbled again about the god-damn prisoners thinking this was the Red Cross and if he gave them blankets, there'd be no saying what they would want next.

*

Years and decades have passed since my mother's death.

I Wish I Could Forgive Her

> *I think of her*
> *grey, spikey, unkempt hair*
> *and her exquisitely aquiline nose*
> *almost hidden*
> *by her thick, black eyebrows*
> *framing melancholic, shifty eyes,*
> *magnifying fear and turmoil,*
> *ideas*
> *thrown around*
> *like balloons ...*
> *some floating away*
> *others*
> *bursting into self-destruction,*
> *into the oblivion of annihilation*
> *Panic frightened into silence.*

> *So many nightmares*
> *entertained sleep*
> *they were routine*
> *and indistinguishable from day.*

> *Still, I can walk by the river where she made books alive*
> *and recall the wonder of those unknown worlds*
> *where*
> *adults loved children unconditionally*
> *and happy endings prevailed.*

> *Time plays games with the mind, of course.*

> *But why do I remember so much pain and disgust*
> *I want to forget?*

> *Why can't I forgive an act brought on by such misery*
> *and break these bonds?*

> *Perhaps reluctance is fuelled by a knowledge that*
> *forgiveness might be synonymous with goodbye.*

Revisiting the poetry I've written over the years about my mother forced me to realize that in many ways, I have become very much like her. I recognize now that she did the best she could. Her own mother died in childbirth before she reached adolescence. She did not have a role model to show her how to be a lovingly, consistent mother—a mother who could guide and not criticize, a mother who could hug and not just hit. She gave as much as she could and what she couldn't, she didn't. My mother was clearly severely depressed. She was hospitalized from time to time, although we were told that it was "for a rest" or, later, "because of a drinking problem."

I, too, suffered through many years of major depression. I lost a son, and during that time, suicide became a viable option; fortunately, I never engaged the cycle of destruction that claimed my mother.

I'd like to say that I am over my mother's suicide and the trauma of my childhood and that she is forgiven, but I'm not sure. Part of me wishes I could have mothered her, surrounded her with love, and healed the emotional scars that plagued her. In this process of recovery, I reflect also on my own mothering, on my lost son, and on my distant relationship with my daughter.

Like my mother, I did the best that I could. Unlike my mother, however, I consciously choose life. I continue to have days when I am saddened that my mother is not here to see what I have become as I write and attempt to make sense of my life. I suppose we all do the best we can under the circumstances, whatever those may be.

It has taken years for me to come to terms with my relationship with that very unhappy woman who happened to be my mother.

Listen

She taught me to write.

The only attention
I can remember fondly is
her reading aloud to me
when I was small.

At least she read
about a gentle world
although she
never knew one.

When I had to write
for school she said,
"Worry about spelling
and punctuation later.

Just let it out and
don't stop until you
are finished."
After that she added,

"Now consider clarity.
But always remember:
listen to the sounds,
hear their beauty."

For that alone
I can now
love my mother.
Even though she's gone,
I still write,

then read aloud to her.

Movement Two
Reimagining: A Way Through

Only after we become conscious of tired narratives and ontological frameworks that no longer serve, can we be free to reimagine our experiences: to recreate and reconstruct the very foundations of meaning on which the emplotment of our lives is based.

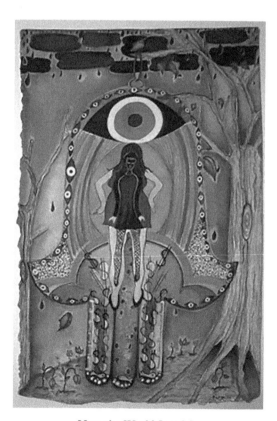

How the World Sees Me

The Question
of Care

Chapter 5

Raising Ourselves: Engendering Maternal Narrative through (Un)remembering Childhood Trauma

Cassandra Hall

"I am not interested in "history for its own sake" but rather by the transformations enabled by walking into memory."

"How can you be okay?" This was all I could manage upon being told I was pregnant with you, my first child. I had felt the stirrings of something amiss for months. Then, as now, sickness and fatigue were part of my ordinary. I found solace in my doctor's assertions that I was not pregnant, just sick, as per usual. And so, I refused the feeling of you until your presence was confirmed thirty weeks into a pregnancy, which I had felt without knowing for months. There were no anomalous symptoms that heralded pregnancy—until I felt you move. Until I felt the flutter of life within my belly, other markers of pregnancy could be explained away.

I had no prenatal care and had taken medication throughout my pregnancy to manage the symptoms that had not yet coalesced into

diagnoses of chronic illness. I was terrified about how this would affect your blooming form. What havoc had I wrought in my unknowing? I was twenty-one and living in an apartment with peeling walls and unyieldingly moist ceilings. By day, I took classes at City College of San Francisco. In the evening, I waited tables before falling asleep on a hand-me-down air mattress. I was nobody's mama.

Stunned in the clinic, with its bowl of violet foil-wrapped condoms next to the sign-in sheet, I could not understand care as process—maternal or otherwise. I did not yet know the messy terrain of parenting, rife with impasses and collective learning. Rather, I imagined I had to become a parent, your mama—a fixed subject from whom care and love emerged organically—in the scant few weeks I had left before your birth. The figural mama I conjured in my mind was grown. She was a settled culmination of past becomings, far from the ever-in-flux person I knew myself to be. In an effort to disrupt the legacies of familial violence I inherited, I tried to become more like her. I felt for care in parenting books, community college courses, blogs, social media, literature, and film. So little spoke to me—a not quite grown queer, crip femme who just wanted you to feel loved and know that you were cared for. But what exactly was care?

Although my financial precarity and your welfare were concerns, my most acute fears focused on something else. I felt this fear as an ache, a profound hunger intensified by the swelling curve of you in my belly. I was consumed by this gnawing lack, this desire for something I could not name but felt anew each time you kicked or squirmed. I am only now finding the words for this nebulous something seven years later as a parent of three. In mothering, the shape of this desire reveals itself as a longing for modes of care beyond the genealogies of abuse and neglect that pepper my familial past—*a past that I am determined to restory.*

Feeling for Care in (Queer) Memoir

You were born eleven weeks after your existence was confirmed. The pervasive hunger that had haunted my pregnancy was dulled by your squishy newness. I filled the stillness of my postpartum haze with the reading of memoir. Serendipitously, I found the care I longed for within these texts, particularly in memoirs that grappled with childhood trauma.

In the transformative act of (un)remembering, memoir creates ruptures in the past, enacted in the present, that move us towards novel, perhaps queer futures. Through embodied memory and memoir, I trouble how memories of being un/cared for are held in the archive of my body. In memoirs of childhood trauma, I found a medicinal model of (un) remembering. As Aurora Levins Morales writes, "The power of history [is] to provide those healing stories that can restore the humanity of the traumatized, and not for any inherent interest in the past for its own sake" (25). Like Morales, I am not interested in "history for its own sake" but rather for the transformations that emerge as we walk into memory. How might engagement with memory create ruptures in the tenuous fabric of an unsettled past, thereby revealing transformative modes of care?

Memoir allows me to interrogate my past and read it with my desire for queer care. Here, queer does not refer only to non-normative bodies and relations. Rather, I locate queer in the "creative power of transforming ourselves and the ways we relate to each other" (Gumbs 23). Thus, I do not limit queer care to modes of care enacted by or for non-normative bodies. Rather, I consider queer as an orientation towards futures not mired in the violences, compulsions, and imperatives of the "broken-down present" (Muñoz 12). Thus, to care queerly is to care against those normative futures that profess to be inevitable. It is to allow for and perhaps enable embodiments, orientations, and ways of being that are deemed unruly and undesirable in dominant culture.

In reading Alison Bechdel's *Fun Home: A Family Tragicomic* and Leah Lakshmi Piepzna-Samarasinha's *Dirty River: A Queer Femme of Color Dreaming Her Way Home*, I consider how transformative maternal narratives are brought into relief through the act of "raising oneself" (Piepzna-Samarasinha 15). Following Piepzna-Samarasinha, to raise ourselves is to refuse the practices of un/caring that we have inherited. The modes of healing enabled through this entangled processes of care and memory are not bound within the limits of reproductive futures that understand the past as settled. Thus, the project of raising ourselves offers healing not only for our children and future generations but for ourselves and those who have come before. Vitally, these modes of healing are not necessarily curative—that is, they do not aim to undo experiences of trauma. Rather, the practice and framework of raising ourselves allows us to hold one another in our brokenness and to find

knowing—perhaps, for transformative forms of care—in our embodied memories of trauma.

Through personal narrative and engagement with memoir, I feel for how queer memoir and memory engender transformative care. When (and how) is care made queer? What does it mean to care queerly? Through an engagement with these questions, I theorize (queer) care as a method(ology), an analytic, and a means of birthing new worlds. I trace how (queer) care allows me to reconcile my childhood past—to raise myself—and open queer futures for and beyond my children.

In grappling with that gnawing ache, I find that queer care allows me to reconcile the perceived lack of care in my childhood. In remembering, I find that my childhood is not devoid of care, but that my experiences of care are mired in their proximity to shame. As Sara Ahmed tells us, "Emotions circulate between bodies ... they 'stick' as well as move" (4). *What happens when care sticks to the body as shame? And how do I ensure that you never have this experience of care?*

Through these memoirs, I am called to venture into my own memories of care. I find *me, small and freckled. Maybe seven—the age that you are now. Like you, I carry a knowing in my body. An awareness of the violences of our world. Of the possibility of futures not mired in the tumult of this moment. This knowledge manifested as unruliness. Like you, I was—I remain—too much. Too sensitive. This abundance of feeling was deemed excessive. Pathologized. Shamed.*

In play, I would pretend that I was in the midst of catastrophe. I imagined that a tornado raged above me, placing me and the objects of my care in peril. I pulled my siblings and dogs onto the couch with me and gathered supplies that might enable our survival. The couch was transformed into basement. A chair, a pillow, a blanket repurposed as a bed. Empty boxes were made into food so that we might be nourished through disaster. I seldom felt as warm and held as I did while pretending that the world was ending. The couch piled high with children and objects, I imagined that we were safe, that my knowing—that welling feeling of impending disaster—and the care by which it was accompanied had saved us all.

The imagined tornado gave form to the quiet horrors of my every day. Even in play, I could not imagine life outside of catastrophe. It was so much a part of my ordinary. The abuse, neglect, and forced compliance of my childhood seldom left marks on my body that would be read as harm.

Those charged with my care seemed oblivious to the violences of my famil-
ial home. Justified them. Posited them as a necessary response to my un-
ruliness. The inevitable consequence of being too much. The world was
ending all around me in ways that were often ignored by others who did not
(want to) see these terrors. I craved a legible disaster. This desire manifest-
ed in my play. I experienced care as a tornado. Brutal. Furious. Fierce. In
my catastrophic fantasies, I brought coherence to this care. I made real the
ways in which care stuck to my body as shame, as abuse, and as neglect.

Counter to my experiences of care as violence, I imagine that *my* care
imparts feelings of safety, of being held and affirmed. Nonetheless, I find
that my care is sometimes articulated through shame. This enduring
desire to move beyond the shame that was constitutive of my experiences
of care reflects my personal, scholarly, and political investments in
transformative modes of care. In this chapter, I engage in a reparative
analysis wherein I unravel and reveal shame's entanglements with
care—for myself, for my children, and beyond—and feel for modes of
care beyond shame.

Care, Shame, and Straightening in *Fun Home*

Queer memoir gestures towards ways of being, futures, and vitally—
modes of care that differ from the violences of my childhood. Some-
times, the care I found in memory and memoir was transitory. Often,
it was revealed through its absence, as a what if? What if care was not
contingent upon compliance and conformity? What if care was not en-
tangled with shame at my own unruly embodiments and orientations
and those of the memoirist I engage with here?

Alison Bechdel's *Fun Home: A Family Tragicomic* traces her relationship
with her father through childhood to his eventual suicide shortly after
her own coming out. With compassion and a sustained sense of loss,
Bechdel considers how her queer becomings emerge despite and with
her father's obscured queer becomings. Bruce is often a violent figure in
Bechdel's memoir. His attentions to their home and the fantasy of the
(hetero)normative family were often maintained through physical and
emotional violence. Alison becomes a focus of his wrath in her increased
deviation from the dictates of normative girlhood. Through shaming care
practices, Bruce endeavours to shift Alison towards the lines of
normativity.

Furthermore, the home represents Bruce's desire to conform to normative conceptions of the (hetero)normative family. As revealed in the encounters between Bruce and Alison, these fantasies are precarious. Much like the restored farmhouse that holds Alison and her family, these fantasies are inevitably sullied. To maintain the house and its undergirding fantasy, they must be worked and maintained through consistent adherence to dominant norms. Notably, the language that Bechdel evokes for Bruce's efforts to maintain the home and the fantasy of the (hetero)normative family gesture to their fictions. As she tells us, Bruce was "an alchemist of appearance, a savant of surface," and a "skillful artificer" (6-7). The façade of the familial home is maintained through Bruce's attention to objects.

In Bechdel's remembering, her father's care is limited to the objects of their antique-ridden mansion rather than his children. She writes, "He treated his furniture like children, and his children like furniture" (15). For Bruce, children are not autonomous subjects. Rather, they are markers of normativity that sustain his place within the normative imaginary. In the curation of the fantastical home, Bruce's children become objects. They are valued for the "air of authenticity [they] lent to his exhibit" (12).

From its onset, *Fun Home* connects Bruce's relationship to (hetero)normative fantasies with death and destruction. In remembering a moment of play between Bruce and Alison, Bechdel reminds us that the acrobatics they performed in their game of airplane are called "Icarian games" (3). In contrast to the myth wherein the son, Icarus, is sacrificed to his father's invention when he flies too close to the sun, Bechdel reminds us that it is Bruce rather than she who will "plummet from the sky" (4). This story of sacrifice is explicitly linked to Bruce's obsession with maintaining (hetero)normative fantasies. As Bechdel writes, "It was his passion. And I mean passion in every sense of the word. Libidinal. Manic. Martyred" (7). In the accompanying panel, Bruce is shirtless and wears only cut-off jean shorts. His back bends beneath the weight of a large column. The house behind him is blackened, a flattened form legible only through its windows and borders. Bechdel writes, "His shame inhabited our house as pervasively and invisibly as the aromatic musk of aging mahogany" (20).

Through *Fun Home*, I am reminded of the shameful care that sticks to my body, so constitutive as to be invisible. This shame is a gut punch,

a breath-stealing beast. I know this monster. I find it in the I'll-kill-us-all-blow-your-head-off-you-made-me-do-this tirades of my childhood. Nonetheless, I am most interested—and arguably, most affected—by the experience of shame in the spaces between these moments of terror. This shame does not hit the body but rather kneads, pushes, and pokes. These enactments of shameful care are normalized, naturalized, and, often, rendered invisible. How do these embodied memories of care through shame shape the ways in which I care?

Past, present, and future coalesce in your body, also small and freckled. They come together in your ginger curls. Your blue eyes round like mine, turned down at the edges like your other parent. Like their father. Your body is an archive. You carry entangled histories of love, survival, abuse, care, neglect, resilience, and shame.

What histories do you carry in your bones? Those of noncompliant children stuffed into closets? Of little bodies touched by those who profess to care for them? Betrayed. Of the constitutive terror of impending violence. Of shame. Also, of removal, of genocide. Of a great-grandmother leaving home so that we might survive, crossing oceans with a belly full of life. Giving birth at the end of the world.

How will my care rest in your bones? Will it rest? Will it sit in your stomach as a live grenade as recollections of care does in mine? Heavy and leaden. Always felt in the metallic taste in my mouth. Like blood. A constant reminder of the devastating potential of these embodied memories of care. Perhaps, of the inevitability of explosion.

In attending to care's entanglements with shame, two distinct but not dichotomous modes of care emerge. Hegemonic care is care that orients its object towards ways of being that enable normative futures. This theorization of care is informed by Sara Ahmed's notion of straightening devices that "reread signs of queer desire as deviations from the straight line" (26) and that compel "bodyminds"[1] towards particular comportments and life paths of compulsory heterosexuality. To care queerly may be to refuse these straightening devices or to engage critically with queer and normative orientations. Ahmed gestures towards a more relational understanding of orientation that is not confined to bodies' relation to other bodies but extends to the ways in which subjects relate to objects and move through the world. In Ahmed's telling, queerness may orient bodies towards objects in ways that reveal nonlinear paths and organic ways of being.

I bring these understandings to my reading of *Fun Home* and, in particular, to Bruce's encounters with Bechdel's non-normative gender and sexuality, and I recognize that the straightening of shameful care is not linear. It oscillates and moves between subject and object. The imposition of care—and its sticky affects—move between bodies. As Bruce tries to straighten his child, the expectations of normative embodiment, comportment, and orientation come back to him, revealing and exacerbating his experiences of deviance and shame. What would happen if we refused shame in our care? Could queer affects find us through the project of caring queerly? Could caring queerly queer the parental body?

In its assumed normativity of reproductive care, dominant branches within queer theory affirm and naturalize hegemonic care. I mark this as a failure of imagination in queer theory and aim to chart other modes of care from this lapse. Queer care is not brought to life through an expansion of hegemonic care or even a fuzzy rendering of the mythical norm, wherein historically marginalized bodies may be encompassed within or placed in closer proximity to dominant norms. Rather, hegemonic care is a living, breathing entity. It consumes bodies once understood to be unruly or dangerous. It kneads, pushes, and distorts until its object is made legible, palatable, and worthy of care. Hegemonic care and its undergirding logics are nourished and made more potent and less susceptible to injury through projects of expansion and inclusion. It exists only as long as its object is able and willing to operate within the logics of white supremacist, capitalist hegemony, and its desired futures.

Femme Care

As explored above, caring queerly refers to those practices and processes that enable becomings outside and beyond normative lines. In feeling for modes of care beyond the shaming practices of hegemonic care, I find femme care. Femme care resists steering its object towards particular embodiments, comportments, and/or ways of being, allowing for the messiness of queer un/becomings. I value femme for its fuzzy, perhaps illegible, shape. My use of femme accounts for its messy histories and manifestations and its "gorgeously radical ... ambiguity" (Westhale). In my theorization of femme care, I am particularly moved

by Mykel Johnson's assertion that "To be femme is to give honor where there has been shame" (83). In tracing care's entanglements with shame, I attempt to remake these tangled objects into something new. Something that does not rearticulate the violences of normativity. Something femme.

Through Johnson's definition of femme, I come to understand femme care as process oriented; it emerges from the continual work of un/ becoming, oriented towards the undoing of shame. When the refusal of shame becomes an imperative (i.e., to refuse in the right way) and a force through which bodyminds are made to conform to particular logics and/ or ways of being, it is implicated in shame. As such, femme care may become another means through which unruly bodyminds are made insecure.

Bechdel's remembering of her father's outbursts and sometimes violent imposition of "artifice" is complicated by our knowledge of Bruce's sexuality. Within the context of his hidden affairs and Bruce's (literal) obsession with maintaining a façade of perfection, how may we understand his efforts to enforce the confines of normative girlhood as care? Perhaps, in urging his daughter towards (hetero)normative practices and comportments, Bruce aims to keep her from the grief and shame that has defined his own tenuous placement within these fantasies. The care that emerges between Bechdel and her father is not defined by either subject; it is in the liminal space between caregiver and cared for. Notably, its shape, ephemeral as it may be, is only revealed through remembering.

In feeling for queer care, I do not neglect care's more problematic entanglements, namely those with (hetero)normative familial fantasies. Rather, I ground my analysis within those moments in which the queer and the normative refuse demarcation. To date, dominant threads within queer theory have failed to imagine how care, reproductive desire, and parenting may disrupt (hetero)normative hegemony. I situate my work within this lapse and endeavour to form an opening through which we may conceive of queer care within and beyond reproductive desire and parenthood. I revel in the tensions of this project, specifically the conflation of queerness and the imagined normativity of parenting. Following these themes, I ask: Do these works provide openings through which we may define queer care, love, family, and collective world making? What does it mean to care queerly? What might queer care offer for transformative feminist politics?

My work acts as an intervention in antisocial queer theories, particularly as they relate to queer critiques of reproductive desire and parenthood. My focus on reproductive care serves to redress the erasure, under theorization, and even contempt of reproductivity within queer theory. In grappling with the queerness of unbelonging, queer theorists have too often equated reproductive desire with (hetero)normativity. This is perhaps no more explicit than in Lee Edelman's polemical *No Future: Queer Theory and the Death Drive*. In asserting that "we"—that is, queer subjects—are terrorized by the figural Child, Edelman does not attend to the ways in which those who imperil white, imperialist hegemony, including but not limited to children, are similarly threatened within the dictates of neoliberal capitalism (18).

My critique of Edelman's work follows my own lived experiences with care and relationality. Wherein Edelman's work is explicitly antirelational and reifies the logics of individualism, my own experiences reflect not only a political inclination towards relationality and collectivity but also a need for engagement with others. Although the impetus of this project is my experience as a parent and a person who endeavours to care, it also reflects my positionality as a crip and neurodivergent person who requires care. Without the relationality of care, my positionality as a person with "no future" is not a refusal but an inevitable consequence of the limits of my ability to survive independent of others.

In *Dirty River*, Piepzna-Samarasinha grapples with the effects of shame. In her writing, shame induces stasis. As she tells us, the experience of being a survivor is entangled with shame. Piepzna-Samarasinha connects crip embodiment with the shame of abuse. As she writes, this shame sticks us there (16). Counter to Ahmed's conception of orientation and oscillating affects, Piepzna-Samarasinha's survivor is stagnant. For her, femme care—articulated as "raising oneself"—emerges in this stillness. Like mine, much of Piepzna-Samarasinha's young adulthood was spent in bed, resting through chronic illness. She does not consider this moment to be tragic. Rather, her sickness enables her to grapple with her past and heal from the wounds of childhood trauma. Here, Piepzna-Samarasinha envisions "raising oneself" as a restorying of sorts. Informed by crip embodiment and a decade spent in bed, Piepzna-Samarasinha "reknits" the past. She alludes to the transformative potential of memoir in writing to her abusive mother in *Dirty River*:

RAISING OURSELVES

Worst daughter.

Best daughter.

I changed this for us, mama.

Rest (220).

Through memory and raising herself, Piepzna-Samarasinha moves towards wholeness. This wholeness incites a desire to "send everything back" to her childhood self to lessen the blows of childhood abuse (228). Although her desire for erasure goes unfulfilled, she is able to restory her trauma so that it is held differently within her body archive. The "choose-your-own-adventure" survivor narrative that Piepzna-Samarasinha offers is not invested in a curative relationship to trauma (15). Rather, she traces how wholeness emerges from traumatic experiences of care and how embodied memories of trauma may be used to create ways of being together that do not rearticulate abusive patterns.

Piepzna-Samarasinha explicitly positions this becoming outside and beyond normative lines. She writes, "In the end, I don't get normal. I get something else" (15). In the stories of care I tell here, femme care remains fuzzy. It does not exist as a defined set of processes and practices; rather, it emerges as a potential. It is the placement of this something else outside of normal that enlivens me. In the story of trauma and healing that Piepzna-Samarasinha tells, attending to how trauma is held in the body as shame does not carry us back to normative lines, orientations, and/or embodiments. Rather, it enables transformation through refusal. Like Piepzna-Samarasinha, care—for myself, for my children, and beyond—allows me to transform trauma and to carry it not as tragedy but as generative refusal and impetus to care beyond shame.

In caring for you, these narratives are transformed. I (we) trouble an unsettled past and conjure futures that do not sustain legacies of violence. Past pools into present; future melds with past. Creating ruptures and gesturing towards worlds enabled by other modes of care. In being your mama, I do not move beyond the traumas of my past. Rather, I travel through time. I use the stories of childhood trauma written upon my body to engender a transformative care. This care is hopeful. Generative. Disruptive and queer in its refusal to sustain legacies of violence that profess to be inevitable.

We pull from the threads of care that emerge from our familial pasts,

105

presents, and futures. From the interconnectivity of the more than human world. From those who care for us and hold us through un/becoming. These threads are often fraught. Frayed. Nearly severed at places. They carry the weight of my experiences of care as violence. Some are entangled with shame, abuse, and neglect. Others, with love, survival, and investments in other worlds and futures. Our bodies are archives of remembered and felt pasts but also of the potential of other worlds and futures. What worlds do you (will you) carry? What histories, what futures will you draw from?

How will this letter find you five years from now? ten? If care can be a tornado, it can also be life-giving breath. How will your memories of being cared for move through time and space? How will care live in your body? Will you remember care as catastrophe? Will it live in your body as a grenade or as life-giving breath? What becomings will (my) care enable in you? How will it shape the ways in which you care and allow yourself to be cared for? In caring, we draw from the futures that we do not yet know but feel as a gnawing hopefulness. Their orienting promise directs the work that we must do. To make these worlds. Where we are free.

Endnotes

1. Following Margaret Price, my use of "bodymind" reflects a recognition of "the imbrication (not just the combination) of the entities usually called 'body' and 'mind'" (270).

Works Cited

Ahmed, Sara. *Queer Phenomenology: Orientations, Objects, Others.* Duke University Press, 2006.

Bechdel, Alison. *Fun Home: A Family Tragicomic.* Houghton Mifflin Harcourt, 2007.

Edelman, Lee. *No Future: Queer Theory and the Death Drive.* Duke University Press, 2004.

Gumbs, Alexis Pauline. "M/other Ourselves: A Black Queer Feminist Genealogy for Radical Mothering." *Revolutionary Mothering: Love on the Front Lines,* edited by Alexis Pauline Gumbs et al, PM Press, 2016, pp. 12-25.

Morales, Aurora Levins. *Medicine Stories: History, Culture, and the Politics of Integrity.* South End Press, 1998.

Muñoz, Jose Esteban. *Cruising Utopia: The Then and There of Queer Futurity.* New York University Press, 2009.

Piepzna-Samarasinha, Leah Lakshmi. *Dirty River: A Queer Femme of Color Dreaming Her Way Home.* Arsenal Pulp Press, 2015.

Price, Margaret. "The Bodymind Problem and the Possibilities of Pain." *Hypatia*, vol. 30, no. 1, 2015, pp. 268-84.

Westhale, July. "Being Femme is a Radical Act of Resistance." *The Establishment*, 30 Nov. 2015, medium.com/the-establishment/dear-my-sweet-queer-family-lets-combat-femmephobia-2a95f6a0d61. Accessed 15 Mar. 2019.

Chapter Six

Narrating an Open Future: Blogs by Mothers of Autistic[1] Children

Daena Goldsmith

"... this uncertainty is both worrisome and freeing:
"I don't have the luxury—or wait, the limitation, yes?
—of knowing what to expect around the next turn."

"I will be forever grateful to Brooke for unwittingly breaking my
insular little world wide open. For allowing me—nay, forcing
me—to see the beauty of difference, the light and colour and
startling depth of dimension in the full range of the human
spectrum. For giving me the gift of a life well-lived thanks to the
variety and the quality of the people in it. I owe her—and
autism—more than I can ever begin to repay." (Wilson, "about")

I discovered mommy blogs in the fall of 2011. I had spent plenty of time
pondering the pressure I felt to be a good mother—fretting about the
discrepancies between my feminism and my practice, and commiser-
ating with friends—but I had no plans to study mothering, much less
the ways it was portrayed in blogs. What little I knew about mommy
bloggers came from an article I had seen in *The New York Times*, which
criticized them for exploiting their children and for drawing narcissis-
tic attention to the unsavory aspects of childcare (Hochman).

It was a student project that introduced me to Jenny Alice and Kristina and their beautiful boys. These bloggers wrote eloquently and frequently about the everyday ups and downs of raising an autistic child. Within weeks, I was figuring out which reader was best for tracking the RSS feeds,[2] which search engines would lead me to more of the blogs, and which system I could use for documenting and analyzing texts that included images, links, and comments that were constantly accruing and changing.

I had studied narratives of personal experience before, but like other scholars of illness narratives, I focused on stories told in retrospect about a health crisis that was sufficiently in the past, such that the narrator was ready to sign up for a research interview. In contrast, the stories in these blogs were unfolding before my eyes, prompted by a storyteller's desire to make sense of experience and, along with her readers, build a visible community through links and comments.

Although I was just a lurker, I found myself connecting with these stories as more than data. Reading these blogs changed my understanding of autism and my ideas about mothering. I began to see why some scholars celebrated blogs as "radical feminist acts" (e.g., Friedman 6; Lopez 743-44) that express both joy and ambivalence about mothering and that expand available representations to include marginalized voices. In this chapter, I describe how these blogs provide counter-narratives for thinking about what it means to be a good mother.

The Ideology of Intensive Mothering

As I began to study mothering, I discovered that the pressures I experienced to be a certain kind of mom had been dubbed "intensive mothering"—a dominant ideology in North America and the U.K. that includes the belief that mothers should be primary caregivers who put their children's needs above their own and expectations that childrearing should be "child-centered, expert-guided, emotionally absorbing, labor-intensive, and financially expensive" (Hays 8). The ideology's prevalence has not diminished in the two decades since Hays's original work (see, for example, the recent volume edited by Linda Ennis). It is relentlessly on offer in the media, and it syncs up nicely with the larger shift towards neoliberalism, including the erosion of economic opportunity and societal support for families as well as a diminished

feminism that emphasizes self-control, personal achievement, and self-perfection rather than collective action for the common good (McRobbie 121). Indeed, some scholars argue that "status safeguarding" has become the core of intensive mothering: maternal emotional and physical labour are directed towards the promise of creating children who can maintain or improve upon their parents' standard of living (Milkie and Warner 72).

Dominant ideologies represent the ideas of more powerful groups, shaping the meta-narratives that are available for sense making and moral judgment, even when those narratives do not accommodate the diversity of women's experiences. Many mothers find their situation at odds with intensive mothering yet continue to attend to it because they have lost faith that society will keep their children safe (Brown 30). They also fear moral judgment. The ideology promotes self and other surveillance as well as a kind of "mompetition" in which children's development becomes an accomplishment and a standard against which good mothers are measured (McHenry and Schulz 299). The impossible standards of intensive mothering contribute to distress among mothers (Mackintosh et al. 150-52) and intensive mothering is discriminatory, as it places mothers at a disadvantage in the workplace and sets good mothering out of reach for those who lack resources to achieve the ideal.

Mommy Blog as Radical Feminist Act?

"I do not think I completely realized how bad it is to do the homeschool comparison game until recently I heard some of it come out of a fellow homeschool mom's mouth. She was comparing herself to me and pretty much saying that I did a lot more with my kids than she did. What type of measuring tool is there to get this type of estimation? Fortunately, it only exists in our own minds…. I think that homeschool parents should sometimes cut themselves some slack (myself included)." (Joy C., "Procrastination")

Several features make mom blogs a space where there is potential for narratives to expose the contradictions of intensive mothering and articulate alternatives. Although some high-profile mom bloggers employ advertising and endorsements, most emphasize authenticity, immediacy,

and self-expression for a small community of readers (Morrison 38). Posts are typically written quickly and unfold over time without a clear endpoint, plunging a reader into the present and showcasing the trivial alongside the memorable. Blogging norms discourage changing previous content and encourage archiving and tagging, enabling readers to see change, contradiction, and ambivalence over time. As a result, mothers "emerge as more complex and hybrid characters" than in other genres (Friedman 63), thus resisting reduction to a single token narrative.

The potential for interaction through links, comments, and reposting facilitates discovering similarities and identifying with others, but can also bring a blogger into contact with unfamiliar perspectives from outside her social circle. Bloggers from different social contexts make connections beyond "traditional identity silos," which helps to form communities of non-normative mothering (Friedman 88), combat isolation, foster interaction between and among mothers, and weave webs of interconnection that, for many, are personally empowering (Morrison 51).

Mothers of autistic children are one social location with potential to disrupt neoliberal beliefs about the role of control, choice, and productivity in motherhood (cf. Landsman 87-89, 153-58). Autism is a spectrum of varying symptoms, skills, and levels of impairment; diagnostic criteria include difficulties with social interaction, problems with verbal and nonverbal communication, and narrow interests and repetitive behaviours. Mothering an autistic child differs from what many mothers expect, what they might have experienced with neurotypical siblings, and what they observe of their peers. Mothers of autistic children are often called upon to make sense of "events that appear random and disordered to outsiders" (Birmingham 228), and they may feel misunderstood and stigmatized (Altiere and von Kluge 150-51). Intensive mothering presumes that a child's development is a maternal accomplishment that reflects the mother's investment; how then do we understand mothers who engage in intensive caregiving without the expectation that a child will achieve typical milestones? And how do they understand themselves? Mothering autistic children is a direct challenge to status safeguarding. As well, the description of ups and downs in a public blog involves sharing vulnerabilities and honouring difference rather than competing with one another.

As I read these blogs, I saw how distinctive features of blogging

combine with the particular experience of mothering autistic children to produce a space that is ripe for counter-narratives. Proceeding as a typical reader would, I procured a sample of blogs by searching blog aggregators and indexing sites. I used combinations of "mother," "mom," "autism," and "Asperger" in three blog search engines and gathered the first ten URLs in each search. From these, I selected a varied sample of nine blogs, and I read all 2,356 of their posts from January 2012 to June 2013. Somewhere along the way, I started following the links to previous posts in these blogs and to other blogs that weren't in my original sample. I developed preliminary themes, then refined them as I continued to read these and other blogs. Over the years, some blogs moved, posting frequency varied, and some even ceased; however, several themes did recur, including a narrative of hyperintensive mothering as well as counter-narrative threads that claim community and an open future.

Hyperintensive Mothering

These mothers describe an experience that is not just intensive but hyperintensive (cf. Sousa 227), in which autism magnifies every element that defines intensive mothering. For example, caregiving requires greater *time and effort* for these mothers. Food preparation needs to accommodate allergies, sensitivity to tastes and textures, or dietary interventions. Getting dressed requires special attention to labels or fabric texture that aggravate sensory challenges. Outings and events are closely watched for frustration arising from overstimulation or breaks to routine. Mothers scaffold children's social interactions and explain unusual behaviour to others.

The blogs also show the need to *take a child's perspective* and to exercise *vigilance.* Autismum's son does not communicate verbally, so she has become adept at "anticipating what [he] needs and reading subtle signs that he may be tired, bored, or hungry" (O'Callaghan, "The Pwd's Progress"). Yet she is careful not to "train" herself so well that she removes incentive for him to communicate. Perspective taking includes anticipating danger to the child or others, which often requires constant vigilance even for older children. Mothers worry about bullying, bolting across a street, or the sexual exploitation of a child with communication challenges.

In addition to providing care themselves, mothers coordinate expert

care. Zoila describes feeling "overwhelmed" by appointments for occupational therapy, social skills training, physical therapy, visual therapy, psychiatry, counselling, and chiropractors, plus visits to the ER, and "just plain sick days." She jokes, "I may not be a soccer mom by any measure, but I sure am an appointment mom" ("First time ever!"). Mothers who seek interventions need to learn what therapies are available, negotiate with insurance companies, monitor progress, and determine when to discontinue or seek new therapy. Mothers whose children attend school participate in determining the level of appropriate integration into various classrooms as well as the services and accommodations that are needed. Several mothers homeschool.

For all its demands, motherhood was, nonetheless, represented as *fulfilling*. Posts that detail hard times are nearly always balanced with descriptions of reward. Joy reveals, "how exhausting, stressful, and downright aging it is parenting a child like my son. There are times I admit, when I wake up in the morning and a sense of dread comes over me ... yet how often I overlook the joys that are right under my nose" ("Take Time"). She describes how her son says things that are "UTTERLY hilarious" and how in routine interactions in public, "he remembers the most particular details about each person. He makes them feel special and important." He reminds his mother to slow down and care for people. For these mothers, the rewards of intensive care are often found in a valuing of care as meaningful in its own right.

At first glance, these blogs appear to be fully consistent with narratives of intensive mothering; however, the intensity comes less from ideological commitment or social pressure than from the concrete needs of their children. These mothers just want their children to be safe and happy and to find a way to communicate with them. Their accounts rework the dominant intensive mothering narrative by decoupling these practices from the ideological assumption that mothering is an individual responsibility that will produce a particular type of child. I discovered in these blogs counter-narrative themes to replace status safeguarding: a willingness to be vulnerable instead of competitive, an assertion of community responsibility for all of our children, and a vision of an open future.

Communal Vulnerability and Responsibility

"It means so much to me that so many of you were able to find
something useful in my words. As I sit here and write at 4:30
every morning, I never know which posts will resonate with
others and which will land more softly—just for me and my
girls. I so often find that the more personal the entry—the more
I think I must be the only one—the more likely it is to be met
with shouts of "Me too!" And I never cease to be comforted by
the knowledge (that somehow feels new each time) that none of
us—no matter how isolating this road can feel—truly walks
alone." (Wilson, "their what?")[3]

The ideology of intensive mothering makes mothering an individual
responsibility. The very act of blogging challenges isolation and compe-
tition. Public confessions of difficulty appear alongside celebrations of
success. Says Erin, "I write because as a person, as a parent, I need to
process" (Clotfelter, "Lock Down?"). Upon reaching her 2,500th post,
Shannon says that she writes, "sometimes to vent, mostly to share in-
formation, Borg-style—through the collective and hive mind that is the
Internet" (Rosa, "Autism & Sharing"). This collective is bound together
by mutual responsiveness. Once established, bloggers express an obli-
gation to their readers, apologizing when they post less regularly. They
receive and give support, which allows them to be a person with much
to offer rather than a failed mother of a bad child.

This communal sharing and obligation does not preclude disagree-
ment. In fact, it was through criticism, including comments from autis-
tic adults and advocates, that some moms changed how they thought
about their affiliations within differing, and sometimes contentious,
online autism networks. Shannon explains that these connections "help
me learn to both understand Leo better, and be a better parent to him"
(Rosa, "Depression & Autism Parenting"). Several blogs include guest
posts by autistic adults who describe their experiences and give advice
about how to advocate, accommodate, and ally with one's own child and
with a larger autism advocacy movement.

The sense of community formed through blogging extends to include
demands that the offline village should invest in autistic children. Many
posts explicitly question the idea that mothers should have sole

responsibility for care and lament the inadequacy of social services. Erin responds to reader comments on a news item about the costs of special education in schools: "Do people really look at my kids and think they are a waste of time, effort, and money? Do they really think that they should not have a public education?" (Clotfelter, "Some Parents"). She rejects the idea that she alone is responsible for her children's needs and claims their right to a free and appropriate public education. Likewise, Autismum regularly posts about proposed cuts to respite care, including sample letters for readers to send to politicians in their area.

Posts decrying stigma and lack of societal support expose the devaluing of autistic lives. In a post on the topic about what to do to make the world more accepting of autistics, Shannon urges readers to "help other people understand that autistic people like my son are your fellow human beings, with your same inalienable rights to live happy and pity-free lives" (Rosa, "Autism Acceptance Day"). Reader comments on posts about daily life often include not only affirmation for mothers but also praise for their kids, such as "Yay Jack!" "See, our kiddos have a great imagination!" or "He is ridiculously cute!" Not only do these blogs provide a space for expressing personal vulnerability and finding individual support, they also call for communal support for mothering and for all children.

An Open Future

> "I do my best to strive to presume, cultivate, and recognize Leo's competence. To give him opportunities to access information and entertainment. To always consider what is possible, what he could do, how he might thrive—and not worry about whether we see any kind of 'return on investment'"
> (Rosa, "Apps & Autism")

These blogs disrupt the expectation that the purpose of intensive mothering is an independent, productive child. As Erin explains, "It's all a total crapshoot ... an uphill battle of therapies that may or may not work... Sometimes, I wonder what difference any of it makes." Although she sees progress, she "still cannot imagine them mainstreamed at any point of their lives. I don't see them ever living on their own. I don't see them having romantic relationships or families or jobs.... And

I am OK with that. I don't feel a need to fix them" (Clotfelter, "The One"). Daily reporting on an uneven trajectory disconnects mothering in the present from results in the future and shapes an uncertain but open narrative characterized by possibility.

There are glimpses across the blogs of a "genuinely open future, one not controlled by the objectives, expectations, and understandings of the present" (Garland Thomson 352). This counter-narrative is especially prominent in the blog *diary of a mom*. Prompted to write a New Year's post about "something you're looking forward to in 2012," Jess writes, "I have no idea," and this uncertainty is both worrisome and freeing: "I don't have the luxury—or wait, the limitation, yes?—of knowing what to expect around the next turn" (Wilson, "looking forward"). Instead, her experience is one of "winding, curving roads" over terrain that is "treacherous" but inclusive of "scenery more beautiful than any our limited imaginations could conjure." She is "thrilled by the overwhelming possibility" but also acknowledges that "the tough terrain scares the crap out of me" because she cannot predict when it might happen or what form it might take. She concludes this post by expressing her confidence that "we'll get through it" and a determination to "follow my girl as she conquers new challenges, breaks apart more and more perceived limitations, and little by little, finds her way in this world" ("looking forward").

Jess returns to this theme later that year, stating, "If we are parenting our children—any children—from a place of respect, over time our dreams for them will evolve as we find out who they are" (Wilson, "D Day"). She gives examples of a father who learns that his son prefers art to football or a mother who dreams of picking out china with a daughter-in-law but instead welcomes a same-sex partner for her son. Jess lacks the map other parents believe they have, but by linking her experiences to those of all parents, she rejects the notion that a good mother can or should control her child's future. Her narrative is validated by 106 comments and replies. Some are mothers of autistic children who describe how, prior to a diagnosis, it was stressful to engage in hyperintensive mothering without getting expected results. Diagnosis can be a relief when it offers a different way to understand their children. Their comments on this post present alternative ways of describing change, including being on their own journey or path, doing things "in their time and on their terms," "unlocking potential," knowing

"something great is going to come from my girl," or letting children be "the best possible versions" of themselves". Like Jess, however, the comments also report "not allowing myself to think beyond the now," worrying, crying, and feeling "terrified" about what adulthood would bring. As another blogger states, "you're always trying to maintain a balance of enjoying today and worrying about tomorrow" (Andy's Mom "Autism Dog for Andy").

One way these narratives strike that balance is to celebrate the present moment not for what it promises in the future but for its own sake and in comparison to the past. Jess models this in a post reporting that her daughter's "language is changing and shattering its containing walls and spilling up and out and over and surfing like water through the streets right before our eyes" (Wilson, "show and tell"). She goes on in this post to describe several examples as "moments ... not the stuff that makes the Progress Reports. It's not remotely measureable." Readers' comments recognize how "autism helps us to really cherish those *moments* when they happen," and they thank Jess "for once again capturing life's lovely *moments* in such a unique way" (my emphasis). Readers also stress the importance of communal validation for this counter-narrative of time. Says one, "I get it and I love that you get that we get it and say so ... I am in good company here in this community, when everyday people wouldn't be able to share the joy of getting it in quite the same way." Together bloggers and readers construct what Rosemarie Garland-Thomson describes as "an experience-based counter-narrative," which is able to "imagine a subject without a future life trajectory perpetually managed in the present moment" (353). And, as Garland-Thomson predicts, "rather than dictating a diminished future," these counter-narratives open up "a truly unpredictable, even unimaginable one" (352).

Finding Spaces Where Counter-Narratives Flourish

These mother's stories do not present a single counter-narrative, either within or across the blog posts I read. Some posts or comments can be read within the dominant narrative of good mothers whose self-sacrificing efforts produce good children. Yet these blogs routinely complicate and challenge the prevailing notion that mothers are individual entrants in a competition to produce conventionally successful

children. Hyperintensive mothering can be a source of collective pride even when the outcome of such efforts is uncertain. Mommy bloggers risk vulnerability to build community, demand better support from society, and model valuing children for who they are now rather than what they might become. Even variations of sense making within and across blogs reveal that the dominant narrative is arbitrary rather than natural and inevitable.

It is no coincidence that this happens in blogs. By narrating daily life with autism as it unfolds, a blog is well suited to revealing uneven development and uncertain connections between what mothers do and what children become—rough edges that are smoothed over in the hindsight afforded by published memoirs and other types of retrospective accounts. A commitment to posting regularly offers bloggers the opportunity to meander or to dwell on the present, ordinary moment. The storyline composed through daily or weekly narration takes unexpected turns that even if reframed from a later vantage point remain messy in the archive. Some storylines simply peter out without a definitive conclusion. Instead of the normative story of raising children through expected milestones, the structure of blogs and the practices of bloggers yield a different kind of emplotment—one that values the present moment and accepts uncertainty about the future.

Blogs also have a distinctive capacity for community in ways that are particularly well suited to these mothers' experience. Initially, these bloggers did not know other mothers of autistic children, and even if they had, the demands of their hyperintensive mothering could have complicated getting together. The blogosphere connects them with similar others and allows it to happen asynchronously. Other mothers who "get it" provide a supportive audience for counter-narratives. Several mothers have also connected with an autism acceptance movement that flourishes online and that has changed those mothers' views and practices.

Reflecting on what features of blogs facilitate counter-narratives is especially relevant, given the changing landscape of social media platforms and practices. In my original sample of blogs, much has changed. None of them blog as frequently as they once did, and some have stopped altogether. They started when their children were small, when mothers were still coming to grips with an autism diagnosis, and when the newfound connectivity of the blogosphere felt heady and

unprecedented. Some of the blogs have ended with accounts of starting a part-time job or grieving the loss of a beloved parent. Some bloggers have moved to a private platform or a Facebook group. For those whose blogs continue, their now less frequent posts often include information about autism or appeals for autism acceptance, vaccination, social services, humane school policies, or better media coverage.

This trajectory is both similar to and different from what has happened to mom blogs more generally. Like other mom bloggers, those who blog about autistic children have become more concerned about protecting their children's privacy. For them, the issue is not only a concern for their individual child but also a larger concern—that autism not be portrayed in ways that stereotype or perpetuate stigma. The blogs by mothers of autistic children were not overtaken by the lure of advertising that has soured some bloggers and readers on the mom blog genre (Borda 138), but many did find the uncompensated labour of writing essays several times a week hard to sustain, especially as the ease and popularity of social media posting from a phone has overtaken reading and writing webpages on a computer. Blog communities constituted in reciprocal linking and commenting are embedded in a more multifaceted web presence, in which social media may be used for frequent updates and interaction, whereas the blog is a place for extended personal reflections or essays advocating for the view of autism that developed, in part, through the earlier experience of blogging.

The distinctive temporal features of blog narratives and the interactions that occur through and around these narratives are not quite replicated in other platforms that focus on short, ephemeral posts, links, and images. Even if a reader goes to a blog narrative from a link on Twitter or Facebook, or if they discover a blog through Huffington Post or another aggregator, this is a different experience than being a regular follower of a near daily stream of posts on the blog itself. Those who visit from a link on another platform may not be bloggers themselves, and they may not be engaged with a community that has formed around regular readership of that blog. Instead, their shared link, or like, or retweet faces outwards to the reader's own individual social media network. This has the potential to spread a counter-narrative to audiences who may not otherwise see it, but I wonder if it can incubate counter-narratives in the same way a blog-centric community can.

Yet mom blogs persist, particularly among mothers of autistic

children. New blogs have sprung up to fill gaps in my reading list and my long-standing favourites have introduced me to an active community of autistic adults who blog about their experiences. Angela McRobbie invites scholars to theorize how "mediated maternity" promotes a neoliberal version of intensive mothering, focused on individual responsibility and productivity (132). She warns that social media can intensify the self-surveillance that keeps mothers bound to an impossible and exclusive standard of motherhood. There is plenty of that online, but I found there is also fertile ground for counter-narratives and communities of resistance. The non-normative experience of mothering autistic children challenges the connection between hyperintensive mothering and status safeguarding and those who share their stories in blogs can overcome isolation and competition to build communities. Those same communities have the potential to expand and change, as mothers (and readers like me) are introduced to individuals they might not have met in person and ideas they hadn't encountered elsewhere.

Last night, I sat in a room with several hundred parents and teens as we listened to a speaker, whose anecdotes had an uncanny familiarity that brought laughter from parents (and even some grins from the teens). There was a palpable flash of recognition and emotional response as we each realized "Ah! We're not the only ones!" and "I guess we're doing all right." I've had that same experience reading blogs, and if you stick around long enough, the conversations can go deeper than the small talk of similar strangers in an auditorium. The online places we go to find these spaces will continue to evolve and the storytellers and audiences reconfigure as our kids grow up and our own lives change. Still, when we narrate motherhood in community, there is power for personal and political change. It's worth paying attention to the social and technological conditions under which spaces like these can flourish.

Endnotes

1. I refer to "autistics" rather than "children/adults with autism" for several reasons. Although there is variability among the blogs I have studied, those who have written about the use of language have argued passionately for this identity-first language, in part because of their contact with adult autistic self-advocates who prefer this term. For them, "autistic" connotes that neurology is a

fundamental part of identity, a part that might be viewed with pride in much the same way that "woman," "Jewish," or "gay" might be used rather than "person with female gender," "person with Jewishness" or "person with gayness." Person-first language (e.g., "person with diabetes" or "person with cancer") is intended to recognize that an individual is more than or distinct from a disease. Those who prefer to be called "autistic" resist the comparison of autism to disease and the assumption that they could or should be viewed separately from their autism. Autistic communities are by no means monolithic in their preferences for self-reference, but I have been persuaded by some mom bloggers and autistic adults to use "autistic" (see, for example, L. Brown; Clotfelter, "What I'm Reading,"; Sparrow; Wilson, "Person First"; Winegardner).

2. RSS stands for real simple syndication. It provides a way for readers to subscribe to a site and receive notifications when new content is added (e.g., through email). A reader can collate notifications from RSS feeds and display content from subscribed sites in a single portal. This not only helps readers stay current on new material, but can also provide a means of saving posts to read later or tagging particular post for the reader's reference.

3. Wilson does not capitalize the title of her blog or of individual posts.

Works Cited

Altiere, Matthew J., and Silvia von Kluge. "Searching for Acceptance: Challenges Encountered While Raising a Child with Autism." *Journal of Intellectual & Developmental Disability,* vol. 34, no. 2, June 2009, pp. 142–52.

Andy's Mom. "Autism Dog for Andy." *Andy's Story,* 12 June 2015, www.andysstory.com/2015/06/autism-dog-for-andy.html. Accessed 27 Jan. 2017.

Birmingham, Carrie. "Romance and Irony, Personal and Academic: How Mothers of Children with Autism Defend Goodness and Express Hope." *Narrative Inquiry,* vol. 20, no. 2, 2010, pp. 225-45.

Borda, Jennifer L. "Cultivating Community within the Commercial Marketplace: Blurred Boundaries in the 'Mommy' Blogosphere." *The Motherhood Business: Consumption, Communication, Privilege,*

edited by A. T. Demo et al., The University of Alabama Press, 2015, pp. 121-50.

Brown, Lydia. "Person-First Language: Why it Matters (The Significance of Semantics)." *Thinking Person's Guide to Autism.* 30 Nov. 2011, www.thinkingautismguide.com/2011/11/person-first-language-why-it-matters.html. Accessed 24 May 2018.

Brown, Solveig. "Intensive Mothering as an Adaptive Response to Our Cultural Environment." *Intensive Mothering: The Cultural Contradictions of Modern Motherhood,* edited by Linda Rose Ennis, Demeter Press, 2014, pp. 27-36.

Clotfelter, Erin. "Lock Down?" 18 Dec. 2012, *The Slacker Mom,* www.theslackermom.com/2012/12/18/lock-down-2/. Accessed 12 November, 2015.

Clotfelter, Erin. "The one where she talks about autism a lot." 25 Feb. 2013, *Mill City Mom,* www.minnesotamom.com/archives/date/2013/02. Accessed 12 Nov. 2015.

Clotfelter, Erin. "What I'm Reading." 3 Feb. 2015, *Mill City Mom,* www.minnesotamom.com/archives/222. Accessed 31 Jan. 2017.

Ennis, Linda Rose. *Intensive Motherhood: The Cultural Contradictions of Modern Motherhood.* Demeter Press, 2014.

Friedman, May. *Mommyblogs and the Changing Face of Motherhood.* University of Toronto Press, 2013.

Garland-Thomson, Rosemarie. "The Case for Conserving Disability." *Bioethical Inquiry,* vol. 9, 2012, pp. 339–55.

Hays, Sharon. *The Cultural Contradictions of Motherhood.* Yale University Press, 1996.

Hochman, David. "Mommy (and Me)." *The New York Times,* 30 Jan. 2005, www.nytimes.com/2005/01/30/fashion/mommy-and-me.html.

Joy C. "Procrastination." *Who's Learning? Who's Teaching?* 14 Apr. 2013 4overyonder.blogspot.com/2013/04/procrastination.html. Accessed 24 May 2018.

Joy C. "Take Time." *Who's Learning? Who's Teaching?* 9 Mar. 2013, 4overyonder.blogspot.com/2013/03/take-time.html. Accessed 24 May 2018.

Landsman, Gail. *Reconstructing Motherhood and Disability in the Age of "Perfect" Babies.* Routledge, 2009.

Lopez, Lori Kido. "The Radical Act of 'Mommy Blogging': Redefining Motherhood through the Blogosphere." *New Media & Society*, vol. 11, no. 5, Aug. 2009, pp. 729-47.

Mackintosh, Virginia H., et al. "Using a Quantitative Measure to Explore Intensive Mothering Ideology." *Intensive Mothering: The Cultural Contradictions of Modern Motherhood*, edited by Linda Rose Ennis, Demeter Press, 2014, pp. 142-59.

McHenry, Kristen Abatsis, and Denise L. Schultz. "Skinny Jeans: Perfection and Competition in Motherhood." *Intensive Mothering: The Cultural Contradictions of Modern Motherhood*, edited by Linda Rose Ennis, Demeter Press, 2014, pp. 299-312.

McRobbie, Angela. "Feminism, the Family and the New 'Mediated' Maternalism." *New Formations*, vol. 80-81, Nov. 2013, pp. 119-37.

Milkie, Melissa A., and Catharine H. Warner. "Status Safeguarding: Mothers' Work to Secure Children's Place in the Social Hierarchy." *Intensive Mothering: The Cultural Contradictions of Modern Motherhood*, edited by Linda Rose Ennis, Demeter Press, 2014, pp. 66-85.

Morrison, Aimée. "'Suffused by Feeling and Affect': The Intimate Public of Personal Mommy Blogging." *Biography*, vol. 34, no. 1, 2011, pp. 37-55.

O'Callaghan, M. "The Pwd's Progress." 17 Oct. 2012, *Autismum*, autismum.com/2012/10/17/the-pwds-progress/. Accessed 24 May 2018.

Rosa, Shannon. "Apps & Autism: Presuming & Expressing Competence." 11 Oct. 2012, *Squidalicious*, www.squidalicious.com/ 2012/10/apps-autism-presuming-expressing_11.html. Accessed 24 May 2018.

Rosa, Shannon Des Roches. "Autism Acceptance Day 2013: 'What Are You Doing to Make the World More Accepting of Autistics?'" 2 Apr. 2013, *Squidalicious*, www.squidalicious.com/2013/04/autism-acceptance-day-2013-what-are-you.html. Accessed 24 May 2018.

Rosa, Shannon Des Roches. "Autism & Sharing Social Skills Insights." September 22, 2012, *Squidalicious*, www.squidalicious.com/ 2012/09/autism-sharing-social-skills-insights.html. Accessed 26 Feb. 2020.

Rosa, Shannon Des Roches. "Depression & Autism Parenting." 24 Sept. 2012, *Squidalicious,* www.squidalicious.com/2012/09/depression-autism-parenting.html. Accessed 24 May 2018.

Sousa, Amy C. "From Refrigerator Mothers to Warrior-Heroes: The Cultural Identity Transformation of Mothers Raising Children with Intellectual Disabilities." *Symbolic Interaction,* vol. 34, no. 2, Apr. 2011, pp. 220-43.

Sparrow, Max. "Why I Call Myself Autistic." 19 Oct. 2016, *Unstrange Mind.* unstrangemind.com/why-i-call-myself-autistic/. Accessed 24 May 2018.

Wilson, Jess. "about diary of a mom." *a diary of a mom.* adiaryofamom.com/about-2/. Accessed 24 May 2018.

Wilson, Jess. "D Day." *A Diary of a Mom,* 28 Mar. 2012, adiaryofamom.com/2012/03/28/D-Day/. Accessed 24 May 2018.

Wilson, Jess. "looking forward." *A Diary of a Mom,* 2 Jan. 2012, adiaryofamom.com/2012/01/02/looking-forward/. Accessed 24 May 2018.

Wilson, Jess. "their what?" *A Diary of a Mom,* 29 Mar. 2012, adiaryofamom.com/2012/03/29/their-what/. Accessed 24 May 2018.

Wilson, Jess. "person first." *A Diary of a Mom,* 7 July 2012, adiaryofamom.com/2012/07/07/person-first/. Accessed 24 May 2018.

Wilson, Jess. "show and tell." *A Diary of a Mom,* 19 Apr. 2012, adiaryofamom.com/2012/04/19/show-and-tell/. Accessed 24 May 2018.

Winegardner, Jean. "Autistic Is Okay." 4 Oct. 2012, *Stimeyland,* www.stimeyland.com/2012/10/autistic-is-okay.html. Accessed 24 May 2018.

Zoila. "First Time Ever!" *Poly Hobby Mommy,* polyhobbymommy.com. Accessed 18 July 2014.

Chapter Seven

Distressed Caregivers or Criminals? Stories of Precarity and Perceived Maternal Neglect in Chile

Michelle Sadler and Alejandra Carreño

"... their maternal subjectivities (when tested in public and political contexts) entered the space of the unthinkable, of the intolerable, of a less than acceptable performance of motherhood."

Gabriela is an Indigenous Aymara woman who lives in northern Chile.[1] Until the dawn of July 23, 2010, her life was similar to that of many young Indigenous women who followed patterns of constant migration; she spent part of the year in the *altiplano*—highlands of the Andes—working as a llama herder. On this particular day, in the middle of winter, Gabriela was taking care of a herd of llamas near the town of Alcérreca, a small settlement on the border with Bolivia, where migratory pressures had almost completely emptied the old Aymara villages. With no other alternative available for the care of her three-year-old son, Eloy, she took him to work with her, carrying him in an *aguayo* (traditional carrying cloth) throughout the day.

In the evening, as she was returning with the herd and the child, she noticed that two animals had left the herd. Seeing the fatigue in her son and aware of the high cost of losing the animals, she quickly decided to leave the child in the *aguayo*, near the shelter where they slept, and ran to find the animals. Upon returning, Gabriela realized with terror that Eloy was no longer in the *aguayo*. Hours went by, but she was unable to find him. As night fell, she feared that he would not survive the cold of the *altiplano* nights. On the next day, she walked 18 kilometres to the nearest town to find help. She found her former school teacher, who was also Eloy's godfather. He recommended that she seek help at the police station. She usually steered clear of the police, due to a long history of harassment that her people had suffered for being Indigenous. Given the situation, however, Gabriela decided to ask for help. Not surprisingly, given her distress, her description of events was confusing and aroused the suspicion of the police officers. Instead of helping her find her child, they transported her to the nearest city and accused her of child abandonment; she was held in jail for months awaiting trial. Within a few days everyone in Arica knew the face of "the Aymara shepherdess." She was accused of child abandonment and later murder, based on the accounts of police officers and truck drivers who frequented the Aymara *altiplano* where she worked. People who claimed to have met her made declarations in the case, which verified her libertine behaviour and questioned her so-called maternal instincts. Eloy was found dead a year and a half after having gone missing, 18 kilometres away from where Gabriela last saw him.

During the trial, her character, sexual behaviour, emotional expressiveness, and the characteristics of the countryside where she worked were subject to detailed analysis and discussion by experts. In the legal proceedings, carrying a young child in an *aguayo* while shepherding had lost its significance as a tradition of Andean women, which made way for a tale of abandonment, neglect, and danger. Gabriela spent three years in prison, accused of child abandonment resulting in death.

Seven years after Gabriela's son disappeared in the *altiplano*, a mother of Haitian origin by the name of Joane, entered a similar institutional labyrinth after arousing suspicion of guilt and negligence in caring for her baby.[2] The press was all over the case: she was accused of having abandoned her two-month-old daughter in the municipality of Lo Prado, one of the poorest districts of Santiago. To the cameras, Joane's gaze

revealed not only impotence but also absence. She appeared lost, disoriented, and unfamiliar with the world around her; it was a world she had only known for a few months that ultimately took her baby away in a matter of minutes. A reconstruction of the story emerged in small fragments during the days that followed the event. Joane, alongside her husband Wilfred, had moved less than a year previously to Chile from Haiti, seeking a better future for their family. Upon arrival to the country, they moved into a room in a domestic space shared by Haitians who formed networks to find work. At the time, Joane was pregnant and did not speak Spanish. She tried to learn what she could in the sporadic contacts she established with neighbours and other people.

On August 30, 2017, just months after the baby was born, a man approached Joane with a job offer for her husband in the Office for the Protection of Child Rights of the Municipality. She eagerly informed her husband, and he immediately went to the office, but he was unable to verify the job offer. Amid the chaos, his family documents were stolen from him. After finding out what had happened, Joane returned to the office with her baby to report the events. She was unsuccessful in establishing communication with the security guard. In her desperation, she asked the guard to care for her baby and ran to find fellow Haitians with a better command of Spanish. She crossed the street where Haitians worked at a construction site but found no assistance, so she ran home to find help. She returned for her baby fifteen to twenty minutes later without having located a translator to explain the situation. While she was gone, a complaint was lodged against Joane for alleged abandonment of a minor. Upon her return, she was arrested and her baby was sent to the state's child protection service.

Until this point, Joane's arrest seemed to be a dramatic misunderstanding, but the situation grew worse over the weeks to come. She remained under arrest, and without his family documents, Wilfred was unable to retrieve their daughter from child protection. Fifteen days later, Joane was sent to medical services for alleged self-inflicted injuries, as she had been beating her head against walls in her confusion and despair. The injuries were not deemed life threatening, but the gravity of the situation as a whole attracted the attention of several organizations who sought to resolve the case. Her health deteriorated, and on September 30, 2017, Joane died. Her death left an open case of child abandonment and immense conflict among the Haitian community in Chile.

Human rights organizations have not ruled out police abuse as the cause of Joane's death. It is possible that police violence escalated during her incarceration, resulting in critical injury to this migrant woman, who according to those who knew her, loved and cared for her daughter immensely.

Territories of Care as Territories of Crime

The decisions of these two women were interpreted as criminal acts of abandonment. Under what circumstances did these children go from being recipients of maternal care to being considered victims of their mothers' neglect? In both cases, available information confirms the effort both women took to care for their children. Gabriela's former teacher—Eloy's godfather—testified in favour of Gabriela during the trial, confirming that she was desperate and trying to find help. Joane had established ties with her Chilean neighbours, joining them on trips to the market and sharing recipes she prepared for her daughter. Isabel, one of her neighbours, saw Joane weave clothes affectionately for the baby before she was born; she became the girl's godmother. According to her account, Joane and Wilfred were caring parents to their baby girl. Making decisions that did not fully adhere to motherhood as constructed in policy and public opinion, both Gabriela and Joane were quickly judged as negligent mothers.

Many changes have been made to public Chilean health policy during the twentieth century to reduce infant mortality. In essence, the state became the guarantor of child welfare. The Maternal and Child Health Program of the National Health Service, created in 1952, focused its attention on the education of mothers. Professionals were trained to better understand the population as well as to ensure that interventions were meaningful and appropriate. Mothers were viewed as instrumental in guaranteeing the survival of children (Zárate). Policies focused on nourishing bonds between nurses and mothers in order to educate them to (better) care for their children through the promotion of their love for their children. The key instrument for success was the institutional-ization of systematic and periodic health controls for pregnant mothers, infants, and children (Zárate).

These policies are part of what Maribel Blázquez and María Jesus Montes identify as the "maternalization of mothers": the incorporation

during the twentieth century of an instructive ideology that teaches women to develop behaviours and technical knowledge regarding the successful exercise of motherhood, advanced mainly by health institutions (82). Following Carol Smart, "these rules can be seen in Foucauldian terms as the calibrations of good motherhood. Initially they covered mainly physical matters of diet, warmth, immediate environment, and physical development. Later these calibrations were extended to include the immense realm of the psychological care and nurture of the child" (46). Thus, the mother would be deemed inadequate if she failed to love and to express this love properly.

The centrality of the mother's bond, as was promoted by the Maternal and Child Health Program of the National Health Service since the 1950s, was consistent with tenets of attachment theory (Ainsworth; Bowlby), which would dominate the discourse concerning the mother-child relationship in the decades to follow. This theory, grounded in Western lifestyles, set standards for what constitutes healthy relationships for humans; it argued that all children develop attachment relationships in the same way and all attachment relationships serve the same purpose (Morelli). Specific behaviours that foster security in children were and still are outlined with the primary caregiver, usually the biological mother, who is considered to be the main protector of the child's development.

Despite cultural critiques of attachment theory, particularly its lack of attention to the interplay of cultural and ecological processes (Morelli), it continues to be the universal standard of good care in Chile. The theory consolidates the figure of the nourishing mother at the centre of its action and prioritizes the best interests of the minor (Morelli et al.; Murray). Attachment theory continues to be central in the current Integrated Child Protection System "Chile Crece Contigo" (Chile Grows with You), which serves as the basis for current policy and law on child rearing in the country (Murray; Rosabal-Coto et al.).

Ultimately, Gabriela's and Joane's behaviours didn't conform to normative maternal care practices. Their cases challenged what the state defines as the best interest of the child in light of diverse cultural origins and interpretations of what constitutes adequate care. The *altiplano*, where Gabriela and her community have lived for millennia, is viewed as a threatening environment. Certain landscapes and practices linked to them are associated with marginalized groups such as the Aymaras,

who have historically been associated with a wild and primitive life (De la Cadena). Psychologists, police officers, and even geographers constructed a narrative of danger and neglect, which was represented by the desert and in the presumption of primitivism that lay behind Gabriela's behaviour. They were called by the prosecution to verify the absence of "normal emotions for a mother who has lost a child"[3] and the danger of a geographical landscape "inhabited by ferocious animals."[4] As a result of projective psychological tests, Gabriela was presented as a woman with a "flat personality," "incapable of expressing emotions," and "not very collaborative."[5] These testimonies were more convincing than those of the experts in the Aymara culture, who tried to situate the case in the context of the cultural differences between the Aymara and Western conceptions of adequate care. Cultural patterns of socialization—that is, the cultural and ecological processes that give shape to differential childrearing practices—were shadowed by scientific proof of a deviant motherhood.

Her reported "lack of emotion" and "lack of maternal instinct" in the wake of her child's death was not given any cultural context. The normalization of infant mortality in contexts of extreme poverty has been widely discussed in contexts such as Brazil and Senegal. Nancy Scheper-Hughes and Doris Bonnet have described the psychological complexity at the centre of what has been called "social neglect" by mothers who seem willing to let children die who are incapable of surviving the harsh living conditions in contexts of poverty. Blunted emotion is viewed as an element of a psychology of survival in such contexts (Scheper-Hughes; Bonnet).

In 2010, during the first oral trial against Gabriela, the Public Prosecutor's Office claimed in the opening statement that she did not fulfill her obligation as a mother, as the "guarantor of the safety of her son," that her acts were "against the laws of nature," and that she challenged "the roles that go with the genetic and biological content of a mother" (Galaz). The laws of nature could be interpreted as maternal instinct, which has been strongly contested by feminist scholars as inherently natural or feminine. But it is a cultural presumption that has led to the generalized tendency to associate the physiology of women with particular expectations for the emotions and behaviour of mothers (Moore).

Joane's and Gabriela's cultural forms of care and providing security were quickly called into question and criminalized: leaving their children

alone was not interpreted as a desperate act in a moment of emergency but as the materialization of negligent motherhood. As a result, their maternal subjectivities (when tested in public and political contexts) entered the space of the unthinkable and the intolerable—a less than acceptable performance of motherhood. Consider Ranciere's description of the "police logic": the processes by which powers are organized and places and social functions are distributed as well as the mechanisms of legitimization of that organization and distribution (43). In these cases, both women were considered to transgress the natural laws of social order ("the laws of nature," as suggested by the Prosecutor's Office) through actions that evidenced conceptions of child care or risk assessment rooted in alternative cultural contexts. Their decisions regarding the security of the space where they would temporarily leave their children, in a moment of emergency, positioned them as criminals. It is within this context that the traditional activity of herding in a landscape inhabited by Indigenous populations since pre-Columbian times crosses the threshold from normal to criminal.

In both cases, the mother's negligence and guilt are constructed from the presumed truth of scientific discourse; however, Joane's story is different from Gabriela's. Hers is a story marked by the impossibility of establishing dialogue, which further accentuates the tragic events that unfold. Joane's narrative takes place in a context of urban marginality, in a district with the highest rates of poverty and segregation in the city. Joane is rendered more vulnerable due to her Afro-descendant origin as well as her newness to the neighbourhood. As Chile is a country greatly determined by the social and economic relations drawn by the neoliberal context, "Haitian migration has adapted to an economic system that broadens or contracts, according to the needs of the moment, the number of individuals available for the worst paid and less rewarding tasks in a specific spatio-temporal area" (Balibar and Wallerstein 56-57). Among immigrants in the country, those of Haitian origin assume the most despised jobs by the national and international labour force. As a country with a recent and low presence of Afro-descendants, Chile includes these inhabitants in a racialized map of social classification, in which factors such as skin color and language constitute enormous barriers to labour insertion and have created important social tensions within the marginal sectors of society. As a result, racism resurfaces (Rojas Pedemonte et al.), and racial hierarchies as well as forms of exclusion

and oppression become increasingly justified.

Joane experienced racism in the way her trust of public space was interpreted and in the immediate suspicion of her actions. In leaving her daughter with a security guard for just a few minutes, while running for help, she transgressed accepted ideas concerning the use of public space in contemporary cities. This distrust of public space, which led to the perception of Joane's maternal neglect, contrasts with the collective sense of responsibility that characterizes childrearing practices in Haitian culture.

Joane belongs to a culture in which the *lakou* system prevails, where people work cooperatively with a strong sense of mutual responsibility among the community that extends to childrearing practices (Yanique et al.). This model has been instrumental in overcoming the numerous crises that have affected the country (Miller). Joane's main transgression was applying her Haitian cultural knowledge in a migratory context that defined her behaviour as negligent. Paradoxically, efforts to change practices that are considered problematic according to Western standards "alter social dynamics and disrupt family or community life, or even increase the likelihood of exposing children to dangers from which they would otherwise be protected by their community's care practices" (Morelli et al. 7). The consequences of such cultural distortion can be seen in the senseless fact that Joane's baby was taken away from loving parents and into child protection services in an effort to protect her.

Precarity

In the stories we have shared, the state conspires against the provision of a mother's care by criminalizing the actions of Gabriela and Joane. In both cases, the precariousness of their living conditions and their cultural differences were overshadowed by hegemonic discourses of "positive parenting practices that are based on caregiving in Western societies" (Morelli et al. 7).

As evidenced by various studies on social marginality, the concept of precarity has come to mean "the politically induced condition in which certain populations suffer from failing social and economic networks ... becoming differentially exposed to injury, violence, and death" (Butler i). If we understand social existence as a system of interdependencies in which institutions and the global context define the place of subjects in

the world, the precariousness of Gabriela and Joane is demonstrated in those moments when their maternal decisions are culturally misunderstood and, therefore, criminalized.

Since the mid-twentieth century, the Chilean state has implemented policies that promote the wellbeing of children through measuring maternal actions against standards of care grounded in Western theories of psychology and development. These narrow standards run the risk of creating situations of vulnerability and precariousness in families that transgress the Western norm, placing childrearing in cultural contexts that are racially unauthorized, as is the case of Indigenous or migrant mothers. Current studies warn of the harmful effects that the implementation of standardized child protection systems have on contexts that are increasingly multicultural (Morelli et al.).

When Gabriela regained her freedom in June 2012, she immediately visited the grave of her son. It is likely that she will always be viewed as that Aymara shepherdess who abandoned—or even murdered—her child.

Joane's husband recovered his daughter from social services in late October 2017. One month later, the court hearing Joane Florvil's case decreed that she did not commit the crime of abandoning her daughter and ordered the case's dismissal.[6]

Acknowledgments

The authors would like to thank Patricia Núñez for her comments. AC thanks the researchers from the Frantz Fanon Center in Italy for their inspiring work with migrant families and their comments on the case of Gabriela. MS acknowledges the insights gained from her participation in the project COST Action IS1405: "Building Intrapartum Research through Health: An Interdisciplinary Whole System Approach to Understanding and Contextualising Physiological Labour and Birth (BIRTH)."

This article was written as part of the research project "Philosophy of Birth: Rethinking the Origin from Medical Humanities (PHIL-BIRTH)," (FFI2016-77755-R), Program for Research, Development and Innovation Oriented to Societal Challenges, Ministry of Economy in Spain, 2016-19, (AEI/FEDER/UE).

Endnotes

1. Gabriela's case is constructed from the trial for the disappearance of the child. Oral Criminal Trial, Arica. 15 April, 2010, N. RUC 0710014873-5; the trial for the adoptability of her daughter, Oral criminal Trial, Arica. N. RIP A16, 2007; Galaz.

2. The case is constructed from the following press descriptions: "El mes de injusticia que apagó la vida de la haitiana Joane Florvil en Chile" and "INDH estudia acciones legales por muerte de ciudadana haitiana."

3. Declaration of a police officer during the oral criminal trial. Arica. April 15, 2010. N. RUC 0710014873-5.

4. Declaration of a military geographer during the oral criminal trial. Arica. April 15, 2010. N. RUC 0710014873-5.

5. Declarations from psychological expert testimony.

6. Extracted from the press: "Muerte de Joane Florvil: Tribunal decreta que ciudadana haitiana no cometió el delito por el que fue detenida", and "Detalles del emotivo encuentro entre la hija de Joane Florvil y su padre."

Works Cited

Ainsworth, Mary D. S. "The Development of Infant-Mother Attachment." *Review of Child Development Research* 3, edited by B. Cardwell and H. Ricciuti, University of Chicago Press, 1973, pp. 1-94.

Balibar, Etienne, and Immanuel Wallerstein. *Raza, nación y clase.* IEPALA, 1991.

Blázquez, Maribel, and María Jesus Montes. "Emociones ante la maternidad: de los modelos impuestos a las contestaciones de las mujeres." *Ankulegi*, vol. 14, 2010, pp. 81-92.

Bonnet, Doris; Purchez, Laurence; "Introduction", *Du soin au rite dans l'enfance*, ERES: Toulouse, 2007, pp. 11-39.

Bowlby, John. *Attachment. Attachment and loss: Vol. 1. Loss.* New York: Basic Books, 1969.

Butler, Judith, "Performativity, Precariety and Sexual Politics." *Revista de Antropología Iberoamericana*, vol. 4, no. 3, 2009, pp. i-xiii.

De la Cadena, Marisol. *Indigenous Mestizos: The Politics of Race and Culture in Cuzco, Peru, 1919–1991.* Duke University Press, 2000.

"Detalles del emotivo encuentro entre la hija de Joane Florvil y su padre." *El Mostrador,* 5 Nov. 2017, www.elmostrador.cl/braga/2017/11/05/detalles-del-emotivo-encuentro-entre-la-hija-de-joane-florvil-y-su-padre/. Accessed 24 Feb. 2020.

"El mes de injusticia que apagó la vida de la haitiana Joane Florvil en Chile." *El Desconcierto,* 6 Oct. 2017, www.eldesconcierto.cl/2017/10/06/el-mes-de-injusticia-que-apago-la-vida-de-la-haitiana-joane-florvil-en-chile/. Accessed 24 Feb. 2020.

Galaz, Gabriel. "La historia no contada de la pastora aymara condenada por extraviar a su hijo," *Ciper Chile,* 1 Jun. 2012. //ciperchile.cl/2012/06/01/la-historia-no-contada-de-la-pastora-aymara-condenada-por-extraviar-a-su-hijo/. Accessed 24 Feb. 2020.

"INDH estudia acciones legales por muerte de ciudadana haitiana." *Instituto Nacional de Derechos Humanos,* 2 Oct. 2017, www.indh.cl/indh-estudia-acciones-legales-muerte-ciudadana-haitiana-estaba-detenida-hospitalizada/. Accessed 24 Aug. 2020.

Miller, James. "Redefining the Lakou: The Resilience of a Vernacular Settlement Pattern in Post-Disaster Haiti." Thesis, University of Oregon, 2013, scholarsbank.uoregon.edu/xmlui/handle/1794/13002. Accessed 24 Feb. 2020.

Moore, Henrietta. *Antropología y feminism.* Cátedra, 1996.

Morelli, Gilda, et al. "Ethical Challenges of Parenting Interventions in Low to Middle Income Countries." *Journal of Cross Cultural Psychology,* vol. 49, no. 1, 2018, pp. 5-24.

Morelli, Gilda. "The Evolution of Attachment Theory and Cultures of Human Attachment in Infancy and Childhood." *Handbook of Human Development and Culture: An Interdisciplinary Perspective,* edited by L.A. Jensen, Oxford University Press, 2015, pp. 149-64.

"Muerte de Joane Florvil: Tribunal decreta que ciudadana haitiana no cometió el delito por el que fue detenida." *El Mercurio Online,* 22 Nov. 2017, www.emol.com/noticias/Nacional/2017/11/22/884472/Muerte-de-Joane-Florvil-Tribunal-decreta-que-ciudadana-haitiana-no-cometio-el-delito-por-el-que-fue-detenida.html. Accessed 24 Feb. 2020.

Murray, Marjorie. "Childbirth in Santiago de Chile. Stratification, Intervention and Child Centeredness." *Medical Anthropology Quarterly*, vol. 26, no. 3, 2012, pp. 319-37.

Rancière J. *El desacuerdo.* Nueva Visión, 1996.

Rojas Pedemonte, Nicolás, et al. "Racismo y matrices de 'inclusión' de la migración haitiana en Chile: elementos conceptuales y contextuales para la discusión." *Polis*, vol. 14, no. 42, 2015, pp. 217-45.

Rosabal-Coto, Mariano, et.al. "Real-World Applications of Attachment Theory." *The Cultural Nature of Attachment: Contextualizing Relationships and Development,* edited by Heidi Keller, and Kim A. Bard, MIT Press, 2017, 335-54.

Scheper-Hughes, Nancy. *Death without Weeping: The Violence of Everyday Life in Brazil.* University of California Press, 1992.

Smart, Carol. "Deconstructing Motherhood". *Good Enough Mothering? Feminist Perspectives on Lone Motherhood*, edited by E.B. Silva, Routledge, 1996, pp. 37-57.

Yanique, Edmond, et al. "The Lakou System: A Cultural, Ecological Analysis of Mothering in Rural Haiti". *Journal of Pan African Studies*, vol. 2, no. 1, 2007, pp. 19-32.

Zárate, María Soledad. "Señora, su hijo no va a morir: enfermeras y madres contra la mortalidad infantil, Chile, 1950-1980." *Rastros y gestos de las emociones. Desbordes disciplinarios*, edited by Antonia Viu et al., Cuarto Propia, 2017, pp. 163-98.

Reclaiming Motherhood
as Readers and Writers

Chapter Eight

Redemptive Mothering: Reclamation, Absolution, and Deliverance in Emma Donoghue's *Room* and *The Wonder*

Andrea O'Reilly

"... the shadowy secret behind the miracle is precisely the redemptive power of mothering ... an empowered practice of resistance and salvation for children and mothers."

In her review "Shadowy Secrets behind a Proclaimed Miracle," Arlene McKanic asks, "Is Emma Donoghue cultivating a new genre? Call it emergency motherhood. Like her 2010 bestseller *Room*, Dononghue's ninth novel (*The Wonder*, 2016) features a woman whose existence is bent around the life, health, and happiness of a child whose circumstances are desperate"(1). In this chapter, I consider how Donoghue's two novels *Room* and *The Wonder* perform "emergency motherhood" by positioning mothering specifically as a redemptive practice. I further explore how maternal practice in *Room* and *The Wonder* achieve reclamation, absolution, and deliverance to perform emergency motherhood, as observed by McKanic. Redemption refers

to both *reclamation*—the action of regaining or gaining possession of something in exchange for payment or for clearing a debt—and *absolution*—the action of saving or being saved from sin, error, or evil. In *Room*, redemption is enacted through reclamation: Ma reclaims the maternal authenticity of her maternal practice as well as her close bond with her son. In *The Wonder*, Rosaleen also seeks redemption but not through reclamation of the mother-child relationship; rather, she seeks it through absolution to save her daughter and son from incest. In other words, for Ma, redemption means the repossession of her relationship with Jack, whereas for Rosaleen, it means saving her children from the sin of incest. In *The Wonder*, redemption also assumes another meaning and practice—that of *deliverance*. *The Wonder* opens with Rosaleen's redemptive attempt at salvation for her daughter and concludes with Lib saving Anna through the redemptive act of deliverance.

Indeed, what this chapter argues—to unpack the title of McKanic's review—is that the shadowy secret behind the miracle is precisely the redemptive power of mothering. More specifically, the chapter contends that in being redemptive, mothering emerges as empowered practice of resistance and salvation for children and mothers.

"All Those Years, I Kept Him Safe": Redemption as Reclamation in *Room*

In a 2010 interview, Emily Donoghue comments, "*Room* is a universal story of parenthood and childhood, and in Jack and Ma's relationship I wanted to dramatise the full range of extraordinary emotions parents and children feel for each other: to put mothering in a weird spotlight and test it to its limits" ("On Room"). In another interview, she elaborates, "I tried to take the common or garden experience of parenting and just by isolating it under a spotlight, I tried to bring out the true, crazy drama of parenting" ("In Donoghue's Room"). The novel *Room*, to use Donoghue's words, seeks to examine "an extraordinary act of motherhood" (qtd. in Ue) through what she terms "a defamiliarisation of ordinary parenthood" (qtd. in Crown). Using feminist philosopher Sara Ruddick's theory of maternal practice, this section explores how Donoghue, in making the commonness of motherhood extraordinary, positions Ma's mothering as both redemptive and resistant. More specifically, the section analyzes Ma's performance of the three demands

of maternal practice as theorized by Ruddick, in both captivity and freedom, and considers how her strategies of preservation and care—in particular her commitment to keep her son with her in Room, her close bond with her son, and her act of extended breastfeeding—are reconstructed as bad mothering upon her escape. Keeping her son is read as maternal selfishness and her bond and breastfeeding are read as violations of social acceptability, particularly for a male child. The section argues that only when Ma reclaims what Ruddick terms the "maternal authenticity" of her maternal practice in Room are she and her son able to reclaim their connection and achieve healing.

Sara Ruddick argues that maternal practice is characterized by three demands: preservation, growth, and social acceptance. "To be a mother," continues Ruddick, "is to be committed to meeting these demands by works of preservative love, nurturance, and training" (17). The first duty of mothers is to protect and preserve their children: "to keep safe whatever is vulnerable and valuable in a child" (80). "Preserving the lives of children," Ruddick writes, "is the central constitutive, invariant aim of maternal practice: the commitment to achieving that aim is the constitutive maternal act" (19). "To be committed to meeting children's demand for preservation," Ruddick elaborates, "does not require enthusiasm or even love; it simply means to see vulnerability and to respond to it with care rather than abuse, indifference, or flight" (19). "The demand to preserve a child's life is quickly supplemented," Ruddick continues, "by the second demand, to nurture its emotional and intellectual growth" (19). Ruddick explains:

> To foster growth ... is to sponsor or nurture a child's unfolding, expanding material spirit. Children demand this nurturance because their development is complex, gradual, and subject to distinctive kinds of distortion or inhibition... Children's emotional, cognitive, sexual, and social development is sufficiently complex to demand nurturance; this demand is an aspect of maternal work ... and it structures maternal thinking. (83)

The third demand of maternal practice is training and the social acceptability of children:

> [The demand] is made not by children's needs but by the social groups of which a mother is a member. Social groups require that mothers shape their children's growth in "acceptable" ways.

What counts as acceptable varies enormously within and among groups and cultures. The demand for acceptability, however, does not vary, nor does there seem to be much dissent from the belief that children cannot "naturally" develop in socially correct ways but must be "trained." I use the neutral, though somewhat harsh, term "training" to underline a mother's active aims to make her children "acceptable." Her training strategies may be persuasive, manipulative, educative, abusive, seductive, or respectful and are typically a mix of most of these. (21)

"In any mother's day," as Ruddick notes, "the demands of preservation, growth and acceptability are intertwined." "Yet a reflective mother," she continues, "can separately identify each demand, partly because they are often in conflict" (23).

The demands of maternal practice—preservation, nurturance, and training—are fully enacted and accomplished by Ma, despite her confinement in Room. Ma is, as Donoghue remarks, "a young resourceful mother. She really civilizes and humanizes Jack; he's not a feral child. She passes on her cultural knowledge to him, from religion to toothbrushing to rules" (qtd. in Wyrick). Indeed, throughout their five years of captivity, Ma commits to the preservation, nurturance, and training of Jack. She sets time limits on television viewing (11), ensures that Jack gets physical exercise (15), and teaches her son reading, spelling, and math through both play (measuring the room, cards, and games) and lessons. She also disciplines and nurtures Jack to foster his social and emotional development. In an interview, when Ma is asked about Jack and his childhood in captivity, she explains: "He's just spent his first five years in a strange place, that's all. It wasn't an ordeal to Jack, it was just how things were" (236). It is, however, with the first duty of protection and preservation that Ma most fervently enacts maternal practice. It was, as Ma explains later in her media interview, "all about keeping Jack safe" (233). When Ma gives birth to Jack, she does not let Old Nick into Room after he refused to help when her first baby died in childbirth. With the birth of Jack, as she explains, "I was ready; this time I wanted it to be just me and you" (206). For his first five years in captivity, Jack only sees Old Nick "through the slats (of the wardrobe) some nights but never all of him close up" (26). One night, Jack leaves the wardrobe not knowing Old Nick is in Room, and upon seeing Jack, Old Nick says, "Hey sonny." "Ma," Jack tells us, "is louder than I ever

heard her even during Scream 'Get away, get away from him!'" (74). When Jack is back in the wardrobe, he hears Ma say to Old Nick, "I can be quiet. You know how quiet I can be, so long as you leave him alone. It's all I've ever asked" (74). Later, when the interviewer asks Ma, "You must feel an almost pathological need—understandably—to stand guard between your son and the world?" Ma responds with a snarl, "Yeah, it's called being a mother" (236). And earlier in the same interview, Ma explains, "All I did was I survived, and I did a pretty good job of raising Jack. A good enough job" (235). Indeed, as Ma says to Dr. Kendrick, "All those years, I kept him safe" (167).

The methods used by Ma in her maternal practice to provide this comfort and security to Jack are then questioned and criticized by characters in—as well as readers of—the novel, which include Ma's extended breastfeeding of Jack and her close relationship with him. The novel opens with Ma breastfeeding Jack on his fifth birthday, and although Ma suggests that "Maybe we could skip it once in a while, now you're five," Jack responds, "No way José" and "[they lie] down on the white of Duvet and [Jack has] lots" (6). Although Ma's breastfeeding of Jack has been commented on in reviews of the novel, commentators have not considered how breastfeeding in the novel functions specifically as an act of both nurturance and preservation. Ma nurses to console and calm Jack when he is distressed or troubled—when he is disturbed by the marks on Ma's neck from Old Nick (56); when he cannot fall asleep after one of Old Nick's visits (66); when he becomes upset as Ma seeks to describe the outside world (85); and when Ma explains their plan to escape and she assures him that he has the superpowers to do it (105, 109). Along with emotional nurturance, breastfeeding also aids and sustains Jack's physical wellbeing. In captivity, the nutritious foods, sunshine, and physical exercise required for a child's health are not available, nor are medicine and doctors. Indeed, Ma's extended breastfeeding, and the nutrients that it provides, has kept Jack healthy throughout his years in captivity; it is a remarkable achievement for a child to have never become ill in their first five years of life. Ma breastfeeds Jack because in captivity that is how she can fulfill the necessary work of nurturance and preservation required for her son's physical survival and emotional wellbeing. So later in the text, when Ma's mother asks, "You don't mean to say you're still ...," Ma responds before the question is complete and answers, "There was no reason to

stop" (215). Following their escape, however, Ma's breastfeeding of Jack is seen not as a commendable strategy of emotional and physical care but as a violation of appropriate mothering. Ma initially seeks to counter and contest this interpretation of her breastfeeding. She challenges, for example, a police officer by asking the female police captain, "Is there a problem? ... Then why is she staring at us? ... I'm nursing my son, Is that OK with you, lady?" (161). Later, when the interviewer says, "You breastfed him. In fact, this may startle some of our viewers, I understand you still do?" Ma responds with a laugh: "In this whole story, that's the shocking detail?" (233). For Ma, breastfeeding her son was the right and appropriate thing to do, but it is not until the conclusion of the novel, as will be discussed below, that Ma can reclaim this act of preservative love from the judgment of others. Until then, in the words of Jack, "In Outside, they don't know about having some, it's a secret. (161).

Just as Ma's extended breastfeeding is viewed with suspicion, if not outright hostility, by characters and readers alike so too is the close and intimate relationship of Ma and Jack, particularly because he is a male child. In her article, "'Room' is the 'Crash' of Feminism," Sarah Blackwood writes "the metaphor of room/womb ... tracks our culture's rose-tinted view of the mother/infant bond, while allowing readers the satisfaction of judging the perversity of that bond when it ... inches into the excessive" (2). "Once outside Room," Blackwood continues, "Ma shrivels ... because she is no longer the sole nourisher of her son [while] Jack must peel himself from a Ma who can't stop taking baths with him" (2). Although Blackwood concedes that the novel is empathetic to the bond's importance, she goes on to assert "that [the depiction of their bond is] ultimately just reproductive of tired gendered messages about motherly sacrifice and childish narcissism" (2). Confined together in a eleven by eleven foot room for five years, Jack and Ma's Room may be read metaphorically as a womb that represents, in Blackwood's words "the deep primal bond between mother and child" (2). I argue, however, that this bond is not pathological or even restrictive as Blackwood argues, but it is rather a redemptive space and one that creates a reciprocal connection of empowerment for both mother and son.

There are many examples, both in captivity and freedom, of Ma and Jack's symbiotic identification and connection. Thinking about the spider web he has not shared with his mother, Jack comments: "It's weird to have something that's mine-not-Ma's. Everything else is both

of ours" (10). When Ma tells Jack her name for the first time, Jack says "My tummy hurts, I don't like her to have other names that I never even knowed" (117) During his escape, Jack cannot speak because, as he explains *Ma, Ma, I need you for talking.* She's not in my head anymore" (142). Later, the doctor asks Jack, "Do you know who you belong to?" and he answers "yourself." Jack thinks, "He's wrong, actually, I belong to Ma" (209). And when Ma asks Jack to be gentle with her present from Paul, her brother, Jack reflects, "I didn't know it was hers-not-mine. In Room everything was ours" (220). Although Jack and Ma are certainly closely connected, their bond, as portrayed in the novel, is not disparaged, as Blackwood suggests, nor is it romanticized. As Donoghue comments, "Lots of people have called the book a celebration of mother-child love, but it's really more of an interrogation. I never had Ma and Jack say 'I love you.' I wanted to conjure up that love but not have big soppy pools of it lying around. Love is what is saving them both, yes, but there are problems to it" (qtd. in Crown).

Indeed, there are several scenes of disagreement between mother and son in both captivity and freedom. Jack, for example, remembers the three fights they had over three days: "one about the candles and one about Mouse and one about Lucky" (42). One time, Jack remarks, "I wish we got those special boxing gloves for Sunday treat so I'd be allowed hit her" (115). In my view, it is ultimately and precisely their trust in, and familiarity with, each other that enables them to plan and execute their successful escape. Ma knows and trusts that Jack can hide in and free himself from "Rug" because of her confidence and trust in him. Their bond gives them the courage and strength to escape and, ultimately, to survive and thrive in freedom. Moreover, as Jack and Ma's connection is reciprocal in the agency it affords to each of them, this reciprocity still allows for Ma's authority as mother. As Ma roars to Jack, "I'm your mother. That means sometimes I have to choose for both of us" (115). Ma also asserts that "I brought you here, and tonight I'm going to get you out" (128).

The intimacy of their connection becomes pathologized in freedom by characters and readers alike, particularly because Jack is a male child. The assumption in patriarchal culture is that boys, as scripted by the Freudian Oedipal scenario, must gradually withdraw and distance themselves from their mothers as they grow into manhood. A close and caring relationship between a mother and a son is pathologized as

aberrant, whereas a relationship structured upon separation is natural-
ized as the real and normal way to experience mother-son attachment.
Olga Silverstein and Beth Rashbaum explain:

> [Our culture believes] that a male child must be removed from
> his mother's influence in order to escape the contamination of a
> close relationship with her. The love of a mother—both the son's
> love for her, and hers for him—is believed to "feminize" a boy,
> to make him soft, weak, dependent, homebound ... only through
> renunciation of the loving mother, and identification with the
> aggressor father, does the ... boy become a man. (11)

Thus, the central and organizing premise of patriarchically mandated
mother-son separation is that separation is both natural and good for
sons. In other words, Western culture sees mother-son separation as
both inevitable and desirable.

In *Room*, Jack's long hair is read as a symbol of this feminization,
which his close relationship with Ma has engendered. Jack's long hair
causes people to think he is a girl, as when the man asks Old Nick, "Is
your little girl OK? (141). Later when Jack is in the mall with Uncle Paul,
a woman asks if Jack is his daughter because of "[his] long hair and Dora
bag" (244). According to critics, such as Blackwood, who regard mother
and son intimacy as emasculating to sons, Jack must, in her words, "cut
the hair that feminized him and kept him tied to his mother like an
umbilical cord" (2). I argue that their closeness is not problematic, but
it is, instead, how the outside world misreads their connection as
restrictive and ruinous that is problematic, especially since for the two
of them, it is both redemptive and resistant.

The third and final way that both characters and readers misconstrue
Ma's maternal practice as deleterious and damaging to Jack is in their
interpretation of Ma's decision to keep Jack with her in Room as a selfish
and an irresponsible act. On his fifth birthday, Jack says to Ma, "You
were sad till I happened in your tummy," to which Ma responds, "I cried
till I didn't have any tears left" (3). Later, when Ma tells Jack about her
abduction and time in Room before he was born, she says, "when I was
asleep was the only time I wasn't crying, so I slept about sixteen hours
a day" (94), and later, she tells him, "I brought you into Room, I didn't
mean to but I did it and I've never once been sorry" (128). Ma says
something similar in the television interview: "Jack was everything.

I was alive again, I mattered" (233). The birth of Jack gives purpose to Ma's life in Room and enables her to endure captivity through his love and their companionship. Indeed as Donoghue comments: "It is a nightmare for Ma, but she's managed to create an idyll for Jack within it, so she benefits too. She gets to escape from her situation by entering into this fantasy that they live in this world of only two people. In a way, they are their own society" (qtd. in Wyrick).

When the interviewer asks Ma, "Did you ever consider asking your captor to take Jack away?" Ma responds, "Why would I have done that?" The interviewer answers: "Well, so he could be free ... It would have been a sacrifice of course—the ultimate sacrifice—but if Jack could have had a normal, happy childhood with a loving family?" (237). Ma responds, "He had a childhood with me, whether you'd call it *normal* or not" (237). After this, Jack tells us that "Ma's got tears coming down her face, she puts her hands to catch them ... and [Jack] gets to Ma and wrap[s] her all up" (238). In her article "Am I Not OK?," Lucia Lorenzi argues that "by the end of the scene, it becomes clear that is not necessarily Ma's trauma that pushes her to the point of emotional breakdown, but rather the trauma induced by the interviewer's violent attempts to shape, control, and manipulate Ma's narrative" (11). I suggest, more specifically, that it is the discourse of normative motherhood that distorts and perverts Ma's maternal narrative of reciprocal mother-child love as self-interested and negligent. Normative motherhood assumes and dictates an asymmetrical relationship between mother and child: a mother is for the child, not the child for the mother. But with Ma and Jack, their relationship is truly reciprocal; Ma needs Jack as much as Jack needs Ma. Because this reciprocity violates the roles and rules of normative motherhood, Ma is deemed a bad mother in her decision to keep Jack with her in captivity. Ma's emotional breakdown and suicide attempt are triggered not only by this judgment of her mothering, as Lorenzi argues, but, more accurately by Ma's reassessment of her maternal practice from the perspective of this judgment and the subsequent self-blame and guilt she feels. It is only when Ma reclaims her maternal authenticity as practiced and honoured in Room that she can heal and reconnect with Jack to form a reciprocal bond of redemption and empowerment in freedom. To this discussion, I now briefly turn.

Sara Ruddick argues that the rival claims of maternal practice become pronounced when they involve the third demand of training. For most

mothers, Ruddick writes, "the work of training is confusing and fraught with self-doubt" (104). Ruddick's discussion of the central and pivotal concept of inauthentic mothering stems from mothering situations such as those presented in *Room*: "Out of maternal powerlessness and in response to a society whose values it does not determine, maternal thinking has often and largely opted for inauthenticity and the 'good' of others" (103). She elaborates:

> By inauthenticity I designate a double willingness—first a willingness to travailler pour l'armée [to work for the army] to accept the uses to which others put one's children; and second, a willingness to remain blind to the implications for those uses for the actual lives of women and children. Maternal thought embodies inauthenticity by taking on the values of the dominant culture. (103)

Mothers are then policed by what Sara Ruddick calls the "gaze of others," which causes mothers to "repudiate of their own perceptions and values," "to relinquish authority to others, [and to] lose confidence in their own values" (111-12). I argue that Ma in freedom is judged by the gaze of the other, causing her to lose the confidence she had as a mother while in Room and to doubt the values and perceptions that sustained her maternal practice while in captivity. When the interviewer suggests to Ma that in freedom, she has lots of help, Ma responds: "It's actually harder. When our world was eleven foot square it was easier to control" (236). Mothering in freedom is, indeed, harder for Ma because she can no longer control the conditions of her mothering that in captivity gave her confidence and purpose. Ma says to Jack in freedom, "I keep messing up. I know you need me to be your ma but I'm having to remember how to be me as well" (221). And earlier when Jack asks Ma if he is meant to forget Room, Ma can only answer, "I don't know" (210). Ma, I argue, to use Jack words, "is still hurting in Outside" (216) because she has lost her own self-created identity as a mother and the authenticity that guided her maternal practice. What Ma valued and what was valuable in Room—namely the reciprocal and intimate bond with her son—is tainted and corrupt under the gaze of normative motherhood.

The novel's conclusion promises a reclamation of Ma's maternal authenticity and a rehonouring of their mother-son bond. Authenticity,

Elizabeth Butterfield explains, "is an ethical term that denotes being true to oneself, as in making decisions that are consistent with one's own beliefs and values [whereas] inauthenticity is generally understood to be an abdication of one's own authority and a loss of integrity" (701). In the context of mothering, maternal authenticity refers to "independence of mind and the courage to stand up to dominant values" and to "being truthful about motherhood and remaining true to oneself in motherhood" (701). I argue that Ma reclaims her maternal authenticity as enacted in Room by the novel's conclusion. The final section of the novel is titled "Living" and concludes with Ma and Jack moving into an independent living residence and their "[making] a deal, we're going to try everything one time so we know what we like" (311). The connection of their past is also held in reverence. When Ma tells Jack that breastfeeding is all done, "Jack "kiss[es] the right and I say 'Bye-bye.' I kiss the left twice because it was always creamier" (303). Also, "Ma and Jack have separate rooms for daytime but sleep together in one room for night time" (304). And when Jack says to Ma, "'I could cut [your hair] and then we'd be the same again.' Ma shakes her head. 'I think I'm going to keep mine long'" (303). Although their relationship changes in freedom, their close bond remains at its core. Ma's rotten tooth that Jack has carried with him since Room is perhaps not lost; Jacks thinks, "Maybe I did swallow him by accident. Maybe he's not going to slide out in my poo, maybe he's going to hiding inside me in a corner forever" (307). Ma's tooth that remains within Jack signifies the depth and endurance of their mother and son connection and love. The novel ends with their visiting Room where Jack "look[s] back one more time. It's like a crater, a hole where something happened" (321). But then "they go out the door" (321), which symbolizes a new beginning created from the redemptive and resistant connection of their past.

During the interview, Ma is asked "Was [giving] birth alone under medieval conditions ... the hardest thing you've ever done? Ma shakes her head [and replies] 'The best thing'" (233). For Ma, becoming and being a mother is, indeed, "the best thing" because it is precisely through her maternal practice and the reciprocity of her close relationship with Jack that she acquires an authentic selfhood. Because her identity as a mother is self-created and sustained by reciprocal mother-child love, Ma enacts resistance and achieves redemption in motherhood. In its portrayal of motherhood as both resistant and redemptive, Room offers

a necessary challenge and corrective to normative motherhood. It conveys how mothers may be empowered through maternal authenticity and mother-child reciprocity.

"The Wolfishness of Mothers": Redemption as Absolution and Deliverance in *The Wonder*

In *Room*, maternal redemption is enacted as the reclamation of maternal authenticity and mother-child reciprocity and is performed by one mother, Ma, the biological mother of Jack. In *The Wonder*, there are two mothers: Rosaleen O'Donnell, the biological mother of Anna—"who her parents claim hasn't taken food since her eleventh birthday" (12)—and Lib Wright, the nurse who is summoned to Ireland to observe Anna and determine the truth behind her fast. In *The Wonder*, redemption is achieved not through reclamation as in *Room* but through absolution and deliverance. This section explores how Rosaleen's endeavour to save her daughter from the mortal sin of incest may be read as a redemptive act of absolution, whereas Lib's mission to rescue Anna emerges as a redemptive act of deliverance.

Echoing McKanic—who describes *The Wonder* as featuring "a woman whose existence is bent around the life, health and happiness of a child whose circumstances are desperate"—a review from the *New Yorker* refers to "an adult who is made responsible for the welfare of a trapped child" (Schwartz 4). Neither review identifies who the individual is, but it is assumed that this person is Lib, the nurse, who eventually brings an end to Anna's fast and saves her from her family. Lib is read as the so-called good mother who rescues her from the bad mother, Anna's biological mother, Rosaleen. Rosaleen may rightly be seen as the bad mother. When she was told, by Anna, of the incest following her brother Pat's death, she told Anna it was a "filthy falsehood" (259). She is complicit in Anna's starvation, feeding her only "manna from heaven"—regurgitated food passed from her mouth to Anna's—throughout her daughter's fast. I would argue, however, perhaps controversially, that Rosaleen may, likewise, be read as a redemptive mother if we locate her mothering in the cultural and religious setting of postfamine Ireland of the 1850s and if we understand her compliance with Anna's fast as a gesture of absolution to save her daughter from the mortal sin of incest. A redemptive reading of Rosaleen, however, is only possible through an

excavation of the narrative point of view of the novel: the limited third-person narrative of the character Lib. Lib is a single, educated, professional, and, most significantly, British woman, who describes the Irish within minutes of her arrival as "impervious to improvement" (7) and the Irish village as "no more than a sorry-looking cluster of buildings" (7). Later in the text, Lib thinks, "In these dim huts nothing had changed since the age of the Druids and nothing ever would" (89). Indeed, as Mr. McBreatry, Anna's doctor, cleverly remarks as he leaves Lib, "You're still on English time" (19). Thus, to read Rosaleen as a redemptive mother, her character must first be redeemed from the limited third-person narration of Lib that frames, and indeed distorts, our perception of Rosaleen.

When Lib first meets the O'Donnell family, her disdain and derision for them are immediate. Upon their greeting, and when Rosaleen thanks Lib for coming such a distance, Lib thinks, "Could she really be ignorant enough to think the war still raged in that peninsula and that [she] had just arrived, bloody from the battlefront?" (25). Lib also spurns in disgust the stool Rosaleen offers: "the log stool the woman was shoving practically into the flames for her guests," only to realize that "the mother looked offended; clearly, right by the fire was the position of honour" (26). When Rosaleen is asked to describe the beginning of the fast, she explains, "The seventh of April, four months ago yesterday. Overnight, Anna wouldn't take a bite nor sup, nothing but God's own water" (28). Lib, we are told, "felt a surge of dislike. If this were actually true, what kind of mother would report it with such excitement?" (27)— a response that reveals Lib's own bias, given the text describes Rosaleen as speaking "with flaking lips pressed together" (28), which is hardly suggestive of excitement. And when Rosaleen agrees to the watch— "Willing and more than willing, so we'll have our characters vindicated that are as good as any from Cork to Belfast" (29-30)—"Lib, almost laughed. To be as concerned for reputation in this meagre cabin as in any mansion" (30). When the mother later asks Anna, "Anything you need pet?" Lib thought, "*Dinner ... that's what every child needs.* Wasn't feeding what defined a mother from the first day on? A woman's worst pain was to have nothing to give her baby. Or to see the tiny mouth turn away from what was offered" (55). In linking good motherhood with the ability to feed one's children, Lib's judgment is particularly callous, given the Irish famine ended only a few years earlier. Later when Rosaleen

tells Anna, "more guests for you my pet," Lib thinks the "big Irishwoman's sprightliness sickened [her]; she was like some chaperone at a debutante's first ball" (75). Rosaleen's innocent words, again I would suggest, do not warrant such judgment; as well, the allusion to "the debutante's ball" reveals Lib's own British and class privilege and bias. Later in the text, when Rosaleen embraces her daughter, "[Lib thinks] like something out of grand opera, the way she barged in to make a show of her maternal feelings twice a day" (143) Commenting on this scene in her review of *The Wonder*, Meghan O'Gieblyn remarks, "Lib is as skeptical of familial love as she is of the faeries. In fact, it disgusts her" (5). I would agree that Lib's judgment of Rosaleen reveals more about Lib's character than it does Rosaleen's.

Later in the text, when Lib visits the son's, Pat's, grave, there is a brief moment of empathy and compassion, which signifies the emergence of Lib's transformed relational subjectivity:

> Lib suspended her dislike of the woman for a moment and con-sidered what Rosaleen O'Donnell had been through; what had hardened her. *Seven years of dearth and pestilence*, as Byrne had put it ... A boy and his little sister, and little or nothing to feed them during the *bad* time. Then after Rosaleen had come through those terrible years, to lose her almost-grown son overnight ... Such a wrench might have worked a strange alteration. Instead of clinging to her last child all the more, perhaps Rosaleen had found her heart frost-burnt. Lib could understand that, a sensa-tion of having no more left to give. Was that why the woman made an uncanny cult of Anna now, apparently preferring her daughter to be more saint than human? (161-62)

When Anna's death from starvation is imminent and Lib asks, "What kind of mother would let it come to this?" Rosaleen, the text tells us, "did the last thing Lib was expecting: she burst into tears" (213). Later Lib thinks, "It confused her, to feel such sympathy for a woman she loathed" (213). Lib's sympathy signals a rupture in her limited and judgmental third-person narration to convey her nascent transformed relational subjectivity. With this shift to a relational perspective, a redemptive reading of Rosaleen is made possible.

In the above scene, Rosaleen explains to Lib, "Didn't I try my best ... Sure isn't she flesh of my flesh, my last hope? Didn't I bring her into

the world and rear her tenderly, and *didn't I feed her as long as she let me*" (my emphasis, 213). Lib does not initially understand the final words of Rosaleen's lament. When Anna finally explains to Lib that the manna from heaven that has kept her alive during her fast was regurgitated food passed from the mother's mouth to Anna's, Lib realizes that "she had heard the mother's grief and remorse and still not understood" (220). For Anna, this food was "manna from heaven" and delivered as "a holy kiss" (220). When Anna explains to Lib that "it's private," Lib thinks the following:

> A secret exchange, too sacred to be put into words. Yes, Lib could imagine a woman of strong character persuading her little girl of that. Especially such a girl as Anna, growing up in a world of mysteries. The young placed such trust in the grown-ups into whose hands they were consigned.... Was it a sort of sleight of hand, the mother reading the daughter the manna story from the Bible and cofounding her with mystical obscurities? Or had both parties contributed something unspoken to the invention of this deadly game? (221).

Lib's reflections remain speculative; we are never told when the mother initiated this holy kiss of manna from heaven, but we do learn later in the text that Anna's brother, Pat, when he was thirteen and Anna was nine, sexually abused Anna until his sudden death several years later. Anna explains to Lib, "He married me in the night. When brothers and sisters marry, it's a holy mystery. A secret between us and heaven, Pat told me" (223). However, the day before her eleventh birthday, Anna attended a Redemptorists' sermon where she was told that what she and Pat had done was a mortal sin. Anna believes that if she recites "The Good Friday Prayer for the Holy Souls to Saint Bridget thirty-three times a day while fasting, [God] will fetch Pat to heaven" (233). Anna explains further, "Souls need a lot of cleaning ... Nothing is impossible to God, though, so I won't give up ... [God] has not promised me anything but maybe he'll have mercy on Pat. And on me too even.... Then Pat and I can be together again. Sister and brother" (233-34). Rosaleen may not have understood fully the reason for Anna's fast, but she did know that Anna and Pat had committed a mortal sin. She believed, with Anna, that reciting the Good Friday prayer, while fasting, thirty three times a day would release a soul from purgatory. The mother

may have allowed the fast truly believing it would offer salvation to her two children. Rosaleen's belief is one sanctified by her religion and church, as the priest earlier explained to Lib: "fasting can be a useful penance" (23). Lib then inquires, "if one punishes oneself, one's sins will be forgiven?" to which the nun adds "or those of others" (23). Rosaleen, with Anna, believes in the words of the priest: "if we offer up our suffering in a generous spirit to be set to another's account" (24). Rosaleen understood that no words or actions would convince Anna to end this fast to save Pat and to make amends for her own sin. As Lib remarks about Anna, "She had a quiet firmness about her, an air of self-command, unusual in one so young" (94). Later, she describes Anna as "lit up with a secret joy. Anna truly believes she is living on nothing" (131).

Believing the fast would bring salvation to her children and knowing that Anna was resolved to continue the fast, Rosaleen had no choice or power to end the fast. Instead, she did only what she could do: keep her child alive during the fast by feeding Anna some regurgitated food, disguising it as manna from heaven. I argue this not to excuse or justify Rosaleen's complicity and compliance with Anna's fast but to emphasize that Rosaleen did this to keep her daughter alive. She hopes the fast would bring salvation to her children. On the sixth day of the watch, Anna refuses her mother's embrace and the manna from heaven, offering no explanation for this other than to say to Lib, "I don't need it" (221). Lib then realizes, "[Rosaleen] had every intention of keeping her daughter alive indefinitely with this covert supply of food. It was Anna who had put an end to it, one week into the watch" (221). Rosaleen's actions, thus, may be read as fulfilling the first demand of maternal practice theorized by Sara Ruddick and discussed above in the section on *Room*: "The first duty of mothers is to protect and preserve their children [and] to keep safe whatever is vulnerable and valuable in a child" (80). In this instance, Roseleen seeks to protect Anna's soul through her sanctioning of the fast and to preserve Anna's body in feeding her the manna from heaven.

In her review of the book, Ruth Scurr argues that "Donoghue's decision to invent an Irish fasting girl in 1859 allows her to evoke a religious and spiritual culture within which extreme fasting could still be viewed as wondrous rather than pathological" (2). In making this argument, Scurr distinguishes between "anorexia mirabilis, a holy

abstinence from food associated with sainthood, and anorexia nervosa, a medical condition that can result in death" (3). The term "anorexia nervosa" was established in 1873 by Queen Victoria's physician Sir William Gull (Scurr), which is significant because "in choosing to set *The Wonder* before this date, Donoghue brings religious authority and motivation back into question" (3-4). Indeed, Anna is referred to by the townsfolk as an *extraordinary wonder*" (9). Rosaleen remarks, "'We can't explain it, but our little girl is thriving by special providence of the Almighty. Sure aren't all things possible to him?' to which Sister Michael nodded. 'He moves in mysterious ways'" (29). When Lib counters the doctor's assertion that "it's a great mystery" and argues "science tells us to live without food is impossible," the doctor responds, "But haven't most new discoveries in the history of civilization seemed uncanny at first, almost magical? (14). The doctor describes Anna's case "to be an out-and-out-miracle" (15) and later explains to Lib that "in the Dark Ages, many saints were visited with a complete loss of appetite for years, decades even. *Inedia prodigiosa*, it was called, the prodigious fast" (194). The doctor continues, "But might some physiological mystery lie behind those tales.... I've formed a tentative hypothesis about that. Might her metabolism not be altering to one less combustive, more of a reptilian than mammalian nature?" (194). When Lib expresses her incredulity, "the doctor's expression was beatific: 'Perhaps nothing is impossible to the Great Physician'" (195). The men of the church and medicine all believe that Anna is truly living without food and that the fast is a miracle and divinely ordained. Indeed, as Lib comments, "To these men the girl was a symbol: she had no body anymore" (240).

I argue that although Lib, and likely many readers, may blame and judge Rosaleen for her compliance with Anna's fast, the text conveys and confirms that it is the religious theology and cultural beliefs of 1850s Ireland that are ultimately responsible for the fast. In her review, Sarah Gilmartin comments that "Anna is physically a child but mentally an adult, a very 19th century Irish one at that, in her warped understanding of sacrifice and penance (1). Significantly, most readers understand and are sympathetic to Anna because in Lib's words, they are "tak[ing] poetic language at face value" (143). Few readers, and certainly not Lib, accord the same consideration and compassion to Rosaleen. I suggest that Rosaleen has also, in William Byrne's words, "mistaken morbid nonsense for true religion" (226); thus, she is also deserving of

understanding. Rosaleen believes the miracle of her daughter's fast simply because that is what her religion has taught her to believe. As Byrnne remarks, "the majority of my countrymen swallow whatever pap our priests feed us" (135). In good faith (implying both meanings of the expression), Rosaleen complies with the fast believing that it is an act of absolution—the action of saving or being saved from sin, error, or evil. And in believing that this absolution will save her daughter Anna, Rosaleen may be read a redemptive mother.

Rosaleen, however, does not believe her daughter when Anna tells her about the incest, following Pat's death. When Lib explains to Rosaleen that her son Pat sexually abused Anna, Rosaleen responds, "I won't stand for any more scandalmongering ... that's the same filthy falsehood Anna came out with after Pat's funeral ... and I told her not to be slandering her poor brother" (259). Later when Lib learns that Anna had told the priest about the incest in confession, the priest explains to Lib, "Such calamities should be kept in the family.... Anna should never have entered on such a subject with you ... I've been telling the poor girl for months that her sins are forgiven, and besides, we should speak nothing but good of the dead" (266). The priest, as he believes Anna, "the only comfort he'd offered was to tell her that *her sins* were forgiven and she should never mention it again" (my emphasis, 266). Lib also realizes that "she couldn't tell anyone else either":

> If Anna's own mother had called her a liar, most likely so would the rest of the world. Lib couldn't put Anna through the violation of a medical examination; that body had endured so much probing already. Besides even if the fact could be proved, what Lib saw as incestuous rape, others would call seduction. Wasn't it so often the girl—no matter how young—who got blamed for having incited her molester with a look? (261-62)

Rosaleen should have believed her daughter—this is what we want and expect of mothers. Rosaleen's own faith, however, viewed the sexual abuse as, at best, a private calamity and, at worst, Anna's sin. Lib cannot tell anyone, knowing that Anna would be the one blamed for the sexual abuse. I do not excuse Rosaleen but instead locate her denial in its cultural and historical context: nineteenth-century, rural, Catholic, and patriarchal Ireland. Women today are still routinely not believed when they disclose sexual abuse and assault, as evidenced by the recent

#MeToo movement. We may rightly have wanted Rosaleen to believe her daughter, but to blame her solely for this denial is to disregard that Rosaleen is only speaking what patriarchal culture and religion have taught her to believe. She is no guiltier than the church that regards sexual abuse as the sin of women or the larger patriarchal culture that both condones and denies any such sexual abuse.

Rosaleen, as noted above, is positioned as the bad mother in her complicity with Anna's fast and in her denial of the sexual abuse. She is juxtaposed with Lib, the nurse, who is situated as the good mother, who ends Anna's fast and rescues her from her family. The two mothers represent two opposing worldviews: Rosaleen signifies Irish, religious, and traditional, familial values, whereas Lib denotes the British values of secularity/empiricism, modernity, and autonomy. In her review, Scurr argues that "*The Wonder* is a narrative vortex within which the old authority of religion and the new authority of science are simultaneously shattered" (2).

As argued, Rosaleen may be read as a redemptive mother if we understand her compliance with Anna's fast as an act of absolution sanctioned by religious authority. A careful reading of Lib shows how she becomes a redemptive mother in and through her renunciation of the authority of science, and its attendant values of secularity/empiricism, modernity, and autonomy. Indeed, as Sarah Gilmartin argues, "The novel is as much about Lib's journey as it is about Anna's decline.... Lib comes to realise that she is the only one who can save Anna from the 'wonder' of her calling" (1). In *The Wonder*, one mother is replaced by another, but Lib can only become this mother through a journey of self-transformation—by paradoxically assuming the very maternal traits that Lib once disparaged in Rosaleen. Lib can only save Anna when she renounces a masculine autonomous subjectivity and embraces a relational maternal one. Only then can Lib redeem Anna through the act of deliverance.

As examined above, Lib regards the Irish with disdain and derision and is especially contemptuous of their combined Roman Catholic religion and pagan beliefs. The church in *The Wonder*, as noted in the *Quill & Quire* review of the novel, is "depicted as authoritarian, irrational, and mean-spirited, enslaving the Irish to the same degree as political dictators the world over." "God," Lib says at one point, "is the real tyrant in this part of the world" (196). She describes the nun who shares the

watch with her as "blinkered by superstition" (29). The novel explains, "Faith had never had much of a hold on [Lib]; over the years it has fallen away, with other childish things" (61). And later, Lib tells Anna, "I never found [praying] did much good" (104). Lib asserts that "Science ... it's all we can rely on" (166). Indeed, as O'Gieblyn emphasizes in her review, "Lib is effectively an atheist, a modern woman who believes in nothing more transcendent than the scientific method" (3). Lib's goal throughout her two-week watch over Anna "is simply to bring truth to light, whatever the truth may be" (16). Lib recalls Miss N's words: "Miss N. warned against personal affection as much as she did against romance. Lib had been taught to watch for attachments and root them out" (203). Lib meticulously records the conditions of Anna's body in her notebook: "colourless down on the cheeks," "bluish tint to her earlobes and lips," "rounded belly," and "very swollen feet ankles and lower legs" (36-38). Lib "wasn't there to be kind" (37), and "she wasn't [there] to improve the girl's health, only to study it" (43). She calls Anna "false little baggage" (36), "*an outrageous* fraud" (18), "*a swindler*" (37), and "*a cheat to boot*" (57). Lib thinks, "*I'm going to crack you* [Anna] *like a nut, missy*" (42) and reminds herself "[*Anna's*] *doing this all to herself. It's all part of an elaborate trick she's playing on the world*" (59). Lib is resolved to not "be gulled by a child of eleven ... to be even more *exact and careful*" (65). Skeptical of the girl's miraculous powers, as O'Gieblyn notes, "[Lib] becomes obsessed with exposing her" (3). The first section of the novel concludes with Lib asking, "What had [Lib] learned so far? Little or nothing" and her realization that "she understand[s] nothing about this place" (62).

In his review of the novel, Stephen King argues that "Lib feels nothing but distrust until the child begins to fade. When that happens, she is able to set aside her litany of Irish prejudices and face the truth: If she doesn't do something to stop it, Anna O'Donnell is going to die in front of her" (2). I argue that it is more precisely the relationship developing between Anna and Lib that causes Lib's masculine empirical standpoint to shift to a maternal relational one, enabling Lib to finally understand and act. Lib acquires understanding only when she begins to interact with Anna as a child who is in need of care and love, and no longer as a detainee to be observed and studied. Scurr argues that as Lib "grows fonder of her patient and comes to feel more like a bodyguard than a jailor, she is forced to admit that she is failing" (6). Only when

Lib's position moves from being a jailor to a protector and her perception of Anna shifts from "false little baggage" (36) to "a delightful dying child" (185) can Lib comprehend the many clues Anna reveals about the reason for her fast and finally rescue her from it. In other words, Lib must become a mother to save Anna and replace disinterested masculinist logic with attentive maternal thinking.

The transformation in Lib's perspective and subjectivity is marked in the novel through the changes in how Lib identifies herself to Anna. When they first meet, Anna asks Lib her name to which she responds, "Mrs. Wright, but you may address me as nurse" (35). Anna queries further, "Your Christian name, I mean" (35). The text tells us that "Lib ignored that bit of cheek and continued writing" (35). Anna seeks a relationship in asking Lib for her first name; Lib rebukes her request to position herself in the masculine realm of professionalism and formality. Over the next few days of the watch, Anna and Lib's relationship develops through the riddles she asks Anna to solve, their discussions on religion, and their walks in the countryside. Lib thinks, "Strange to feel so yoked to another person" (54). When the doctor explains to Lib that Anna was in danger from eating so little, Lib feels "an impulse to put her arms around the child" (108). Their budding intimacy shifts Lib's view of Anna from distrust to concern: "[She] had seen no real evidence of craftiness in the girl" (81); "What if Anna wasn't lying?" (114). The growth of their relationship causes Lib to reconsider the purpose of her watch: "It came to Lib that the question to ask was not *how* a child might commit such a fraud, but *why*? (94).

A few days later, when Anna greets Lib with "Good morning, Mrs. Whatever-Your Name Is," Lib thinks, "That was impudence, but Lib found herself laughing, 'Elizabeth'" (119)—a stark contrast to Lib's initial response to this question a few days earlier. As well, with the telling of her name, the text discloses for the first time, some personal history about Lib: "[Elizabeth] had a strange ring to it. Lib's husband of eleven months had been the last one to use that name" (119). A few days later, when Anna tries to guess Lib's pet name, we learn again more about Lib's past: "*Lib* was what her whole family had called her, when she'd still had a family, while their parents were still alive, and before her sister had said Lib was dead to her" (141). Later, when Anna teases her in laughter and says she will call her "Mrs Iddly-diddly" and Lib responds, "you will not, you goblin girl," the text tells us that "Lib. The

word came out of her on its own, like a cough" (154). Lib then, for the first time, shares with Anna her personal history: she is a widow, after only a year of marriage. (We learn later in the text that Lib was actually deserted by her husband after the death of their infant daughter.) Again, the joyous intimacy in this scene—as Lib thinks "were the O'Donnells and their friend Flynn wondering at all the mirth coming through the wall" (154)—contrasts sharply to the somber formality of their first meeting. Near the end of the novel, when Anna finally discloses the meaning of the manna from heaven, Lib wonders, "Had the girl always been ready to answer so candidly the moment she was asked. If Lib had been less contemptuous of pious legend she might have paid more attention to what the girl was trying to tell her" (220). Their developing relationship, as signified by the changes in Lib's self-identification, not only shifts Lib's perception of Anna but also affects a transformation of Lib's selfhood: from the detached Mrs. Wright to a relational Lib.

With Lib's relational perspective comes comprehension. Lib reflects, "Why had she resisted the obvious? Arrogance ... she'd held firmly to her judgment and overestimated her knowledge" (186). In her review of the novel, Alexandra Schwartz argues, "Donoghue, narrating her novel from the nurse's perspective in a close third person, makes sure that we notice clues that Lib blinkered by her own parochialisms doesn't" (6). Lib's misreading of the clues is, indeed, abundant: Lib misses the significance of Anna wearing her brother's boots; fails to recognize that the brother Pat is dead in the daguerreotype on the mantle; mistakenly believes that Pat immigrated to America when hearing that he had "gone over"; mishears the key Good Friday prayer as the Dorothy prayer; miscomprehends the meaning of "manna from heaven;" and misinterprets Anna's constant expression, "He comes to me as soon as I am asleep," thinking she refers to Jesus when it is in fact her brother Pat. And most significantly, Lib misreads the signs of Anna's starvation, in particular her round belly, believing that she "[knows] what starvation looked like [from her nursing experience at Scutari]" (36). Later when Byrne, who both survived and studied the Irish famine, meets Anna, he asks Lib: "Are you blind? The girl's wasting away in front of you." And as he further explains, "Some starve fast, some slow. The slow kind swell up, but it's only water, there's nothing there" (184). Only then can Lib see the evident signs of Anna's starvation: the ghastly fuzz on her face and the vinegary smell of her breath (185). Throughout the novel, Lib offers Anna riddles to solve. I suggest that Anna's fast is similarly

presented as a riddle for Lib to solve and that she can do so only when her perspective shifts from one of masculine observation to that of attentive maternal love.

By the end of the novel, Lib assumes both the commitment and responsibility of motherhood or, more specifically, that of maternal practice as theorized by Ruddick and discussed above: "For the first time, Lib understood the wolfishness of mothers ... [and] in times to come, when Nan-who-once-Anna blamed someone, it would be Lib. That was part of motherhood, she supposed, bearing responsibility for pushing the child out of warm darkness into the dreadful brightness of new life" (281). Lib's maternal subjectivity also enables her to understand the need for hope and faith. Whereas she once scorned the rituals of the holy wells and the Hawthorne tree in Ireland—believing "there was no use looking for a seed of science in a superstition" (176)—"Lib saw the point of such superstition now. If there was a ritual she could perform that offered a chance of saving Anna, wouldn't she try it?" (260). Lib finally convinces Anna to eat by promising her that she will be reborn as a "little girl who's never done anything wrong" (273) and by explaining, "'This is "holy milk'. Lib held up the bottle as solemnly as any priest in front of an altar. 'A special gift from God'" (273). Lib further reflects, "What gave [her] tone conviction was that it was true. Didn't the divine sunshine soak into the divine grass, didn't the divine cow eat the divine grass, didn't she give the divine milk for the sake of her divine calf? Wasn't it all a gift?" (274). As Lib thinks this, "deep in her breasts [she] remembered how her milk had run down whenever she heard the mewing of her daughter" (274). This embodied remembering of Lib's own mothering signifies and solidifies the attainment of Lib's maternal subjectivity. As *The Wonder* opens with Rosaleen's redemptive attempt of salvation for her daughter, it concludes with Lib saving Anna through the redemptive act of deliverance.

Conclusion

Schwartz suggests that both *Room* and *The Wonder* may be read as fairy tales: "As in fairy tales, the child protagonists are put in terrible danger in order to be saved before they come to real harm" (7). I argue, however, that unlike traditional fairy tales, it is a mother who saves the child in these two novels by Donoghue and it is achieved through the power of redemptive motherlove conveyed as reclamation, absolution,

and deliverance. In her review of *The Wonder*, O'Geiblyn asserts, "Donoghue has presided for some years now over a literary empire that envisions motherhood as a kind of religion" (8). Commenting specifically on *The Wonder*, O'Geiblyn argues further that this novel "is especially insistent—at times even polemical—on the nourishing effects of childrearing" (8). "It is tempting to read into Donohgue's vast ecology of metaphors," O'Geiblyn, continues, "a troublesome import that childlessness is a kind of starvation, a willful spiritual emptiness" (8-9). For O'Geiblyn, Donoghue's portrayal of motherhood—"sweeping in its powers of transfiguration ... [making] a woman more emphatic, more emotionally acute, more attuned to the injustices of the world"—is "dismaying" because "to become a mother, we are told, a woman must surrender everything, spirit and flesh" (10). "But most crucially," O'Geiblyn concludes, "[the mother] must come to *believe* in the importance of the task, and in her capacity to become a new being" (10). Although I agree with O'Geiblyn's description of the portrayal of motherhood in Donoghue's fiction, I challenge her interpretation. For Donaghue, motherhood does not require surrender, as O'Geiblyn contends. Rather, *Room* and *The Wonder* convey and confirm the redemptive power of mothering, particularly as it is enacted in reclamation, salvation, and deliverance. Indeed, as Scurr argues, both novels "are ultimately redemption narratives ... The end of *Room* is 'I look back one more time. It's like a crater, a hole where something happened. Then we go out the door.' *The Wonder* ends similarly with a forward looking question: 'Shall we begin?'" (8). *Room* and *The Wonder*, thus, do "envision motherhood as a kind of religion," as O'Geiblyn contends, but one that affords redemption to empower both mothers and their children. And in this, both novels convey and confirm the necessity and value of emergency motherhood for both children and their mothers.

Works Cited

Blackwood, Sarah. "'Room' is the 'Crash' of Feminism." *Los Angeles Review of Books*, 4 Nov. 2015, lareviewofbooks.org/article/room-is-the-crash-of-feminism/#. Accessed 1 Oct. 2017.

Butterfield, Elizabeth. "Maternal Authenticity." Encyclopedia of Motherhood, edited by Andrea O'Reilly, Sage Press, 2010, pp. 700-01.

Crown, Sarah. "Emma Donoghue: 'To Say Room Is Based on the Josef Fritzl Case Is Too Strong." *The Guardian*, 13 Aug. 2010, www.the guardian.com/lifeandstyle/2010/aug/13/emma-donoghue-room-josef-fritzl. Accessed 1 Oct. 2017.

Donoghue, Emma. *Room*. HarperCollins Publishers, 2010.

Donoghue, Emma. *The Wonder*. HarperCollins Ltd. 2016.

"In Donoghue's 'Room,' A Child's World Of His Own." *NPR*, 27 Sept. 2010, www.npr.org/2010/09/27/130143360/in-donoghue-s-room-a-child-s-world-of-his-own. Accessed 1 Oct. 2017.

Gilmartin, Sarah. "The Wonder by Emma Donoghue," *The Irish Examiner*, 26 Nov. 2016, www.irishexaminer.com/lifestyle/arts filmtv/books/book-review-the-wonder-by-emma-donoghue -432420. html. Accessed 25 May 2018.

King, Stephen. "Stephen King Reviews Emma Donoghue's Latest Novel." *New York Times*, 2 Oct. 2016, www.nytimes.com/2016/ 10/02/books/review/stephen-king-emma-donoghue-the-wonder.html?mcubz=1. Accessed 25 May 2018.

Lorenzi, Lucia. "'Am I Not OK?': Negotiating and Re-Defining Traumatic Experience in Emma Donoghue's Room." *Canadian Literature*, 2016, canlit.ca/article/am-i-not-ok-negotiating-and-re-defining-traumatic-experience-in-emma-donoghues-room/. Accessed 1 Oct. 2017.

McKanic, Arlene. "Shadowy Secrets behind a Proclaimed Miracle," *Bookpage*, bookpage.com/interviews/8614-emma-donoghue#. WcvFO7KGPIU. Accessed 1 Oct. 2017.

O'Gieblyn, Meghan. "Maternal Ecstasies in Emma Donoghue's *The Wonder*," LA Review of Books, lareviewofbooks.org/article/maternal -ecstasies-in-emma-donoghues-the-wonder/#!. Accessed 25 May 2018.

"On Room." *The Economist*, 17 Nov. 2010, www.economist.com/blogs/prospero/2010/11/room. Accessed 1 Oct 2017.

"*Qulll & Quire* Review." *Qulll & Quire*, quillandquire.com/review/the-wonder/. Accessed 25 May, 2018.

Ruddick, Sara. *Maternal Thinking: Toward a Politics of Peace*. Beacon Press, 1989.

Schwartz, Alexandra. "Emma Donoghue's Art of Starvation," *The New Yorker*, 19 Sept. 2016, www.newyorker.com/magazine/2016/09/19/emma-donoghues-art-of-starvation. Accessed 25 May 2018.

Scurr, Ruth. "The Dreams and the Demons of Fasting," *NY Books*, 23 Mar. 2017, www-nybooks-com.ezproxy.library.yorku.ca/articles/2017/03/23/emma-donoghue-dreams-demons-fasting. Accessed 25 May 2018.

Silverstein, Olga, and Beth Rashbaum. *The Courage to Raise Good Men.* Viking Press, 1994.

Ue, Tom. "An Extraordinary Act of Motherhood: A Conversation with Emma Donoghue." *Journal of Gender Studies*, vol. 21, no. 1, 2012, pp. 101-06.

Wyrick, Katherine. "Emma Donohue: Life Behind a Locked Door." *Book Page*, Sept. 2010, bookpage.com/interviews/8614-emma-donoghue#.Wxy4vIpG3IU. Accessed 10 June 2018.

Chapter Nine

Killing the Angel in the Ether

Victoria Bailey

"The literary road for women may have been envisioned by female writers years ago, but I'm not so sure the path has been smooth or has had a clear trajectory, nor does it have a definitive final destination."

Virginia Woolf's maternal grandmother was apparently friends with Coventry Patmore, the poet who wrote, "The Angel in the House" in the 1800s. I think that's as good a jumping off point as any for reflecting (what with theories abounding on mirrors and mothers and self and all) on Woolf's essay "Professions for Women," in which she describes (spoiler alert) her compulsion to kill 'The Angel in the House.' I was invited to write this piece after submitting an abstract that resonated with the editors' concern regarding the employment of mothers who write, and they kindly created space for me to tell you a little about my own experience. There's a presumption in the ether that we're all invited to join in (anyone can write on the Internet, right?); credibility is still so often in the eye, and most often the hand, of the beholder. Despite the creation of an electronic behemoth of word space, there's still a concern about the equitable employment of women writers, especially those who are mothers, and so I thought I would share "something about my own professional experiences"

(Woolf 1). Not least of these is the worry that despite a keyboard and Internet access of my own, no one will read or pay heed to my typed words, perhaps even less so if my sentiment is over 280 characters, focused on my children, or dismissively categorised as the ramblings of a mommy blogger.

Am I a woman? Yep. Mother? Yes. Employed? Tick. By traditional capitalistic patriarchal Westernized standards? Ummm ... *kinda?* It's complicated. My profession is writing, but when I say that, what do I mean? What does it, the word 'writer,' even mean? What do I need to have accomplished to apply that term to myself? One published article, story, or poem? two? Do I have to have been paid for my words or not? Does the publication need to have local, national, or international reach? Is online okay or on paper only? Does the time I spend writing have to trump being perceived by myself or others as being a mommy first? What about how my kids respond when asked, "What does your mom do?"

Unfortunately, regardless of whether a mother's writing takes the form of scriptwriting, copywriting, playwriting, fiction, nonfiction, or journalism, the literary selection, reviews, and awards are arguably gendered (and seemingly validated) unfavourably for women. Throw (raising) a baby or two or more into the story, and you will likely be looked upon even less positively, and that's if you can still find time to write. There are still "fewer experiences for women" (1) in all writing's realizations. And what of the more recently developed literary art forms, such as the spoken word work of women who have brought about a beautiful blurring of poetry, speech, rap, singing, and beatbox—is that writing? Is the unpredictable fluidity of their tongues any less valid (perhaps more threatening) than the more conventional captured, printed word? (The reproduction of which can be controlled.) Does their melodic rhyme and rhythm, often accompanied by a performance-induced rocking, evoke a sense of mother-linked customs that have no place making her mark in a word world of rules, regulations, and standardizations?

The 1931 gathering of the National Society for Women's Service probably didn't consider intersectionality too much. The barriers and deterrents outlined above are—we now (should) know—further (still) compounded by continued colonialist pomposity much as they were in the interwar years. The literary road for women may have been envisioned

by female writers years ago, but I'm not so sure the path has been smooth or has had a clear trajectory, nor does it have a definitive final destination. Perhaps all roads lead to Rome for men alone? What material obstacles have I encountered? If one has access to a keyboard on anything from a phone or handheld device, to a failing yet familiar desktop, a significantly sticky and stickered school laptop, or a loaned library console—a mode of writing is literally at hand (providing that it works and you've paid your family Internet access or data plan fee). Of course, you'll require a reliable method of saving, spellchecking, and back up—no one's going to trawl though your loopy cursive anymore. Instead you must harness your truth, your message, your voice, and your wonderful imaginings through the same device that is used to communicate with your children, receive school calendar alerts, access teacher's emails, participate in your children's sports teams' group chats, keep track of medical appointment schedules, provide a data monopolizing multitude of child-distracting games (ah, the free babysitter), and, perhaps, contain your children's writings too. That is, if you can actually find time to use it, and no one else is in need of the device. Even if you have access, chances are you'll need to give it a bit of a clean before using it. For female writers, the separation between work and home, public and private, is so minimal now that an accidental click of a finger, or heartless hack, can result in untold embarrassment, vulnerability, and potential exposure. For mothers, this risk extends beyond their own immediate privacy. As mother-writers, especially those who write about mothering or mothers, you always run the risk of exposing not just yourself but your family. Who owns that copyright?

Writing, according to Woolf, was apparently once "a reputable and harmless occupation" (1). Oh, the greatness those third wavers envisioned with the unleashing of the Internet and its potential of cybernetic promise. How dreams of freedom of voice and of words came crashing down in a tsunami of sexual exploitation, the survivors left to be spat at by misogynistic trolls. If a woman isn't safe on the street, safe in her home, or safe on the Internet, where is she safe? The female writer is routinely disrespected and dismissed. What mother-writer would risk being disparaged by ignorant, faceless assailants or, worse, bringing their abuse into her children's home in whatever manner it may manifest? What mother-writer has time to battle for her disavowed opinions? Wasn't it enough to put them out there in the first place? This occupation

warrants its very own health and safety standards; where's the policy and procedures manual for our abiding wordy warrior, her HR representative, her riot? At one time, reviews of women's writing were limited to traditional and controlled venues. Now, our woman writer is vulnerable to vitriolic rants, ridicule, and threats to her livelihood. Thumbs up or thumbs down? Like? Share? The flaneur has left the street and sits in his ergonomic chair executing things he does not do in person. His fingers, his taps, and his clicks are everywhere. It's no longer enough to protect yourself! How do you protect your children? Would you encourage them to write?

My "family peace" is "not broken by the scratching of a pen" (1) or the tapping of keys, because I have far too much positive attachment (yet not too much to be considered helicopter-ish) parenting to do. I can buy all the paper that suits my fancy and upgrade to all kinds of super-sonic speed software and Internet access, but that doesn't change society's expectation that I turn out three independent, clean, and well-fed children each day who perform well and arrive on time for any and all extracurricular activities (after I exercise, but before I nurture my partner and take care of myself first). My sustainably sourced writing paper may remain relatively cheap, but expectations—both mine and those of society—on my time are not. This is in part why so many women, particularly mothers, still struggle to succeed as writers. If I do not leave the house that contains my room, will I be left to write? Am I ever off the clock within my own four walls? When I am asked, "What are you thinking?" My response is either a defensively dismissive, "Oh, nothing," or a frank, "Leave me alone; my thoughts are the only space I have." When the bubbles of ideas break through to the surface of the sometimes seemingly monotonous flow—at other times a stagnant cesspool or raging whirlpool of consciousness (never a clear gentle stream)—how should they be best captured—voice to text? How could I have no hand in it? Every mother knows the importance of the gesture that accompanies her words. I want to feel my words travel from my head, my heart, from inside, down my arms, and out of my (no time to be manicured, and don't put polish on cause you'll only bite it or chip it, and it'll make you prone to cancer and you'll get sick and who'll look after the kids) fingertips.

I was once a girl in a bedroom who moved her pen from ten o'clock to one at night, when all expectations that fell upon me had been

fulfilled. But that was a more traditional time, with a more traditional means of publishing; its measured processes were perceived as carrying more authority. Now hours—oh sweet countless celeb updating, online shopping, Facebook snooping, horoscope comparing, family photo organizing, school email answering, children's activity registering—can also be spent looking for submission matches. To be paid or not to be paid, that is the question. And so I click the red "submit" button in the corner of the screen and wait and tell no one, especially the children. I'd only be met with indifferent shrugs or, alternatively, relentless questioning bordering on outcome obsession—they have extreme sports, and I have extreme writing.

It was thus that I became a writer. I wrote a humour piece, about two men no less, and received a cheque for fifty dollars in the mail. Between submitting the piece and receiving payment, I had separated from my husband, become a single mother of two young boys, and enjoyed both the independent significance and intellectual irony (that would have been completely lost on him) of cashing that cheque and buying cat food and topping up my gas tank with my earnings. To celebrate this first capitalistic validation, I ordered in Chinese food, which I paid for with my brand new Visa card (the first I'd had in my own name) and signed for using my maiden name on the doorstep of a house that only I, and my children, occupied. I had no time to write, although I continued to find "nothing so delightful in the world as telling stories" (6) to my babies, before falling asleep next to their dozing bodies and rousing myself to finish chores only to fall again into a pattern of interrupted sleep. The stories still came—they swam in my head, insisting on release, but I simply didn't have time to do any more than acknowledge them. I was too busy being 'Everything in the House.' I wasn't exactly excelling "in the difficult arts of family life" (3), but ask anyone and they'll say, "She sacrificed herself daily" (3) and my stories.

But I digress (as the men who laid our literary foundations so often do). Since writing that article and going through pitching, researching, contract work and stifling self-doubt, a first book, and dalliances with academia, I came to realize that if I was going to continue to write I needed to do battle with a certain phantom: the Angel in the Ether. It is she who comes between me and getting to a point of being reviewed, never mind submitting. Her skirts crackle on the power lines, and her wings cast a shadow over every screen. She is, by nature and necessity,

suspicious and sneaky—browsing user histories and applying parental controls. If there's a glitchy gadget, she'll make do. Prioritizing the perform-ability of others, she jimmies charger cables that are wire bare at the joint and fiddles with iffy connections, contorting herself into uncomfortable positions to stay seated and empowered. Filthy screen? She gets to work with screen cleaner and micro-fibre cloths because "You can't just use anything to clean screens you know!" Weak WIFI signal? She's on hold with the supplier's customer service department. Printer ink running out? She'll print it in green 'til she can get to the store.

Above all she is pure—no porn for her. She scans and polices cleared histories the best she can to safeguard her children from exposure to images of exploited women or the grooming efforts of pedophiles or religious extremists. She's also busy ensuring that all online bills are paid on time and that everyone is registered for their recreation classes, that volunteer spots are filled, and that her social media accounts project a positive presence of her family while being bombarded by pop-up ads vomiting mommy blogs, life hacks, clothing ads, beauty tips, and pseudo-spiritual relationship advice on her screen.

Daily she is reminded the information diet of both herself and her family must be just right; not so meagre that they become information ignorant or, worse, suffer from inforexia; not so copious as to be accused of uncontrolled media binging. She must devise and enforce a balanced media meal plan for herself and her dependents. Although her kind are commodified and exploited via marketing mediums, she is at the same time deemed by the media machine too wild and hysterical by nature to control herself suitably and reliably, and as a mother, even less so. She apparently needs familial information guidelines. Dominated and disparaged, she is, at the same time, distorted into self-judgment and critical comparison. Her compulsive consumption of creative content becomes embodied in herself and those she shapes, God forbid, without professional guidance. She is presumed to gorge on mass (and en masse: guidelines aren't determined and distributed for an audience of one; homogenization is on the menu) media junk rather than perceived as immersing herself in a sea of limitless information, education, and power. Did the mothers of Gates, Jobs, or Zuckerberg set timers for their electronic time or limit their browse-ability?

Swimming upstream against a continuous current of content and

text, is it possible to make five hundred pounds (or dollars for that matter) anymore? Is it possible to write for a living without depending on charm or an inheritance? I have tried to kill the Angel in the Ether to better my chances, but every day she wears me down. My strategy? I choose to click the other way; I constantly run from her influence, grab on to the next story, comment or tag, and swing from sentiment to sentiment. I dump the links that reiterate, reaffirm, and realize her presence and influence into the abyss, and I cleave to the ones that buoy me and gratefully rest a while on imparted information that distracts me from both. My excuse, should I need one, is self-preservation. Thus, whenever I encounter a pop-up ad or tweet notice or news update, I fight to close those indiscernible and slippery small "x" boxes and continue my creation of content, fuelled by the embers of feminist anticipation for an alternate egalitarian domain. It is an everyday experience that is bound to befall the majority of women writers. Killing the Angel in the Ether is impossible: her big data-driven, stalking presence multiplies and magnifies each quarter. One can only run away and try to remain one click ahead, or put in place blocks and boundaries that hinder her access and unrelenting advance. So the struggle continues for a young woman and mother to be herself. But what does that mean? What is a woman? A mother? These questions are far more loaded, deconstructed, contested, and critiqued now than one hundred years ago while female expression through the arts continues to be controlled in scope and limited by venue, which further silences the voice of mothers and mothering.

Be that as it may, imagine finding space and time to sit for hours in a coffee shop, office, bedroom, dorm room, or bar? Where can the mother-writer possibly go, not to find isolation (we are all attuned to blocking out background noise in a public space when without kids or grabbing onto nap time or electronics-facilitated breaks in our day) but to escape the Angel in the Ether? Where can the mother-writer go once she has found some time of her own to avoid a constant onslaught of the messenger via radio, TV, announcements, email, tweets, news updates, magazine covers, instant messages, phones, iPads, laptops, ads on bus stops, billboards and buses, washrooms, and walls? She would have to escape. But what kind of fate would befall the mother-writer who abandons her child for words? Regardless, given what great lengths she'd have to go to, could her extreme remoteness only serve to reinforce and echo the Angel's presence via a prioritized self-imposed profound lack?

Better to shoulder the Angel's existence than be constantly looking over your shoulder for it.

Less a fisherperson and more a deep sea diver, the mother-writer searches for an original idea in a postmodern volcanic void—one that is simply not a reaction or rebuttal or stymied by her maternity-muddied scope. What if she shocks? Will she be defended by an unknown army or unfollowed and attacked by a mysterious mob? In a world that relentlessly demands information from a machine that requires constant input, favouring quantity over quality, will she ever be able to find a quiet safe stillness on the surface and float there long enough to master her own reel? Even so, one line would likely never harvest enough to be successful, unless she's part of a deep trawling machine, dredging and churning out ideas and words for mass consumption—the great and valuable potentially lost amid the simple, cheap, and plain. How long will she be at sea before wondering if should she be teaching her children to fish instead or gutting and cleaning up their catches?

Let's say she does hook on a big idea and reels it in for others to see. If her reason told her that men would not be shocked by her words, is that necessarily better? Is the idea of any value if it's to be simply accepted and consumed by men without exception? What of her own sons, will her words ever shock them? Healthily consumed by their own pediatric narcissism, mine take little interest thank goodness; otherwise, I may think it better not to rock the boat at all. How does it feel to be the son of a mother who spends her days pondering how to best effectively communicate in words the gendered inequality she observes and experiences daily? (I've already experienced a few, "Oh Gawd, Mooooommm, it's not always about being a woman," sigh, eye roll, tut, and walk away moments. And that's when I tone it down). Although I share no manuscripts or proposals with them, there is energy being generated within their own four walls and some conversations. Okay, more rants are overheard. Everyone reflects differently on memories as they develop and time passes. Could my own children challenge me one day in a literary realm or just around the dinner table?

If a mother's writing is shocking to men, does this fuel her imagination? Will they admonish her and disavow her angelic-like standing or bestow her work with a credibility and validity on par with their own? Will men publish it? Read it? Promote it? If promoted, will it be classified as women's interest, chick lit, parenting issues, (given recent marketing interests) feminist, or, even worse, a mother's "how

to" guide. Can't a woman's interest be considered an interest for all? Can't a mother's interest be an interest for all, especially given she's always thinking of everyone else? Will she be nominated or receive awards at the same rate as her male counterparts for her textual travails? How many fathers win literary awards? (I couldn't tell you—it's hardly mentioned.) If a mother-writer is nominated or evens wins, should she accept? Does acceptance of a prize normally given by and to male writers mean that men are making gains in their appreciation of women's voice and experience, proficiency, and perspective? Would it have more of an impact if women were to stop writing or to stop sharing their writing? Grounding my children gets me nowhere, but not having the light of their mother's attention shine on them—that sees results. Will continued engagement with, "the extreme conventionality of the other sex" (7), fire the mother-writer's imagination or suffocate it? Is she doing a disservice to future generations by doing so, or her future generations?

Have women achieved the same literary freedom as men? Have mother-writers achieved the same literary freedom as father-writers? Will we? How many famous writers have I read that were fathers? How many were mothers? I believe it is impossible, at least for me, to kill the Angel in the Ether. She has not died for me. She seems to thrive more than ever; the intricacy of her pervasiveness thwarts her eradication and ensures her endurance. As Woolf poignantly states, there are "still many ghosts to fight, many prejudices to overcome" (8). But I don't want to kill the Mother Angel. I just want to freely set her down at times of my own choosing and be, well, free—free in space, in thought, and in care. The last place I want to be is in a room of my own choosing or beholden to a sponsor, dead or not. In our more global, intersectional, and culturally sensitive Western realm of creativity—where we tread on the literary eggshells and bullet casings of colonialism and our artistic trusses are underpinned by a white middle-class supremacy—I realized what I had to do. I had to kill Virginia Woolf. I had to end an unquestioned feminist devotion to a hallowed prescription from a privileged, elitist, and female writer, who wrote almost a hundred years ago, who was never a mother, and who has been glorified and often cited for her writings, including "Professions for Women"—a speech inspired perhaps by a public dig at her own family, specifically her maternal line, and delivered to young women who most likely literally and figuratively looked up to her.

It seems so sad (given her tragic end and the feminist authority with which she is credited), but the often unchallenged reference to her limited perspective knows no bounds: "literature, the freest of all professions for women" (8). When has this ever been so? For what women? For what mothers? For Woolf perhaps it felt that way, contextually more so than many other 'career' options perhaps, but for all women? Woolf claims, "if I have laid stress upon these professional experiences of mine, it is because I believe that they are, though in different forms, yours also" (8). Not true then, less so now. It is no more than a precious presumption. Woolf may have been granted room to write, but she wasn't also expected to create nut-free snacks each day, maintain an acceptable level of beach readiness, make solid, well-informed career choices, volunteer for a worthy community cause, take ten thousand steps, and cook an organic meal of clean food each evening. And that motorcar she bought? It never called from the driveway as she tried to write, beckoning her to clean it of the Cheerios and goldfish crackers smooshed into its carpeted floor, the dried vomit between the cracks of the seats, or the festering juice boxes hidden in the door handles. What of the cat? No seriously, what of the cat? Has anyone seen the cat recently? Fed it? Hmm, don't worry; it'll turn up. Beyond the tranquility of her room, Woolf's time was her own, her income was her own, her mental space was her own, her heart was her own, her paper was her own, and her pen was her own.

I, too, inherited the blinkered privilege of a white English background, albeit working class, and my literary education was built upon the tools of classic patriarchy and colonialism and is, therefore, suffused with an oppression that shapes my writing and understanding of being a writer. Given how much I've read, how does the writing of others (among other information mediums, granted, but from the earliest age and in more profound a capacity than any other) shape my mothering and understanding of being a mother? I can't count or seek out or appreciate or challenge alternative views on women's writing by writers who were mothers or their views on mothering if these women were historically unable to write. In agreement with Woolf, it is only in discussion and definition, in exposure and expulsion, that we can start to kill the "many phantoms and obstacles" (8) which limit us all in so many ways. And she's also right that the aim of these battles "must be perpetually questioned and examined" (9). But when she made these claims,

delivered her speech, and looked around the hall, it may as well have been a mirror, as her audience was predominantly, if not exclusively, young, white British women brought up on a diet of British classicism. My failed efforts to kill the Angel in the Ether were perhaps an attempt to hush the noise so that I could look to the gaps for the mother-writers and for the other writers who were missing—to seek out the echoes of their voices in the voids.

Virginia's time is up, and she must cease.

A room is no longer enough. Why should I or any female writer be boxed in? We now know a woman's home, regardless of its room allowance, is often not a safe space. Some of us still rally in an attempt to reclaim a sense of safety on the streets (has that ever existed?); online is no different, and the Angel in the Ether offers no protection. We need more space. We need a new space. We need an open, inviting, inclusive, safe, supportive, and communal space. We need a limitless space of our own. The time for safe enclosures has passed; we must think beyond the constructed ether to which we are given limited access. As mother-writers, we must nurture each other and other writers similarly misguidedly locked away in their own room or echoing in the void without traditionalist acknowledgment. We must knock over our literary pedestals and see what's underneath while never forgetting—and, thus, herein lies my only motherly advice—the most important story is (y)our own.

Works Cited

Woolf, Virginia. "Professions for Women." *The Death of the Moth*, 1942. Rpt. in *Killing the Angel in the House: Seven Essays*, by Virginia Woolf, Penguin Books Limited, 1995, pp. 1-9.

Chapter Ten

Mammas Who Brunch: Is Soup on the Menu?

Hinda Mandell

"The best thing about our mama brunch group
is knowing that we all have each other's backs."

"I really don't like that you tell bad stories about me to your girl-friends," said my husband amid the morning rush on a weekday morning. I was seated at our kitchen table, struggling to stuff our one-year-old into his Stay Puft Marshmallow-like jacket. I was already on the verge of being late to teach my 9:00 a.m. class.

The baby was fidgeting with the force of a small bear.

And I was in no mood for a morning fight.

"Ok," I said, settling on as neutral a word as I can muster.

Matt wasn't ready to drop this thread for a more opportune time. "I don't talk badly about you to my friends," he continued.

I momentarily stopped trying to push the baby's balled-up fist through the crumpled jacket sleeve and looked up at my husband, his expression calm. He wasn't gearing up for a fight at all. He was just being matter of fact.

"You're right. You don't complain about me to your friends."

That was the truth. But other dimensions of the truth were left unsaid. Maybe an emotional vacancy in his male friendships prevented him from being completely forthcoming about his marital grievances, or, perhaps, revealing his spousal frustrations would leave him vulnerable

to their judgment if they weren't well versed in the grief-sharing ritual that so many women have mastered with their closest female friends: *If you bare your secrets to me, I'll bare mine to you.* No one is left hanging. Just the opposite. We feel supported, loved, and validated by our close girlfriends. They hear us in ways that our husbands don't—or can't.

*

The night before this early-morning exchange with my husband, I was catching up over the phone with my best girlfriend, who lives halfway across the country. She had just given birth and was in the throes of newborn chaos. It wasn't the time for me to unload my latest husband grievance. But this was a good one. Besides, Matt was sitting next to me on the couch scrolling through movie reviews on YouTube, so there was the added benefit of indirectly chastising and shaming him while simultaneously retelling the story to my bestie.

"So, you know how during Thanksgiving Break, Matt and I decided that each of us would have two days to sleep in while the other gets up early with the baby?"

"Hmm-hmmmm," she said. "I'm pumping—that's the whirring sound you hear."

"OK, well, so Thursday and Friday roll around, and I get up with the baby—not that he offers—thinking I'll sleep in on Saturday and Sunday, right? So, on Saturday the baby cries at some godforsaken hour, and I nudge Matt and tell him it's his turn to get up. Matt sleepily says, 'I'm not ready to get up yet.'"

She gasped.

"Matt," I said, turning to my husband to interrupt his video binge watching, his eyes glued to the TV screen. "She gasped. That's how shocking your behaviour is." Oh, the validation felt so sweet. I was jubilant.

But I wasn't done. I turned away from my husband and curled into the phone. "So, I say to Matt—well, I was on the verge of screaming, really— 'Not ready yet? What does 'ready' have to do with anything?' And then he pulled the covers over his head and told me to leave him alone."

My best friend tried to think of some plausible reason, a rational excuse, to explain this out-of-bounds husband behaviour: "Are you sure he was really awake?"

*

Back to today, the day that Matt requested, in a placid and nonconfrontational tone, that I not speak badly of him to my girlfriends. I wanted to say, *Then don't do bad things, things that when conveyed to girlfriends make them gasp in disbelief*. But, instead, we had two kids to drive to preschool and daycare—with our four-year-old still languishing in her pajamas on her bed without any concern for the clock or our tempers—so I just said, "Okay."

<div align="center">*</div>

I am a part of a close group of girlfriends, and the four of us meet monthly for brunch dates. The bulk of our conversations focuses on our husbands (four in total) and our kids (seven under the age of five). We met through a common daycare, and our kids have grown up together. Demographically, we are similar: double-income households in solidly middle-class jobs, still struggling to make ends meet. Our spousal grievances are also similar: husbands who are involved in family life, but who lean towards a more passive approach when it comes to the demands of parenting. Really, it just feels good to vent.

Over a shared stack of pumpkin-cake French toast, with cinnamon-infused mascarpone cheese oozing between its layers, we dug into our latest round of grievances. Haley shared a tale of woe from a neutral party—a friend from college that the rest of us don't know. Apparently, this woman asked her husband for an afternoon's reprieve of child work one weekend so she could study for her certification. He was tasked with the sole responsibility of watching their three kids, ranging in age from toddler to preschooler, as she hit the books. When ruckus upstairs caused her to emerge from the basement, she found the three kids running around and—Haley paused for effect and leaned into the brunch table for emphasis—the husband asleep in their bed.

We gasped.

That was a good story, after all. Though not entirely unfamiliar, it was the magnitude of the situation—three kids running around unsupervised while the father enjoyed time to himself. Our brunch conversation quickly proceeded from *How is it that men can block out the chaos around them and erect a man-cave mentality wherever they are?* to a swap of similarly-themed stories. I shared the time from two years prior when I came home from a solo weekend outing to find my daughter wandering around the kitchen in nothing but a diaper. Matt was asleep on the couch—

snoring. Our living room looked like an explosion at a toy factory.

Haley jokes that another of her friends wanted to start a Tumblr called *Men Sleeping in Inappropriate Places*, featuring snaps of unsuspecting dads asleep when they should be parenting.

<center>*</center>

Matt is always eager to hear the gossip from these sessions when I return home (when he's not asleep on the couch or in bed). In these moments, he seeks redemption in the fact that his spousal misbehaviour isn't as bad as others', and together we revel in the knowledge that our dynamic—me nagging and disappointed, him deflated and defensive—isn't unique to us at all. Call it marital schadenfreude or call it conjugal pettiness, but it brings us closer for a few hours.

"Women are just better at parenting," Matt likes to say when I come home from brunch, and I eagerly tick off the list of various paternal deficiencies that have emerged over the course of multiple rounds of pour-over coffee. He adds, "You can multitask and focus better than we can."

If brunch reinforces anything, it's the distinction of us (mothers) versus them (fathers)—a demarcation that is socially contrived but that they (fathers) think is natural.

My response to Matt is always the same: "We multitask and focus better because we are the line of last defense. We are the last resort. You know that we will always pick up your slack. If we wait for you to make the lunches, pack the swim bags, and remember picture day, we would probably be expelled from every daycare in town—and our children would go hungry and never learn the doggy paddle."

I love delivering that line with gusto because I am confident that Matt and I agree that it's an accurate depiction of an imagined, alternate future—a future that we'll never meet because he's off the hook for proactive parenting, and I perversely relish in ensuring the smooth functioning of the daily machinations of our well-oiled household apparatus, despite the gendered tedium of my lot.

<center>*</center>

Our daughter attends a Jewish preschool that enforces a strict vegetarian and nut-free and bagged-lunch (from home) policy. When I was out of town earlier this year on a four-night work trip, I prepacked our

daughter's school lunches. I told my brunch girlfriends over text that if I left the lunch packing to Matt, he'd unintentionally assemble four lunches worth of peanut and bacon butter sandwiches, a strict violation of the school's religion-based and food-safety policies.

We guffawed over husband foolishness, but Matt didn't quite get the joke when I relayed the texting exchange for him. "Peanut butter sandwiches are vegetarian," he said. "Why can't I pack those?"

I answered his query with a question of my own, although mine was dripping with condescension: "Do you not see the signs on every door in the preschool, alerting us that we're entering a nut-free facility?"

"See," Matt retorted, "Mothers just notice these types of things."

Right, I thought, because fathers don't read.

<p style="text-align:center">*</p>

In between our monthly brunch dates, a string of snarky texts ping into my phone on a daily basis from the mamma crew, a type of emotional sustenance to sustain us as the weeks tick by before our next coffee klatsch. The texts are a continuation of our caffeine-fuelled conversations, mostly about our husbands floundering on the home front and our offspring's shenanigans. The texts are supportive, like digital cheers encouraging us, brainstorming solutions to the problem(s) du jour. A popular thread is when we ask our husbands to do the grocery shopping, and they muck it up in some monumental way. There was the time when I asked Matt to buy a bag of arugula for a simple dinner salad—and he came home with four bags of an arugula-spinach blend. What could I possibly do with so much roughage with an expiration date only days away? When I texted a photo to the brunch crew of the greens that occupied an entire crisper in my refrigerator, my friend Reena texted back, "Quiche for dinner?"

And then there was the time when Haley's husband was five dollars short to earn a twenty-dollar gift card at Target, and when the cashier brought this up and suggested he buy an extra packet of baby wipes in order to net the gift card, he politely declined the suggestion—and left Target sans the much-anticipated reward.

There was also the instance when Melissa sent her husband to the store with a list that had one item on it: Size 5 Pampers Cruisers. He came home with the right brand of diapers, the right size, but the wrong style.

It was around this time when a new thread emerged in our mamma-texting correspondence: the #nosoup commentary for when a husband slacks off or simply enters the cognitively cloudy state of Husband LaLaLand.

The hashtag about the hot and steamy food group refers—of course—to sex.

For instance, "My husband just told me he needs to figure out how to make more time for himself #nosoup."

Or, "The husband just put his dirty dish in the sink after I told him, twice, that the dishwasher is filled with dirties and can he run it, please #soupinseriousquestion."

And then this: "Matt just tore up the verbena I planted because he said they looked like weeds #nosoupforever."

Soup can be spicy hot. It can be salty or bland, comforting and homey. But it can also be weaponized for bad behaviour and incentivized for good. The sex-as-soup hashtag metaphor pays homage to the *Seinfeld* episode in which an overzealous soup maker expresses exacting expectations for his patrons' behaviour. The soup maker chastises customers who do not adhere to his strict standards for their behaviour, thereby ritualizing how his patrons should act as they wait in line for his delicious soup. His loyal customers submit to his antics, and potentially to his fury, because his soup is so delicious that it's worth it.

And so, too, us wives have admittedly become "soup Nazis"—the eponymous name of the 116th episode of Seinfeld—when our husbands' behaviour strays from our expectations of what is good, decent, helpful, and responsible in our household. They may not like when we nag, and they may not understand the difference between Pampers Swaddlers and Cruisers, but what happens between the sheets, they understand without question.

Lately, Matt has become jealous of my regularly scheduled brunch outings, of the time I spend in the company of close-knit confidantes while he holds down the fort at home. In fact, it's developed into a type of competition. I came home from our last brunch to find that Matt had already texted one of the husbands, his friend, and arranged a movie and dinner date for later that same day.

When Matt returned late at night, I was already tucked into bed. I asked Matt if they griped about their wives over the course of the evening. He shook his head.

"We talked about the movie and about social ills," he said, offering a list of topics that seemed so impersonal and generic that I was at a loss to comprehend how the subject matter could vociferously fill up a four-hour buddy date. It sounded dreadfully boring, lacking gossip, intimacy, or support.

*

The best thing about our mama brunch group is knowing that we all have each other's backs and that we are often more reliable to each other than our husbands are to us. Last year, while at the grocery store with Matt and our kids, we ran into Melissa's husband and their two children. Melissa was at home. I sent her a friendly text: "I ran into your husband at the supermarket! We're all getting lunch together at the food court."

She immediately texted back. "Can you ask him to pick up a baguette? He's not responding to my texts."

I turned to Dave, and relayed the message. "I forgot my phone at home," he said with a shrug.

I immediately texted Melissa, alerting her that her husband was sans phone, which was information that I hoped would explain his absence and thereby soothe any annoyance she felt towards him. And with that communication, I felt so profoundly tied to Melissa, just one wife to another. We wives are in it together—a safety net that regularly pulls us back from the edge of marital frustration.

I looked at David as he settled his young kids into their seats, making sure they were equipped with eating utensils, drinks, and the right carton of takeout food, and I wondered if Melissa's annoyance at not being able to reach her husband would result in a #nosoup night. But as David told one kid to eat two more bites of vegetables, and another kid to watch her elbow lest she knock over her juice, I imagined Melissa at home, content that her husband would bring home that much-anticipated baguette along with two fed children, and I realized that soup may be on the menu after all.

Movement Three
Rewriting: A Way of Becoming

Finally, by reimagining, we create opportunities to rewrite all dimensions of experience (temporal, personal, and cultural) in ways that reclaim and redeem the narrative composition of our lives.

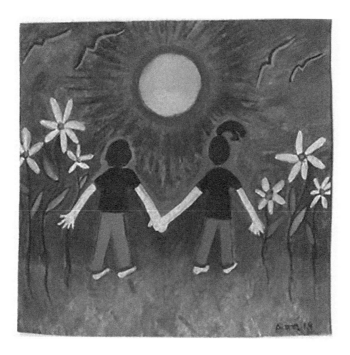

The Perfect Childhood

Rewriting the Self:
Acts of Transformation

Chapter Eleven

Grandmothering in Remission[1]

Michelle Hughes Miller

"I don't think many of us can do this, can let go of our present
to step into an unknown future, without desperately hanging
onto some truth, some sense of self, some reserve of energy
to guide us back home again."

*X*ander, your Grandma is really sorry, but right now I can't concen-
trate on this upcoming milestone in your life, your first birthday, be-
cause today I'm having my two-year scans. With this letter to my
grandchild, I begin a personal journey to process my grandmothering
from a position of uncertainty—in this case, cancer in remission. Here,
I incorporate letters to my young grandson and his mother, my daugh-
ter. I narrate the context of these letters through survival poetry,
personal reflections, and entries from my cancer journal, using these
musings to describe my expectations for, and experiences of, being a
grandmother within the context of my simultaneous efforts to under-
stand myself as a cancer "survivor" and the liminality and time limited-
ness of that particular status. Caretaking, in myriad forms, shifts and
transcends, hurting and healing. Worry abounds, centred on memories
and relationships. I struggle. I place my musings as a grandmother and
cancer survivor in interaction to ask *how do I grandmother authentically
when I no longer feel like me?*

I was alone when I got the phone call that the biopsy was malignant. But I already knew. I knew since the moment I found the ridge in my left breast and then found it again in the same place the next day. I knew since the ultrasound technician stopped mid-exam and said, "You're going to want to get this biopsied." I knew, I think, when the phone rang, even before I answered it. It was January 2014. Happy New Year.

During my first conversation with my surgeon, she looked at me very seriously and told me, "Cancer is not a crisis; it is chronic." I didn't understand, and I expressed frustration that it was taking weeks to make a plan for my treatment. I could not understand why she did not have the same sense of urgency to get this tumour, this 4.5 cm ridge of hardness living in my breast, out of my body before it spread (spoiler alert: it already had).

Two more times during that conversation she used the word "chronic." We didn't have to hurry, her demeanour implied. Speed wouldn't cure me. We could do all the testing we wanted, meet with all the doctors we needed to because cancer was chronic.

She was preparing me: I would have to deal with cancer for the rest of my life.

October, 2016—Twelve days until your first birthday

Xander, I have to tell you something, although I'm pretty sure you're not going to understand, seeing as you're not really talking yet. Your Grandma is really sorry, but right now I can't concentrate on this upcoming milestone in your life; because, today I'm having my two-year scans. What this essentially means is that from 9:00 a.m. to 2:00 p.m. today, I will be lying on various tables after various concoctions have been pumped and/or drunk into my system while big machines take pictures of what is inside of me. This is what they will find if I am lucky: nothing new. This is what they will probably find because this is what they always find: something new that doesn't exactly look suspicious, but they don't really know what to think about it, so they will want to run more tests. "Something suspicious" is what they will find if the cancer has come back and sometimes even if it hasn't. So far, the second set of tests has always come back negative.

The technicians have found various things inside me, although nothing fun like a train or a seashell. Instead, they find things like tiny weird-shaped bumps on my liver, a spot on my lungs, a strange bright spot on my twelfth rib, and some thickening of my peritoneum. Don't worry. I won't make you learn how to

say "peritoneum." It's one of those words that is actually easier to spell than to say, and since you are still working on how to say Grandma, I'm not going to push for anything harder.

Anyways, I want to celebrate with you, I really do, as you take this next "step" into toddler-hood (we both know you've been walking for a while, so all this is old hat), but frankly today is only midway in my semi-annual worry fest (because my scans are twice a year, of course). Two weeks before the scans, I start envisioning what would happen if they found something—if the cancer were back. Tears spring to my eyes unbidden, and I cough and claim a cold so no one notices. I meticulously soap my body in the shower, feeling for any lumps or difference that might be a sign of what they will find. Any ache gets reconsidered in light of a potential discovery. I become convinced that this time around I won't get good news, and it gets harder and harder to concentrate on work, on PopPop[2] and his silliness, or even on you and the upcoming celebration.

The worry builds until by the day before my scans I am practically incoherent. You and your mommy Skyped me that day, if you remember. That was only yesterday, but when you're almost one, your perception of time, I think, is a bit sketchy. Mine, on the other hand, is almost visceral, with each minute ticking off as the scans, and the potentially bad news, get closer.

I was sitting in my living room and you were, per usual, sitting on mommy's lap, smiling and laughing as soon as the camera came on. I always feel so special when you look happy to see me as we begin our Skype visit. I wish your attention span was longer so you could stay interested in me during the entire conversation, but I consider myself blessed that you look happy to see me during the first thirty seconds, at least. Later, I hope, we will have real conversations via Skype (if the cancer hasn't come back).

Because we are flying up to be with you on your first birthday, we discussed the particulars of our trip. We fly to you the day after I get the official results from the scans—and for a moment, I couldn't breathe as I considered having to tell your mommy, a few days before your birthday, that my cancer had returned. Yes, that was when I excused myself because I had something in my throat and needed a drink of water.

I'm actually not sure what made me cry right then: the thought of telling your mommy—my daughter!—that they found something or the overwhelming worry that this will never be over, and as much as I want to celebrate your birthday, I can't get away from this chronic disease that has

me by the ... well, I was going to say breast, but that's gone now so maybe by the brain? That appears to be where all the hubbub is coming from right now anyway.

*

Both children came for my surgery in April 2014. It was an intimate time. I did not know how to be cared for. I did not know how to accept nurturance from those whom I had nurtured. I wanted to do it for myself, be the hostess and be their mother! Yet they were so kind, so mature, and so calm—I felt silly in my fear and embarrassed by my complaining. They didn't seem to notice, even as they drained my tube, prepared my food, opened my doors, and held onto me as I walked gingerly around the block. But I tried not to cry in front of them.

December, 2014

> Gratitude (or dependence)
> I owe debt too heavy I
> Cringe beneath its weight
> I shrink below the sight line to
> Hide. I'm in deep.
> I whisper thanks on the
> Wind but the chill
> Doesn't leave and I can't
> Dig fast enough to keep my
> Regret at bay.

May, 2014, Journal Entry

> I've been thinking about attitude. My ruminations started when my friend Ray, who has just gone through chemo for bladder cancer and been finally declared cancer free, told me with glee in his eyes that I needed to be "aggressively optimistic." That's the trick, he assured me, to a full recovery. Believe, over believe, that everything will be okay and eventually it is. Be so aggressive about it that you annoy people with your optimism.

> I'm not sure how to do that. Pollyanna is not a role to which I've ever aspired, or one I've actually rehearsed. How is one aggressively optimistic about their cancer diagnosis?

Living with cancer is not conducive to optimism. Just when you think you've found equilibrium, nausea kicks in again. Take exercise. If I was aggressively optimistic, I would believe every morning that I could walk my speed, my distance, and have enough energy to return home to perform the tasks of the day. But the reality is that my energy requires a careful balance of conservation and expenditure—I must be aware of my energy needs so I can manage the energy that I have, which can dissipate in an instant when I don't even expect it.

I am reminded of the character Anton in Gattaca,[3] who didn't understand why his brother Vincent, a genetically inferior human, always beat him swimming. "You want to know how I did it? ... I never saved anything for the swim back," Vincent explains. If I were being aggressively optimistic, I would be like Vincent, the victorious brother—always putting my all into everything, into every bit of exercise, without concern about the journey home.

Perhaps my resistance to the mantra of aggressive optimism is rooted in a lack of trust. Trust that my body won't fail me. Trust that my nausea won't return. Trust that the chemo drugs are working as well on my cancer as they are on my hair follicles. Or perhaps my resistance is rooted in a basic conservatism that comes from my upbringing—the same upbringing that has me washing out plastic baggies and clipping coupons. Can one be both a planner and aggressively optimistic?

Chemo is decidedly not aggressively optimistic. It's the opposite: aggressively pessimistic. Chemo is based upon the premise that cancer has spread, that its cells are throughout my body, and that by feeding them these toxic cocktails they will eventually remutate and stop reproducing, thus making me cancer free.

What is the journey back for which I should not save energy—if I'm being aggressively optimistic? The journey after this round of chemo? The journey over the next ten years, while I wait to see if the cancer has returned? How do I not acknowledge that which they told me during my first doctor visit—that cancer is a chronic illness? One that is managed. One that, presumably, might require you to have some reserve strength because guess

what—you're in this for the long haul, possibly the rest of your life. That's a long journey and a long journey back.

But perhaps that is the real problem: my insistence on journeying back. Perhaps there is only forward in this journey. I must travel through. There is no returning to a time precancer and, therefore, no reason to conserve energy and self for the return trip. Perhaps being aggressively optimistic just means packing the bags, all the bags, and going on the journey knowing—and accepting—that whatever you're leaving behind is gone forever. There's no reason to conserve energy, or self, because there is only change ahead of you.

I don't think many of us can do this, can let go of our present to step into an unknown future, without desperately hanging onto some truth, some sense of self, some reserve of energy to guide us back home again.

But aggressive optimism, like the victorious Vincent in his one-way races, demands, dare I say it, faith. Not faith in a higher power but faith that resources will be there when needed. That energy will come. That truth will be retained, that one's self will grow and not mutate like the cancer cells. That it's okay to let go. That there's maybe an end to all this. Though that end isn't where we began, so many months ago.

<p style="text-align:center">*</p>

Finally, in November 2014, I celebrated finishing treatment (chemo and radiation). I was exhausted and overwhelmed and still amazingly in denial that this ~~had happened to me~~ was happening to me. I celebrated Christmas with my children and their spouses. I celebrated the new year with my love. I celebrated a new semester, a new moon, and a new project. I drank alcohol again. I grew my hair back. I put away the fantasy of writing a book about cancer that was feminist and would not invoke the violent masculinist metaphors so common to cancer survivorship (beating, fighting, war, etc.). I mean, *what do I know anyway?* The work to research the book alone would take forever. Instead, I concentrated on getting through the next day.

And then I got the news! A positive pregnancy test. A beaming

daughter. A plea in her eyes to be happy, to see the future, and that 2015 was going to be a much better year! I was going to be A GRANDMA. I felt such an inhale of joy it permeated my body, emptying me of the stale breath of cancer fear I'd been holding onto.

I tried to be there for some of the major pregnancy events—driving fifteen hours or flying when I could for various activities. I was at the baby shower, making fun food to represent children's books, and building diaper cakes. I was there for the twenty-week ultrasound and knew instantly that I was going to have a grandson, even before the big gender reveal. I helped my daughter with the registry, painted the nursery with my son-in-law, and tried to provide support and encouragement to my daughter that it was okay to sit down, to put her feet up, to claim her own needs, and to relax. I tried to give care, whatever she needed, and I tried to encourage self-care. I thought the latter even more important, as I clearly remembered how little I cared for myself after I became a mother; I did not want that same fate for my daughter.

Upon her request, I loaded a pregnancy app on my phone and received updates about fetal milestones as they became available. Each time the app sounded, I smiled. I thought about my own pregnancies and realized just how much I'd forgotten and how much everything had changed. What advice could I give?

I spent a lot of time listening and telling my daughter she was making good decisions, the right decisions, for her and for her baby. But the mom in me worried about her health (the mom in remission, that is). I worried I wouldn't be there when she went into labour. I worried and made plans and drove my husband crazy with my worries and planning because worry—railing against the unknown future fraught with possibilities of risk and danger (God bless the Internet)—seemed like something I could do.

Something I was doing.

Throughout the pregnancy, I kept getting called back to cancer; my joy was tempered with worry and doubt. Sometimes the worry and doubt fuelled by doctor visits and scans left little room for joy, and they merged into a generalized fear that I wouldn't be there, that I couldn't help her, that something would go wrong, and that all my planning wouldn't be good enough. It didn't help that Xander's due date was almost a year to the day from when I finished my cancer treatments—an annual reminder of how long I've been in remission.

43%

I am not a math hater, but odds of winning a lottery intimidate me and chance of rain annoys me and

the tax forms have to be double and triple checked because numbers move when they shouldn't.

I am not a math hater, but I would like to burn the piece of paper you gave me that said even with chemo and radiation and five years of tamoxifen I have a 43% chance of recurrence over ten years.

I'm 52 years old. I just became a Grandma. Nine years left.

*

Xander—I take one step towards you, towards the future, and then I'm back in the present, in my body, for the quarterly search for where the cancer went. I wish it'd left a forwarding address so we could stop looking.

I went back to the doctors again and again ... my list of appointments seemed endless, divided between my surgeon's physician's assistant (PA), my oncologist's PA, my radiation oncologist, my scans. Blood tests every three months made me decide to keep my port in—a constant reminder that it wasn't over. Each person felt my scar, then my remaining breast, and then my lymph nodes. Said I was doing fine and sent me on my way with another appointment slip.

Dear Xander: I don't like playing hide and seek. I mean, I love playing hide and seek, but sometimes I feel like it's too real, you know. Something hides. Someone seeks (in my case using really expensive technology). Finding the something means you win. I'm not so sure.

December, 2014

 Free
 Until the word comes I
 Listen to my body
 Interpreting each little
 Movement's pain through
 Ears that worry and
 Fingers that probe.
 A breath catch terrifies
 And I'm waiting
 For the word.

*

My daughter watches me, sometimes. I don't know if she's watching me for the same reason the doctors are or if she's watching me because she can tell how vulnerable I am sometimes around Xander.

Or maybe she's just watching to see what kind of grandmother I am. I'm pretty sure she has an idea what kind of grandmother I should be. *I wonder if our ideas align.* I want to be loving and fun and someone my grandkids want to talk to and hang out with (sometimes). I want to say "yes" more than their parents can but still teach them values important to me. I want to be someone who matters to them. I want to be someone they remember. I want them to have Grandma stories to tell.

I bought this book before Xander was born called *The Invisible String.* The story is a simple one: the mom explains to her children that they are never alone in the world because they are connected to everyone they know by an invisible string that stretches everywhere. As soon as I could, I started reading this book to Xander, usually the day before I headed home after a visit. I'd put him on my lap and we'd share a moment where I would read the story, and then I'd tell him how special he is to me and that I'm never far away.

My daughter makes this happen. Sometimes she asks me to read to Xander before bed on my last night, knowing I'll take the opportunity to read our special book. Sometimes she watches me read to him on the baby monitor. *Does she worry I won't be here, too?*

When I bought the book, I was thinking about distance. Fifteen hours away. That is soooo far. If I could only wiggle my nose like Samantha on *Bewitched*,[4] I could be where I want to be anytime. I could help my daughter mother. I could help my daughter by being her mother. I could help my daughter be the mother she wants to be.

But it's not really the distance that is the problem.

I bought the book because I wanted the ritual—the time with Xander to talk about me not being there. To tell him that even though I may be gone, I would still be there, just like Uncle Brian in the book is still with the children, even though he is in heaven. I didn't buy the book and I don't read the book because I want to call him up when he's ten and say you've been tugging on my invisible string. What I really want is for Xander to remember me and to feel connected to me. Now.

And when he's ten.

Even if the cancer comes back. Especially if the cancer comes back.

Xander, I do so much to try to create memories for you, even though you're just now two and chances are you won't remember anything.

Our weekly Skype ritual? So you don't forget me. PopPop gets annoyed that you seem to think the Skype call is passé—you're more interested in your toys than us most of the time. But I don't care. If I'm passé, that means it's because you know me; you are comfortable with me; I'm a presence in your life.

Sometimes when mommy's not watching I just talk to you—tell you stories about my life, and tell you stories about your life from my perspective. Sometimes I play a game I secretly call "What does Grandma like?" Does Grandma like books or puzzles? What is Grandma's favourite colour? What does Grandma like to do? These are "educational" questions I can weave into the conversation any time, like when I told you I liked when dinosaurs danced rather than stomped, and then we danced around the living room. I do this a lot, Xander. Maybe some of what Grandma likes, or what Grandma is like, will stay with you.

I sing to you every chance I get, even in the car when we're just driving some place. I know I don't have a great voice, but for some reason it's important you hear the songs I sang my children when they were little— that you learn the words to the old songs that brought them joy when they were young. I want you to hear some songs and think of me.

I read into the recording book for you—just so when I'm not around you can listen to my voice. PopPop did too but not for the same reason, I think. I love that sometimes you choose to get those books off the shelf and listen to us read you the story. When you read some books, I want you to think of me.

I write stories for you, in my head. Some I record, some I write down, and some I bring to you. You're so little! How will you ever know that you inspired me to write?

When you're older, and you read this, you'll probably feel like I was trying to leave my imprint on you—to make you subconsciously remember my voice, my smell, my laugh, and my songs. And honestly, if I knew how to do that, I probably would, even though that sounds a bit creepy. But I will do what I have to do so that years from now when you're talking about your Ga-ma, you will have something to say. Just in case the cancer comes back.

I'm crying while I write this. I'm sorry. The need for you to know me is so intense. And it doesn't feel grandmotherly at all.

*

July, 2014 Journal Entry

The other night I found myself in a conversation with casual friends about my cancer. I didn't intend to be in this conversation, but it seems like that's all I get to talk about with acquaintances these days. In the midst of this conversation, one woman told me that I looked better than I did before cancer. In fact, I was the only person she'd ever met who looked better with cancer than without. Another woman in the conversation tried to temper this comment by saying that I looked more peaceful—like I'd given away all the petty travails of life and that this peacefulness just showed through my face. Not to be outdone, the first woman claimed that I was soon going to discover that cancer was the best thing that ever happened to me. To explain this, she discussed her own lupus diagnosis from ten years ago, which gave her the ability to just say "no" to things that weren't working in her life. You'll see, she told me, you'll be better off now.

I let that thought percolate in my head. *Cancer is the best thing that ever happened to me. Really?*

Probably correctly reading the incredulity on my face, the second woman again tried to temper the comment. Maybe your husband is the best thing, and cancer is just in the top five, she suggested. Maybe my children are somewhere above cancer in their importance in my life, I join in. I then have this surreal out-of-body experience in the middle of this conversation, as I realize the three of us are trying to rank cancer in terms of its positive effect on my life.

Dear Xander:

I hope I never have to talk with you about cancer. But Xander, I had cancer. (Is that the right tense?). In 2014, before you were even conceived. And I'm still dealing with the lingering aftermath of this chronic disease. I just had another scan last week! And I still worry that I won't be there as you grow up and that I won't see you play your first ball game or graduate from college. I want you to remember me as the woman who played with you, read to you, sang to you, laughed with you... I want to be present in your life. I want you to not just remember me but to know me, as I'm getting to know you.

But there's something you need to know: the Grandma you know isn't the woman I was before you were born. I'm different. I feel different. The difference isn't in my missing flesh, although when you curl up against my prosthesis I wonder how it feels to you, this fake pillow under your cheek.

The difference is in me: my heart, my brain, my sense of self, and especially in my sense of time. There's so little time, really, even in long lives. And the uncertainty of how much time and what kind of time makes me want to hold on tightly to time with you, even though I'm still overtly living the life I had before both you and cancer. You never met the Grandma before cancer, the Grandma who worked and loved and partied and mothered your mother. Throughout your whole life, I've been in remission, wondering if the cancer will come back. Wondering when it will come back.

I've been on this long journey that never seems to stop. No matter how I try to concentrate on you, on your future, on my future, on our future, I keep getting pulled back into the visceral experiences that remind me that cancer is chronic.

I know some cancer survivors are good at letting go, of believing they are free, like my friend Ray was. I'm trying, Xander. I'm trying for me. I'm trying for you. I'm trying for our relationship because I don't want a relationship with you that is shadowed by the fear you will forget me. Or will never know me. Or that I won't be here to celebrate your life.

I want to see the future as possible and to see us, together, in the distance. I want to finish a letter to you in hope, rather than tears.

On one level, grandparenting is so much better than parenting. It's like eating cheesecake without the calories or seeing a Broadway performance from the front row for free. You get to watch one of the loves of your life love and care for another, and your only real responsibility is to enjoy—although helping is pretty fun, too.

But grandparenting is also more tenuous because your own aging takes you further from your grandchild's future. That's the natural order of things, and I actually take comfort in knowing that I'm supposed to/must/will go first. It makes the time together sweeter.

At least it should—if it wasn't for the damn cancer, messing with my sense of self, screwing up the timeline, encouraging me to think of myself as an unwitting passenger on the chronic cancer journey, and pulling me constantly back into my body with the search for mutations.

I do not know this Grandma, this woman who thinks about herself as vulnerable. I do not like this Grandma, who worries about everything and sees life as fragile and dangerous. I do not want to be this Grandma,

whose joy is constrained by what-ifs. I want to exhale all the fear and only have joy to breathe.

Help me, Xander, to be in the moment, with you. I'm so in love with you, my grandchild. Somehow, despite everything, you make this journey—this awful, unknown, and scary journey—magical.

*

Leftover

I cup my breast feeling its surprising fullness. I

Thought it would be lessened by the cancer, this remaining

Flesh on my scarred chest. But

It is warm and human and it feels like me.

Endnotes

1. A shorter version of this paper that was presented at the 2018 I Love M.O.M. Conference in St Petersburg, FL, was published in the *Journal of the Motherhood Initiative*, vol. 9, no.1, 2018.

2. PopPop is what Xander calls his Granddad.

3. *Gattaca* tells the dystopian tale of a man (Vincent Freeman, played by Ethan Hawke) whose presumed genetic inferiority marks him officially as incapable of and inappropriate for success (at athletics, work, love, etc.), a pronouncement he continually confronts and overcomes in the film.

4. *Bewitched* was a television sitcom that portrayed a married couple dealing with the wife's identity as a witch. Samantha, played by Elizabeth Montgomery, frequently used her magic to deal with problems they encountered.

Works Cited

Bewitched. Ashmont Productions, 1964–1972.

Gattaca. Directed by Andrew Niccol, performance by Ethan Hawke, Columbia Pictures, 1997.

Karst, Patrice. *The Invisible String*. DeVorss and Company, 2000.

The Possibility of Everything: A Mother's Story of Transformation

Michelann Parr

"I might have been able to pare down this process by being more mindful and attentive many years ago, but I cannot change the past, only who I am in the present."

"When God closes a door, he always opens a window."
—The Sound of Music[1]

Birth of Motherhood

August 24, 1984
Suspected date of conception.

October 5, 1984
Pregnancy confirmed and estimated delivery date given as May 31, 1985. Antenatal period uneventful.

December 1, 1984
Catholic banns of marriage for upcoming wedding formally published.

January 19, 1985
Wedding vows exchanged.

"Love is always patient and kind; it is never jealous. Love is never boastful or conceited; it is never rude or selfish; it does not take offence, and is not resentful. Love takes no pleasure in other people's sins, but delights in the truth; it is always ready to excuse, to trust, to hope, and to endure whatever comes. Love does not come to an end."

—1 Corinthians 13: 4-8

May 27, 1985

Fetal ultrasound and pelvimetry. Fetus is frank breech and the capacity of the mother's pelvis is inadequate to allow the fetus to negotiate the birth canal.

May 30, 1985

Fundal height, as determined by obstetrician, suggests that estimated date of delivery (as reported by mother and ultrasound) is incorrect. Follow-up appointment scheduled for Thursday June 6, 1985.

It was dark. Long past bedtime. The curtains were drawn, shutting out the faintly twinkling stars and the three-quarter moon. I was safe in the embrace of night, or so everyone thought. The discomfort I felt in my lower abdomen and the sharp pinch of an IV in my arm reminded me of that morning's emergency Caesarean section, which was given after I unexpectedly went into labour. Fighting the sedation, I tried to recall bits and pieces of what I had heard throughout the first day of my daughter's life.

Hospital televisions earlier in the day reported whirling clouds and an angry Mother Nature, who delivered death and destruction on an almost unprecedented and unimaginable scale. Twelve died, hundreds were injured, and even more left homeless in a series of tornados that began in Hopeness, Ontario.

Waiting with my parents and husband, my younger brother caught a glimpse of my daughter as the pediatrician whisked her through the waiting room: observing a very well-placed umbilical cord, he cried out in joy, "See? Told ya. She's a boy!"

As I allowed myself to fully wake, I reached into the deep recesses of my mind; I knew that I had given birth to a baby girl, but that was about

all I knew. And there was no way to be sure even of this. As my eyes adjusted to the darkness, I looked around the room for the pink flowers, shiny balloons, lacy cards, and frilly dresses—anything that would have marked her arrival. But there was nothing to be found. Where there should have been light, there was darkness. Where my arms should have been full, they were empty, leaving me devastatingly alone to seek a truth and to understand where my baby was.

Panic set in. I slipped my feet into the hospital-issued slippers and shuffled to the door, accompanied only by my IV pole. One step at a time, I made my way down the hall toward the nursery, every step seeming like the journey of a lifetime.

I approached two sets of windows. I remembered from my hospital tour that the healthy babies were on the right—little ones, carefully swaddled in pink and blue, sleeping peacefully or hungrily awaiting their mother's breast. The left bank of windows looked in on the neonatal intensive care unit (NICU) where little ones rested bare and naked; some were hooked up to machines, all carefully watched over.

Intuitively, I wandered to the left. I stood at the windows, quickly scanning the pink and blue cards that marked the incubators. A sturdy nurse with a no-nonsense demeanour looked up from the back corner, seeming to recognize me. She hustled to the curtain and quickly closed it, leaving me alone in the dim corridor. The door opened a crack, and she told me, "It is late. You shouldn't be here right now. You shouldn't be up. You shouldn't be on your own."

The door closed, and I was alone again. There was no one at my side; no one to hold me through the darkness and the pain of not knowing why she is not with me, why I haven't held her, and why I can't see her. *Where else should I be?*

> "Sometimes in the darkness all we can do is keep going,
> even if the road is rocky, uneven, confusing."
> —Sharon Salzberg[2] (110)

I heard movement behind me. With tears streaming down my cheeks, I turned around. The maternity nurses approached, who were ready to put me back in my room, to put me back to sleep, to rid me of my apparent exhaustion, and to calm me. Little did they know that my exhaustion was nothing when compared to my fear and despair. I couldn't move, and they couldn't move me. There was no way I was leaving until I knew

where my baby was. I didn't care what time it was. Realizing that I would not go back to my room, they offered me a sterile gown.

May 31, 1985

3,240-gram female neonate was born at term gestation by emergency Caesarean section without a significant trial of labour. Oligohydramnios (abnormally low level of amniotic fluid) noted. Obstetrician questioned possibility of manual premature rupture of membranes. Maternal grandmother vehemently denied. Neonatal respiratory distress (bilateral pneumothorax) requiring needle aspiration was followed by intercostal catheter for ongoing management. Supplemental oxygen via hood was administered. Hypertension was noted, monitored, and treated. After hand, arm, and foot sites were exhausted, IV was inserted into superficial temporal vein. Physiological and behavioural responses associated with pain were observed; ongoing analgesia was ordered.[3]

I was allowed to enter the NICU, and the nurses escorted me to my daughter's side. I stood for a long time, looking through the glass shelter that enclosed her. She looked so fragile and so very small. How I longed to have her back inside my womb, safe, and close to my heart. I would have settled for having her wrapped in a pink blanket. Instead, she had monitors and wires and tubes. I heard the monitor as it captured the soft but rapid beating of her heart. I watched the expansion of the blood-pressure cuff as it squeezed her tiny arm and registered numbers I did not understand. I saw the gentle rise and fall of her chest as the oxygen inflated her lungs and sustained her life just a minute, just an hour, longer. I saw the tubes on each side of her chest and anticipated lifelong scars—reminders of how her life began, evidence of her first breath. Silent tears were shed, and a prayer whispered into the night.[4]

"She is a fighter. She survived a very tenuous birth. Her pediatrician is a miracle worker. Her surgeon was amazing. Her vitals are excellent." Gentle encouragement was offered, but it was little consolation. My tears fell quicker as I saw the very little hair she was born with shaved to make way for an IV. The nurses assured me that it would grow back. With all the courage I had, I tried to reach into her and to touch her in a way that my hands could not. I wanted to tell her: "I hold you. I see you. I love you. You are not alone. I am watching over you."

Grace under Pressure

As she struggled to breathe, so too did I. My mind raced. I thought how unfair this all was. *I did everything right. What did she do to deserve this? What did I do to deserve this?* In that moment of quiet desperation, I noticed her pink name tag. Knowing in my heart that she was not yet named, I expected only to see her weight, date of birth, and last name. But as clear as day, there was a first name. I looked up and asked, "Mary?"

The nurse with the no-nonsense demeanour must have seen the shock on my face because she gently offered: "Before your parents left for the night, your father baptized her Mary. He could have baptized her with his tears."

> "Hail Mary, full of grace
> The Lord is with you.
> Blessed are you ..."
>
> —Anonymous

My heart plummeted and my distress became laced with anger and fear. *How blessed is my daughter?* I knew what baptism at birth meant—that she was being cleansed of original sin and bathed in God's light, that she was being welcomed as a child of God, and that she was not expected to live long. Her name was a prayer to Mary, asking that my daughter be kept under her watch.

I was finally extracted from the NICU and returned to my room. I was asked to be a good patient. I was reminded that getting up and down after surgery required nursing support. Once again, I felt the cool release of a sedative into my arm. But sleep did not come easily, as I fought against what the nurses and my doctor felt was protective calmness. I was not long at peace, imagining that my newborn daughter felt as I did—abandoned by the world, by my husband, and most certainly by a God that I had come to trust.

> "Now I lay me down to sleep,
> I pray the Lord my soul to keep.
> If I should die, before I wake,
> I pray the Lord my soul to take."
>
> —Anonymous

My mind worked overtime: *Mary? How could this have happened? Why had my husband not spoken up? Where was he? Where is he now?* He knew how I felt about the name Mary, or at least I thought he did. My middle name is Mary; it is the part of my name that I least understood, the part that I could not trace back to my grandparents. Never had we considered Mary as part of a name for our child.

I was devastated, yet, on some level, I understood what my parents did and why. I had lived my life as a good Catholic girl, often known as the deacon's daughter. By choice, I attended an all-girls Catholic high school; I worked hard and left early to go to university close to home on full scholarship. I went to church every Sunday, sometimes twice. I participated in Catholic youth groups and retreats to deepen my faith. I engaged in weekly bible study and daily prayer. I worked at the church. And I spent many years in the Legion of Mary, a group dedicated to service in her name.

But at that moment, I was less than happy with God, and I was certainly not seeking any type of spiritual redemption for myself or for my daughter by naming her Mary. And I was more than angry that I hadn't been consulted or even present. *And what if she does not live through the night? Do I really want her soul to be taken by the God who allowed her to enter the world this way?*

The sedation began to take hold. As I fell into a dark, tormented slumber, I was plagued by decisions I had made in my life and by the reasons for which I might have been punished: *Was it because I hadn't been a good girl? Because I hadn't waited? Because she was born four months into my marriage?* It wasn't the end of the world, so I was told. I had already heard my grandmother's "so what?" wisdom.

All the way through the first night, I fought, I negotiated, and I pleaded with God to save her, to watch over her, and to let her wake. I promised to keep her safe and to do whatever it took.

As I drifted fitfully to sleep, I heard her name.

> "Do not be afraid for I have redeemed you.
> I have called you by name;
> You are mine."
>
> —Isaiah 3:1

I awoke the next day in a hospital-issued gown, not the pretty one I had packed with shoulders that slid up and down to make breastfeeding

easy. The one they gave me was threadbare, sterile, and cold. It was everything I had planned to avoid. *Was I already failing as a mother? If I could not keep her safe at birth, how could I possibly hope to keep her safe in life? And if I could not be at her side, hold her, and feed her, how would she know that I was there from the very beginning?*

My husband returned to the hospital, and we made our way to the NICU. The first order of business? Change her name.

June 1, 1985

Parents permitted skin-to-skin contact. Nasal-gastric tube feeding with colostrum initiated.

June 2, 1985

Locum pediatrician from Shriner's Hospital in Montreal arrives. Neonatal ultrasound reveals bilateral enlarged echogenic kidneys. Preliminary clinical diagnosis: kidney disease. Approximately 30 per cent to 50 per cent of these infants die in the neonatal period or within the first year of life from respiratory insufficiency. Prognosis: Uncertain. Appointment with Nephrology at Hospital for Sick Children in Toronto, pending.

Each morning, the doctors and nurses made their rounds, often accompanied by student doctors and nurses. That day, they asked my permission to have the students listen in. There was a new doctor, who ordered another round of tests. Later that day, we were finally offered an explanation: "We think she has a kidney disorder. Her prenatal kidney function produced an insufficient amount of amniotic fluid that limited lung expansion causing both lungs to puncture with her first breath. We have relieved the pressure on her lungs; we are treating high blood pressure, and we will continue to monitor her vitals. When we are comfortable that she is breathing on her own, we will ..." Wait ... I felt like I was suffocating. Words in my head drowned out the voices in the room: disorder, limited, insufficient, pressure. I came up for air long enough to hear: "Enjoy every single moment. Of those who survive such a traumatic birth, 30 to 50 per cent die in the first year of life. But be hopeful. As each day passes, her chances of survival increase."

I had more questions than answers, more confusion than clarity, more tears than smiles, more shame, more fear, more anger, just ... more. But there was no one who could offer me more than "God always has a purpose." *What was the purpose of the multiple deaths and injuries in this week's tornados? Why would God allow me to carry a child full term only to lose her at birth or shortly thereafter?*

We finally began to amass the coveted pink flowers, shiny balloons, frilly dresses, and lacy cards. Some felt like hope, some like pity, some like denial, and some like a cruel joke. My little one was freed from her sleeping chamber for an hour here and there, just long enough to be dressed up and passed among the many arms of visiting family and friends who had drifted from far and wide to see her.

There was little anyone could say, and little that I was willing to hear. What I really wanted was to just have her, hold her, and keep her safe. I didn't want to hear any more about God or how babies are gifts from God. *How can that possibly be if he is so willing to put her at risk?* I didn't want to hear how miraculous her birth was or how I should be giving thanks for the angels who watched over her. *Angels? I'm just thankful that she had such a responsive doctor.* What I wanted most of all right then was just to be in the presence of my daughter and to ward off the impending sense of loss—loss of certainty, loss of faith, and loss of my daughter's health.[5]

Day after day, they brought me yet another gown. Blue, yellow, green—I took what I was given. It was my symbol of despair, of shame, of failure.

> "Shame is the fear of disconnection—it's the fear that something we've done or failed to do, an ideal that we've not lived up to, or a goal that we've not accomplished makes us unworthy of connection. *I'm not worthy or good enough for love, belonging or connection. I'm unlovable. I don't belong.*"
>
> —Brené Brown[6] (*Greatly* 69)

A friend and fellow worshipper gave me a book called *Listening to the Littlest;*[7] I angrily but desperately flipped through the pages, searching for answers and wondering whether I would ever have the opportunity to truly listen to my daughter, to blow bubbles, and to paint with all the colours of the rainbow. Looking at the words through a blur of tears, my eyes rested on the first few lines of a poem:

"If I have special needs remember,
they are special but I am not.
Treat me like all the rest,
except when I must be set apart or different."

Special needs. This was beyond what I wanted for my daughter. Beyond what I wanted for myself. And how exactly could I ensure that the world didn't treat her differently if, in fact, she survived? Fear settled in, and again, my mind was filled with questions: *What are the long-term implications? How long will I have her? What will be required to care for her? Will I be able to fully embrace a child whose needs may be different, a child who has a 30 to 50 per cent chance of death? Do I have the emotional capacity to care for my child, to care for my husband, and to care for myself?*

Day after day, I made my way to the NICU and sat with my daughter during each of my waking hours. I held her through the sterile sleeve of her incubator when I couldn't hold her skin to skin. I heard the obstetrician's apology for his flippant accusation. I watched as they removed the intercostal catheter and the IV. I learned to attach the nasal-gastric tube to a small syringe filled with breastmilk. I pumped my overflowing breasts at regular intervals. I longed to feel the soft, gentle tug of her little mouth and be rid of the insistently relentless breast pump. I became adept at changing her diaper and weighing it; I remembered to keep a detailed log of inputs and outputs as I watched how her kidneys functioned better in the outside world than they had inside my womb.

June 4, 1985
First bottle of breastmilk.

June 5, 1985
Released from oxygen-supplemented incubator.

June 6, 1985
Started breastfeeding. Permitted to room in.

Days that felt like a lifetime passed, but it was only six days before I finally put her to my breast. The nurses reminded me to check that her ears were not folded as I nursed her. "That would make for floppy ears,"

they winked. They showed me how to break the strong seal of hungry suction; thankfully, it was no longer as simple as flipping a switch. They demonstrated how to administer medication through a tiny syringe—sneaking it in at the beginning of a feeding to ensure that it was swallowed and accompanied by nourishment.

Seven days into her life, I began to feel hope. I refused the gown offered. I donned my new mother clothes. And they sent me home.

This was definitely not what I had planned, anticipated, or dreamed of for the last nine months. From the moment I felt her within me, I loved her. I cherished her, and I did everything in my power to let her know that, above all, she was loved from the very first moment I knew she was there and that once I got over the initial shock, I was thrilled with the possibility of being a mom. I knew what I wanted for my child and for myself, as mother.

We had prepared for natural childbirth, attended weekly Lamaze sessions, and given consideration to a midwife and home delivery. We opted for a family physician, the same one who had delivered me in the very same hospital. I attended La Leche League sessions to familiarize myself with the struggles and successes of breastfeeding. I read countless books on what to expect when pregnant, what to be aware of in the first year of life, and what to feed children to keep them healthy in a world of pesticides and additives. Cloth diapers were laundered, folded, and stacked. Gender-neutral sleepers and denim overalls were hung with care. The bassinette sat in the corner of our bedroom, lovingly adorned with lace and ribbons and eagerly awaiting the sweet smell of a newborn.

But there I was, a week into my daughter's life, being asked to leave the hospital—without her.

My obstetrician and family doctor were firm: "It is not good for you to be here. You are not sick. And other mothers are coming and going with their babies. It is just not healthy for you to experience that." The pediatricians told me: "We don't know when we can release her. We just need to wait and see what tomorrow brings." The NICU nurses tried to console me: "You can come back and visit. We are doing everything we can to keep her safe and comfortable." The priest reminded me: "To everything there is a purpose and a season. God just doesn't give us more than we can handle."

What does he know? I thought.

Faithful Intentionality

I disguised my feelings of abandonment with an invisible, yet heavy, cloak of strength. I made a conscious decision to conceal my anger, vulnerability, and shame, and to exhibit nothing other than unconditional love for my daughter. I vowed not to waste a day, an hour, or a minute in contempt, in betrayal, in anger, or in the selfishness of pity. I would not allow myself to engage in the blame game and hold God accountable—a God who did not, in any way, seem to be listening. I would not continue to be resentful, and I would certainly not give anyone the impression that I felt abandoned in her birth and that I was fearful that she would feel any differently. I would be strong. *I was strong.* I would do what it took to care for my child.[8] I pushed the negative feelings down, knowing that no good would come of sharing them and that declaring my hurt and vulnerability would interfere with the reality that I needed to live.

I left it all at the hospital, wrapped in that threadbare, hospital gown.

"He who has a why to live for can bear with almost any how."

—Nietzsche[9] (2)

At thirteen days old, she was finally allowed to go home. We lived only a few blocks from the hospital. In fact, we could see the emergency entrance by hanging out our front door. I weighed her before and after feedings; each diaper was measured, even in the dark of night, to ensure that her intake of liquids was reflected in her output, continuing to keep close watch on how effectively her kidneys were functioning. We returned to the NICU twice a day for the first week to monitor her blood pressure. The second week, we were down to once a day. And at one month, after our first appointment at the Hospital for Sick Children where we learned the name of her condition—autosomal recessive polycystic kidney disease (ARPKD)—there was unmistakable joy when we were told that every second day would do it for now.

June 30, 1985

Welcome to the church, a formal celebration of baptism.

July 12, 1985

Hospital for Sick Children. Formal clinical diagnosis: ARPKD, which

is a genetic condition with an estimated incidence of one in twenty thousand live births. No noted family history of renal diseases on the maternal or paternal side. As a recessive condition carried from both parents, there is a 25 per cent chance of recurrence in each subsequent birth. The majority of individuals with ARPKD present in the neonatal period with enlarged echogenic kidneys. Approximately 80 to 90 per cent with ARPKD who survive the first month of life will live until they're at least five years old. More than 50 per cent of affected individuals with ARPKD progress to end-stage renal disease within the first decade of life. Approximately 50 per cent of infants will have clinical evidence of liver involvement at diagnosis although histologic hepatic fibrosis is invariably present at birth. Long-term prognosis: dialysis and/or renal transplant. Genetic counselling recommended.

"Kids these days just don't die of kidney disease" is what her nephrologist said. And that is what I chose to believe.

I began to do all the things a new mom does. I was on the lookout for all her developmental milestones, willing her to be well. I celebrated her first smile, her first Christmas, her first step, and her first words. No one single moment was taken for granted. I let myself begin to worry about the stuff that I imagined other new moms worry about. At my weekly appointments with her pediatrician, I would ask, "Will she ever have kids? Can I have her floppy ears taped down? Will her hair grow back? Will her incessant bedtime crying raise her blood pressure? When will she sleep through the night? Will she be able to play contact sports?"

Her pediatrician was ever patient: "Kids? Let's just worry about tomorrow. Ears? Has she not been through enough? Hair? For goodness sake, put her in a frilly dress. Crying incessantly? Not sleeping through the night? You've spoiled her; give her a shot of Tylenol, maybe two. Close the windows, turn on the baby monitor, and go outside until she cries herself to sleep. And contact sports? Why would she ever want to do that?"

As her first year came to a close, the miracle of my daughter's life, her strength and resilience, and the incredible relief that came with knowing she was going to be okay eased the fear and uncertainty of her future and opened our hearts to the possibility of more children. We had always wanted a big family, and once the devastation of birth faded from

memory, the joy of life took over. Assured by doctors that we could be prepared for future births by measuring amniotic fluid and examining kidney size through fetal ultrasound, we made a conscious decision to brave the one-in-four chance of recurrence.

February 26, 1987

Daughter Number Two was born at term gestation via scheduled Caesarean section under general anaesthetic. Third trimester ultrasound did not reveal echogenic kidneys. Shocking mass of black hair was so unanticipated that lightly sedated mother asked, "Are you sure she's mine? She sure doesn't look it!" Released from hospital March 2, 1987. Baptized April 25, 1987.

May 1988

Miscarriage at eight weeks. Doctor's Diagnosis: Sometimes, nature has a way of taking care of itself.

July 31, 1989

Son was born at term gestation via scheduled Caesarean section with epidural; obstetrician won the battle convincing the mother that her perceived risk of being awake, aware, and possibly traumatized was irrational given that the third trimester ultrasound did not reveal echogenic kidneys. Father cut the umbilical cord. Released from hospital August 3, 1989. Baptized September 16, 1989.

Prayer was a daily occurrence. Faith was a way of life. Miracles were my daughter and my two other children, both with uneventful births and healthy kidneys.

> "Now I lay me down to sleep,
> I pray the Lord my soul to keep,
> Angels watch me through the night,
> And wake me with the morning light."
>
> —Anonymous

Every six months, we packed ourselves into our Toyota Tercel and made the almost four-hour trip to the Hospital for Sick Children in Toronto. We dropped our other two children off at the hospital daycare,

promising to return for lunch or at the end of our full day of appointments, which rarely ran on time.

I consistently anticipated the worst—that this would be the time when the doctors gave us the promised two-year notice that it was time for renal dialysis, transplant, or both. I typically left the hospital relieved, knowing that we had just a little more time.

Her nephrologist greeted us at each clinic visit with his charming Irish brogue; he spoke directly to her and asked us to fill in gaps only when she had exhausted her recall. From the time she could talk, she was encouraged to be an active participant in all clinic visits. Every once in a while, her nervous sarcasm made an appearance, which signalled her growing awareness that although she was not sick, there was something different about her health.

Comorbid conditions were added to the mix when we least expected it, rendering us helpless and fearful of just how much worse it could get. As years passed, we learned that ARPKD put her at greater risk for Caroli's disease, congenital hepatic fibrosis, portal hypertension, esophageal varices, and other conditions. To her semi-annual nephrology clinics, an annual gastroenterology clinic was added.

Our distress was palpable when we were told that she would likely require a dual transplant of kidney and liver. And that was the day we made a request to the medical team: "No more surprises. We cannot keep coming back with the fear of having something else added to the list. Just as we adjust to one thing, you add in another. Please give us the full list of health implications now."

Because hospital visits often served as painful reminders of her illness, tensions ran high, but so too did moments of pride. The day the student nurse tried to find a vein in three different sites was the day I angrily asked for a veteran nurse. I snapped a gasket when the technician suggested sedating my toddler for an echo-cardiogram at the end of a six-hour day filled with blood work, an ultrasound, bone density x-rays, a renal scan, and two clinic visits. I lifted her off the bed and said, "Enough for today. Next time, book the echo at the beginning of the day if she needs to be quiet and still." When—after years' worth of crying, angst, and a minimum of three adults and restraint—a four-year-old, in a very matter-of-fact tone of voice, told a team of nurses when, where, and how to take her blood, I cried tears of pride and gratitude for her strength, independence, and precociousness.

In addition to the looming threat of transplant was the concern that she weighed in consistently around the third percentile; thus, we were expected to do everything in our power to not only keep her weight consistent but to raise it above the curve. Our cupboards were stocked with high-calorie foods, and for close to six years, I maintained a daily record of everything she ate and how that translated into calories. When we slipped below the required recommended intake for growth, we added tasteless nutritional supplements to her milk, to her cereal, and even to her beloved mashed potatoes. We felt compelled to force feed, and we continually complemented meals with an extra spoonful of butter or peanut butter. Yogurt was made from scratch with whipping cream, not milk, and banana milkshakes allowed us to sneak in calories while still giving her a treat. And we were not averse to bribing; we filled our freezer with cases of Reese's Peanut Butter Cups and Twix Bars from Costco, both of which boasted the highest caloric and fat contents, much to the delight of my other two children. We celebrated little bumps above the third percentile and did what we were told by the nutritionists until it affected our family life, until meal time was no longer fun, until we were all exhausted from the daily battle that might result in a single gram gain, until we realized that this was an eating disorder in the making, and until we had two other children, who also barely rose above the third percentile.

> "Perhaps this is how suffering leads to faith. In times of great struggle, when there is nothing else to rely on and nowhere else to go, maybe it is the return to the moment that is the act of faith. From that point, openness to possibility can arise, willingness to see what will happen, patience, endeavour, strength, and courage. Moment by moment, we can find our way through."
>
> —Sharon Salzberg (118)

Accepting Impermanence

In the between appointment spaces, life was lived, and we found our way through her illness, recognizing that while she did have some pretty significant health issues, they did not make her sick. Life was always filtered through a lens of normalcy and a desire for her never to be set apart or different.

Her first day of school came (and went). I asked if I could drive her to school. She declined. I pleaded to take the bus with her. She refused. I begged to visit her part way through the morning, even offering to bring a snack for the class. But she boarded that big yellow school bus on her own. Seeing my tears, she turned, stomped her foot, and quite indignantly said, "Really mommy! I'll only be gone for a couple of hours."

Just in time for Christmas 1989, she tried out her hairdressing skills on her almost two-year-old sister. "Look mommy," she beckoned with pride, "A pretty haircut, just like you do for daddy." I was devastated. Her hair had still not grown back. Perhaps she wanted her sister to be more like her. Seeing the dark locks scattered on the floor, my strength weakened, and for the first time in her life, I yelled at her. I don't know whom I scared more, her or me.

We went to church every Sunday. My three children made their sacraments of initiation while I facilitated the children's liturgy program. Over the years, there were children's choirs and Christmas pageants. All three attended Catholic school, and when I began teaching, they came to school with me. In the end, she was the only one to graduate from a Catholic high school.

In the years that followed, we portaged and camped deep into Algonquin Park, setting aside advice to never be further than two hours from a hospital. We drove cross-country, hiked two kilometres into Takakkaw Falls, canoed at the foot of the mountains, hung our food high up in the trees far from bears' reach, and listened to wild animals sniff around our tent at night. We searched out monarch eggs laid to hatch on milkweed plants, waiting patiently to nurture the caterpillars as they grew and transformed into chrysalides. And we watched with awe as butterflies emerged, lovingly releasing them to take flight and explore their own freedom in the world.

Years later, anticipating dialysis and further complications, we moved away from camping and bought a log cabin in the woods in order to share our love of the outdoors. Although it was accessible only by boat, it did have the capacity for electricity and was within two hours of the nearest hospital. We lived as fully and as intentionally as possible, somehow knowing that her life and our life would be exactly how it was meant to be and that her time for transplant would come, with or without strict adherence to the rules. Whereas other children might have felt they had

an invisible friend, my daughter often felt that she had an invisible illness. She could neither see it nor feel it, but it was always there.

As her independence grew, she claimed responsibility for her healthcare. She took her medications if and when she wanted, stating that they didn't make her feel any differently. I could not convince her that the intent of the medication was to lower blood pressure, with the longer term effect of kidney and heart health. Resentment started to build, and I would silently plead with her, not wanting to say it out loud and push her further into rebellion. *I worked so hard to keep you healthy, and here you are, turning your back on it. It's okay to rebel against me, but you are not invincible. You are taking too many unnecessary risks. And I am powerless to do anything about it.* Mornings were awful; struggles were daily. Like most teens, alcohol became her friend not her foe; but to me, it appeared that she had little respect for her already compromised liver. She would make her predetermined curfew, only to turn around and sneak out her bedroom window to avoid the door alarm, not realizing that her footsteps were imprinted in the new fallen snow.

Battles ensued, and the day I lost control was the day she went to stay with her grandparents for a few weeks to let it all cool down. I'm not even sure what we fought about, but, to this day, recalling the incident puts me right back in that threadbare hospital gown and leaves me as devastated as I was the day she cut her sister's hair.

At eighteen, against my wishes and when I was away from home, she and her sister, at the time sixteen, got their first tattoos—not just any tattoos ... butterfly tattoos. I caught a glimpse when they least expected it, as they were putting on makeup one day in the bathroom, singing along to music as they often did. In my head, I could hear *"Are the tattoos life-threatening, morally threatening, or unhealthy?"*[10] But I could not help but feel completely and absolutely powerless and more than a little betrayed.

And as I had questioned many years before, I questioned again: *Do I have the emotional capacity to care for three teenagers, to care for my husband, and to care for myself?*

I slipped back into my invisible, now unravelling, cloak of strength; I hid my inner life of quiet desperation, a vulnerability, which I was unwilling to share, as well as a deep shame at what presented to the world as a picture-perfect family but was far from what I had hoped for. I willed my thoughts to stay silent, finding myself knee deep in the grim

relationships and tensions that I had worked so hard to avoid.[11] I came to fully understand why tigers eat their young:[12] they take the easy way out. I didn't much like myself. And I was certainly not impressed with the life I had created. My children's ongoing demands for independence and their seeming lack of need for a mother left me once again in darkness and a state of not knowing.

September 2004

Began a PhD program in the Department of Integrated Studies in Education at McGill University.

For close to a year, two days of each week were spent travelling to Montreal from North Bay, a round trip of thirteen hours with optimal weather. At the end of my first semester, my professor asked a very simple question, "Where are you in this piece of writing?" She challenged me to see myself where I had not looked before. This was the beginning of a years-long journey that allowed me to realize that in the seemingly picture-perfect scenario that the world saw, everything was in its place—everything, that was, except for me.

In 2005, we backpacked as a family through Europe, never quite knowing where to find a hospital or whether we could get home in an emergency. I booked Eurail passes, hotels, flights, and tours; we each selected a book to carry and share. My heart was set on spending quality time together as a family, on finding my way back in. But plans on paper are often better than experiences in reality, and my lifetime of unexplored disappointments and stored-up resentments bubbled to the surface.[13] In a less-than-proud moment, I threw my children's and husband's passports across a busy Parisian street and threatened to forfeit my ticket home. Not only had they become unrecognizable to me, but I was no longer recognizable to myself. I had finally become what I feared most: the wicked mother. In the next few months, I grew uneasy, as I felt that along with their passports, I had thrown away what mattered most to me—my relationships with my children.

I recall with deep sadness the day they collectively said, "Hey mom, it's okay to laugh. We really are that funny." And in reality, they really were that funny, but life was not, and as a result, I could not crack a smile. I had reached my limit.

November 2005
Filed for legal separation.

April 2006
Moved out of the house.

December 2006
Officially divorced.

I left behind my seemingly picture-perfect family, shattering the illusion that I could outrun the family dysfunction of my beloved fairy tales.

Hopeful Renewal

June 17, 2016
Mother and daughter board a flight leaving Toronto, Ontario headed to Lake Atitlán, Guatemala.

June 18, 2016
Eleven hours and 340 natural rock-stairs later, arrive at The Yoga Forest for a weeklong *Storyteller Within*[14] retreat.

> "We were strangers, on a crazy adventure
> Never dreaming, how our dreams would come true
> Now here we stand, unafraid of the future
> At the beginning with you."
> —Donna Lewis and Richard Marx

We arrived many hours away from home at Lake Atitlán, nestled deep in the western highlands of Guatemala, surrounded by seven volcanoes. We found ourselves high up at The Yoga Forest, a place designed as a sustainable living experiment and inspired by a desire to live simply and in communion with everything around it. The retreat was designed to help us find power in our lived stories. We had come to experience the wonder and awe of the outdoors, mindful meditation, empowering yoga and dance, and sacred storytelling, and to find a comfortable,

peaceful space conducive to growth and sharing. Reflective writing prompts challenged us to see the positive and to find what we had lost, given away, overlooked, or set aside, or what had been taken from us. We were invited to find the storyteller within and write our way out of the darkness; today, writing has become my struggle against the silence I've lived for so very long and my way into the light.

> "Every hour of the light and dark is a miracle."
>
> —Walt Whitman[15] (255)

Thirty-one years into my daughter's life and edging closer to transplant, I was ready to consider the purpose of it all. I was ready to speak my truth. My children were, and will always be, my purpose and my truth. That week, I was *with* my daughter, and my purpose was to understand my self and seek my truth with my daughter at my side. Brené Brown[16] tells us, "People are hard to hate up close. Move in. Speak truth to bullshit. Be civil. Hold hands. With strangers. Strong back. Soft front. Wild heart" (*Wilderness* 36). I gave myself permission to get up close and personal. I sought to listen, to consider, to lean in, and quite honestly, to back off, if and as necessary.

> "The truth is that when we really begin to do this, we're going to be continually humbled. There's not going to be much room for the arrogance that holding on to ideals can bring."
>
> —Pema Chödrön (3)

Early in the retreat, I encountered my first butterfly, lifeless but beautiful. A day later, a bright blue butterfly peacefully landed on my hand while I ate breakfast, not once releasing herself as I moved about. Two days later, I spotted not one but two glasswing butterflies playfully chasing each other, beckoning me to follow. Their transparent wings allowed for light and sight all the way through—nothing held back, nothing to be hidden. I recalled the story of "The Butterfly,"[17] which was shared in a sermon shortly after my divorce. I learned then that the butterfly's struggle out of its cocoon forces fluid from its body into its wings so that it has the strength required to fly. The story continues to serve as a reminder that sometimes struggle is exactly what we need in our lives and that a life without obstacles is crippling. As the retreat progressed, I began to see butterflies everywhere. A fellow traveller told me,

"Butterflies are a sign of powerful transformation, of renewal, of lightness of being." Even today, they give me strength when I need it most, when I doubt the decisions I am making, when I am anxious or self-chastising, and when I am tempted to take the easy way out. *Butterflies, I think, are a sign that someone, maybe my grandmother, is watching over me, reminding me to seek joy in life.*

During the retreat, we were asked to write a response to the question, "What would you say if people listened the way you wanted them to?" To my daughter, I wrote:

> From the moment you were born, I have celebrated every minute, day, and year that you have been healthy. You have grown strong, independent, intelligent—a true warrior, who in so many ways has triumphed despite all odds. For that, I am so very grateful and proud.
>
> It's hard for me to let go, to recognize that you are now a woman with your own story to tell and your own journey to live. I fight against this, wanting to be your mom, wanting to keep you safe in this world, wanting to hold you as closely as I did when you were so very small.
>
> I don't know what you experience every day, but what I do know is the life I've lived watching you for thirty-one years, as you adopted a fearless, devil-may-care, seize-the-day perspective on life. You were never one to give in and not live each day to the max. You always, like I did in your early years, cherish every single moment, and keep moving and becoming.
>
> I can't take the next leg of your journey for you much as I'd like to, but what I can do is ensure that you don't face this journey alone. I am here to listen. When I ask questions, they come from genuine care and wanting to know, not just how you are physically but where you are at emotionally and spiritually as well. I fully recognize that there are no easy answers outside of taking each day as it comes and not letting the anticipation of tomorrow get in the way of living today.
>
> I am here, as mom, as friend, as you need me.

Peaceful Reinvention

> "In the light, we read the inventions of others; in the darkness,
> we invent our own stories."
>
> —Alberto Manguel (252)

As I sat writing and revising, I realized how many times I have retold this story, to myself and to others. Responding to questions or suggestions, exploring insights, holding strong to particular perspectives, and working through the power of writing to heal my soul have not been easy.[18] My inner critic was alive and well, and there were days when all I heard were the lyrics of Great Big Sea singing in "Consequence Free": "I could really use to lose my Catholic conscience/'Cause I'm getting sick/Of feeling guilty all the time." Guilt, as Brené Brown tells us, is inextricably linked to shame, often rendering us unlovable in our own eyes (*Greatly*). And for years, I felt unlovable, if not by my children, then by myself. But throughout the retelling and the writing, and the living, I was challenged to show up, with all of my vulnerability, my imperfection, my anger, and my shame, and I came to both accept and forgive myself.

To her doctors, my daughter is an anomaly. The long-term outcome of children escaping early renal failure is, and continues to be, largely unknown. I give thanks daily for faith and for the angels who watch over her. I credit her health to strength, to resilience, to never being set apart or different. She says that mind over matter only goes so far and that she doesn't believe in an external God or fairy tales. Today, some thirty-three years after her birth, we now agree to set aside this particular conversation, and I try to stay grounded in today, leaving the worries and fears for tomorrow, trusting instead in the moments of life I hold in my hands.

Sometimes what seems like an ending is just the beginning. Sometimes we are privileged enough to change the story as we live it. Sometimes we need the struggle to survive and face each day. And sometimes, we just need to rely on a little faith, trust, and pixie dust.

September 28, 2016

Living donor forms submitted to the Living Donor Kidney Program at Toronto General Hospital.

June 5, 2017

Phase one tests, donor questionnaire, and consent forms submitted.

August 28, 2017

Phase two appointments: initial cross-match test, chest X-ray, CT scan, transplant coordinator, social worker.

To qualify for the Living Donor Kidney Program, I was required to talk with a social worker who asked, "Why do you want to donate a kidney? What do you gain? Are you okay with donating, even if you are not a direct match to your daughter?" I responded: "When I filled out the forms, I had already accepted the unlikelihood that I would be a direct match. Given the tensions of her teenage years, I won't be the least bit surprised if her body retains antibodies that will attack my blood cells. But I am her mom, and donation is a way to show her how much I love her. It doesn't much matter whether she gets my kidney or not, I am still willing. This is just another part of our journey, something that I have prepared myself for all her life." At the conclusion of the session, the social worker asked: "How does she feel about the possibility of receiving your kidney? Do you think she might feel that she would owe you something?" A little puzzled by the question, I responded honestly, "We have not really discussed it ... yet."

September 6, 2017

Phase two appointment with donor doctor.

September 29, 2017

Phase two renal scan.

October 5, 2017

Notification of maternal match, two days prior to Thanksgiving weekend.

The call from the Living Donor Kidney Program coordinator was one of the best gifts I could possibly receive. My kidney was a direct match for my daughter. I made many calls and sent many texts that day; I needed to hear myself say it out loud and/or see it in print as often as I

could to make it real. I needed to settle in to the full sense of gratitude and relief that I felt. To this day, tears still spring to my eyes as I think about it.

I was never apprehensive. Not once. I did not have a single doubt. And I am finally at peace. Certainly, the days of waiting to find out were tough, and I wanted to be hopeful but not too hopeful for fear that I would jinx it. I worried about some imperfection that could disqualify me from the program, but I never worried about being a direct match.

She was the last one I told.

We were two days away from Thanksgiving, and she was coming home for the weekend. Like mother, like daughter, she is strong and independent, often bordering on stoic. At times, I sense that she has borrowed my invisible cloak of strength to hide her own vulnerability. Was I worried about her response? Maybe a little. I worried that she might have preferred her sister's kidney to mine. I worried that her response would not reflect how I was feeling. Her response was simple: "I was never really concerned about it. It didn't really matter whether you were a direct match or not. I knew you were committed to being a living donor and that you had already qualified."

At the core of my being today is realizing that, like the butterfly, I needed to struggle through the ideal shell of motherhood, to set aside the fairy tales of my childhood, and to trust my own deepest experience in order to find my own peace as mother.

December 6, 2018

Maternal laparoscopic nephrectomy followed by renal transplant. Toronto General Hospital. Both mother and daughter recovering well.

I might have been able to pare down this process by being more mindful and attentive many years ago, but I cannot change the past, only who I am in the present. I now understand that peace is not the tranquility of order, the absence of conflict, or the serenity experienced when there is no conflict;[19] it is instead a calmness of heart in the midst of seeming chaos. Peace means to live life with ease, breathing a sigh of relief when you worry about something but finally get good news. Peace is living with a sense of tranquility, without a sense of deficit or disturbance. Peace calls us to be aware, to be a witness and an open

space through which sights and sounds, thoughts and feelings, arise and disappear. Peace requires acknowledging that some things are unchanging, more than words, and beyond full understanding.[20]

As I put the finishing touches on this story, verifying names, dates, and places, I pause on the final page of her baby calendar. On it is a watercolour image of a one-year-old child with very short hair, dressed in denim overalls. She is kneeling peacefully in front of a milkweed plant, observing mindfully a monarch butterfly that has just emerged from its chrysalis. The caption reads, "Nothing is impossible."

"Birth is the sudden opening of a window, through which you look out upon a stupendous prospect. For what has happened? A miracle. You have exchanged nothing for the possibility of everything."

—William MacNeile Dixon (np)

Endnotes

1. I grew up with this quote. It was offered as a way to deal with disappointment in life and keep us open to possibility.

2. I would be remiss to not acknowledge the authors who have influenced and shaped my process of being and becoming over the past few years, particularly since my divorce in 2006. For the purposes of keeping the story going, I have not interrupted the narrative by sprinkling in citations of particular researchers and texts. I have instead chosen to use endnotes, leaning in to Salzberg's advice to trust my own deepest experience and let it speak for itself.

3. In the process of writing this chapter, I researched autosomal recessive polycystic kidney disorder and its associated conditions. Reading the papers written by Erum Hartung and Lisa Guay-Woodford, William Sweeney and Ellis Avner, and Klaus Zerres et al., I solidified and clarified my understanding of what I heard many years ago. Rereading also gave me pause to express my gratitude for the incredible gift of her life.

4. In my later years, I have come to understand that "prayer is communication from the heart to that which surpasses understanding (Lamott 1). Through prayer, often unspoken, I was "reaching out to be heard, hoping to be found by a light and warmth in the world, instead of darkness and cold" (Lamott 7).

5. I now understand, thanks to Pema Chödrön, that I was grasping for understanding, that the life that I had envisioned was falling apart and that it was very necessary for me to grieve this loss. As I was living it though, I truly didn't fully understand, and I probably denied myself the grieving process.

6. No matter what I read or view of Brené Brown's work, I not only see myself but I find new understandings of why I did what I did, and how I reacted. Although I cannot boast that I am over it, I can at least claim to be working through it. Touchstones include *The Myths of Imperfection*, *Daring Greatly*, *Rising Strong*, and most recently, *Braving the Wilderness*, my daughter's 2017 Christmas gift to me.

7. Ruth Reardon is the author of this collection of poems. I could not possibly have predicted that this particular poem would be so instrumental in shaping who I am as a parent but also as an educator.

8. Although it would be years before I encountered Oriah Mountain Dreamer's prose poem "The Invitation," I am sure that I instinctually responded to her challenge: "I want to know if you can get up, after the night of grief and despair, weary and bruised to the bone, and do what needs to be done to feed the children" (2).

9. Long into my daughter's teenage years and graduate school, I encountered Nietzsche in the work of Viktor Frankl's *Man's Search for Meaning*; these words gave me strength as well as understanding. It is my understanding that this maxim originally appeared in Nietzsche's (1911) *Twilight of the Idols* (2).

10. See page 81 of *Kids are Worth It!* Barbara Colorosso was my go-to expert when my children were young. I read her books; I heard her speak at my church, and I did my best to follow her philosophy of parenting. In fact, hers was the first parenting book I passed on to my son when he had children, and I do my best to live by her advice when now grandparenting.

11. I grew up with fairy tales. They were my bedtime reading and my daytime reading. Although I still believe in happily-ever-after, I'm not entirely sure it is the same happily-ever-after I believed in as a child. Maggie Kirkman and Gayle Letherby offered me a way to view and unpack my ideals—the good, the bad, and the ugly.

12. Life with teenagers was definitely not easy, and, to be fair, life with the mother of teenagers was probably worse. We quickly outgrew

Barbara Colorosso. Peter Marshall became my go-to expert, and I devoured his book *Now I Know Why Tigers Eat Their Young.* The title drew me in with full understanding of just how difficult teenagers can be, particularly this new generation with the world and information at their fingertips.

13. Reset, reset, reset. Thank you Brené Brown for *Rising Strong,* which reminds me that it is within my capacity to reset and transform. It is not always easy, but it is always doable.

14. Storyteller Within: Journey into Sacred Expression is a women's writing retreat facilitated by Aimee Hansen. Details can be found at https://www.thestorytellerwithin.com.

15. Regardless of how we define "miracle," like Whitman (255), I have come to accept that every moment, light or dark, is a miracle. Dark gives way to light in the same way that pain and struggle give way to joy and, ultimately, peace.

16. With *Braving the Wilderness,* Brené Brown once again challenges me. Rising strong day by day, I now take back my views and perspectives. I will myself to stand strong in my own wilderness: "an untamed, unpredictable place of solitude and searching ... a place as dangerous as it is breathtaking, a place as sought after as it is feared ... [a place that] can often feel unholy because we can't control it, or what people thing about our choice of whether to venture into that vastness or not." The courage it takes to experience true belongingness may take me down a path of "breaking down the walls, abandoning [my] ideological bunkers, and living from [my] wild heart rather than [my] weary heart" (36-37).

17. It is beyond the scope of this chapter to recount the entire "Butterfly" story. If you're interested, you can find the telling I encountered here: https://www.habitsforwellbeing.com/poem-the-butterfly/

18. While there are many authors whom I have read to support narrative writing, Susan Zimmerman stands out. I could relate intensely to her story, her struggle through fear, denial, guilt, bitterness, and despair as she came to terms with her daughter's neurological disorder. I have come to understand the healing that comes with the telling and with the sharing.

19. It is sad to say, but this definition of peace, found at *Catholic Culture,* was likely the one I grew up with. Growing up Catholic gave me a

deep faith, but in adulthood, as I unpack some of it, I come to understand the dangers of some of that earlier theology. My inclination today is still to have faith, but that faith is increasingly rooted in trusting my own deepest experience (Salzberg).

20. When I began writing, this felt a little like a redemption story. But, as I finished writing, I found Rick Hanson's work, and I realized that even more than redemption, I was seeking peace.

Works Cited

Brown, Brené. *Daring Greatly: How the Courage to Be Vulnerable Transforms the Way We Live, Love, Parent, and Lead.* Penguin Random House, 2012.

Brown, Brené. *Rising Strong: How the Ability to Reset Transforms the Way We Live, Love, Parent, and Lead.* Random House, 2015.

Brown, Brené. *Braving the Wilderness: The Quest for True Belonging and the Courage to Stand Alone.* Random House, 2017.

"Catholic dictionary." *Catholic Culture,* www.catholicculture.org/culture/library/dictionary/index.cfm?id=35483#. Accessed 10 March 2018.

Chödrön, Pema. *When Things Fall Apart: Heart Advice for Difficult Times.* Shambala Publications, 1996.

Colorosso, Barbara. *Kids Are Worth It! Giving Your Child the Gift of Inner Discipline.* Somerville House Books, 1994.

Dixon, William MacNeile. *The Human Situation.* Edward Arnold, 1938.

Dreamer, Oriah Mountain. "The Invitation." *The Invitation.* Harper One, 1999, pp. 1-2.

Frankl, Viktor E. *Man's Search for Meaning: An Introduction to Logotherapy.* Translated by Ilse Lasch. 3rd ed., Simon & Schuster, 1984.

Great Big Sea. "Consequence Free." *Turn,* Warner Music Canada, 1999.

Hanson, Rick. *Enjoy Four Kinds of Peace.* www.rickhanson.net/enjoy-four-kinds-of-peace/. Accessed 10 March 2018.

Hartung, Erum A., and Lisa M. Guay-Woodford. "Autosomal Recessive Polycystic Kidney Disease: A Hepatorenal Fibrocystic Disorder with Pleiotropic Effects." *Pediatrics,* vol. 134, no. 3, 2014, pp. 833-45.

Kirkman, Maggie and Gayle Letherby. "Some "Grimm" Reflections on

Mothers and Daughters: A Fairy Tale for Our Times." *Journal of the Association for Research on Mothering*, vol. 10, no. 2, 2008, pp. 196-210.

Lewis, Donna, and Richard Marx. "At the Beginning." *Anastasia: Music from the Motion Picture*, Atlantic Records, 1997.

Lamott, Anne. *Help Thanks Wow: The Essential Three Prayers*. Penguin, 2012.

Manguel, Alberto. *The Library at Night*. Vintage Canada, 2011.

Marshall, Peter. *Now I Know Why Tigers Eat Their Young: Surviving a New Generation of Teenagers*. 2nd ed., Whitecap Books, 2000.

McBride, Martina. "In My Daughter's Eyes." *Martina*, RCA National, 2003.

Mohlke, Megan. *The Grimm Fairy Tales: An Analysis of Family and Society*. 8 April 2016, hdl.handle.net/1805/10381. Accessed 1 Mar. 2018.

Nietszche, Friedrich. *The Twilight of the Idols: Or, How to Philosophise with the Hammer*. Translated by Anthony M. Ludovici and T. N. Foulis, 1911, www.gutenberg.org/files/52263/52263-h/52263-h.htm. Accessed 31 March 2018.

Reardon, Ruth. *Listening to the Littlest*. C. R. Gibson, 1984.

Salzberg, Sharon. *Faith. Trusting Your Own Deepest Experience*. Riverhead, 2002.

The New Jerusalem Bible. Edited by Henry Wansbrough. Doubleday, 1985.

The Sound of Music. Directed by Robert Wise, Twentieth Century Fox, 1965.

Sweeney, William E., and Ellis D. Avner. *Polycystic Kidney Disease, Autosomal Recessive*, 2001/2016, www.ncbi.nlm.nih.gov/books/NBK1326/. Accessed 01 February 2018.

Whitman, Walt. "Miracles." *Leaves of Grass: A Textual Variorum of the Printed Poems*, edited by Sculley Bradley and Harold W. Blodgett, New York University Press, 1980, pp. 255-56.

Zerres, Klaus, et al. "Prenatal Diagnosis of Autosomal Recessive Polycystic Kidney Disease (ARPKD): Molecular Genetics, Clinical Experience, and Fetal Morphology." *American Journal of Medical Genetics*, vol. 76, no. 2, 1998, pp. 137-44, www.onlinelibrary.wiley.com/doi/10.1002/(SICI)1096-8628(19980305)76:2%3C137::AID-AJMG6%3E3.0.CO;2-Q/abstract. Accessed 1 February 2018.

Zimmerman, Susan. *Writing to Heal the Soul*. Three Rivers Press, 2002.

Mapping Motherhood: Where Do We Go from Here?

Michelann Parr and BettyAnn Martin

"Motherhood is a geographical place with its own language, customs, rituals, and taboos. The terrain is dizzyingly rugged in some places, deadeningly monotonous in others. The weather is unpredictable year-round. No sooner do you adjust to one climate than the temperature changes.... Lots of mothers ... experience feelings of isolation, loneliness, and exile. Most of us acclimatize with time, but then we realize with a gulp that there is no going back. We are lifelong citizens of this other country."

—Garrigues (1-2)

Who defines this geographical place and culture of motherhood? Are we mothers by discovery, by design, or by default? The birth of children positions mothers to participate in a recreation of the landscape of motherhood, but how do we initiate this process? And how might mothers in addition to the idea of motherhood be potentially redeemed and transformed through the act of writing, which is itself "an act of discovery" (Hopper xxi)? What happens if we find ourselves, figuratively and literally, living in a foreign country? How do we deal with moments of exile—from ourselves and often our children? How can we navigate the emotional terrain of both success and struggle? Do we choose the path weathered and smoothed by others, or will we blaze a new trail? How do we see ourselves? How

do we see ourselves through the eyes of others? How does reimagining create space to reinvent, remap, and rediscover motherhood? What supplies or resources do we need to explore this new and undiscovered wilderness?

Our story of motherhood is told through many voices and in many contexts. As mothers and editors, we embarked upon this journey seeking answers, but we have come to realize that open questions and ongoing dialogue create the possibility for open futures. As you move forward in the exploration of your own narrative, we ask that you carry these stories with you. Allow them to grow your perspective and fuel conversation. Let them serve as starting points to collectively re-map motherhood with language, customs, and rituals of our own design. Our stories—those lived, those told, and those yet to be written—engage us in a quest to reclaim, to restore, and to transform our personal and social mothering spaces, leading us towards liberating social, cultural, and institutional narratives. This chapter is our final gesture of care for you, our readers and potential writing mothers.

Rewriting the Self: Acts of Reclamation, Connection, and Cocreation

"Stories do not simply report past events. Stories project possible futures, and those projections affect what comes to be, although this will rarely be the future projected by the story. Stories do not just have plots. Stories work to *emplot* lives: they offer a plot that makes some particular future not only plausible, but more compelling." (Frank np)

No one ever said motherhood was going to be easy; in fact, we can recall being told that we would never fully appreciate what it means to mother until we mothered our own children. We know this to be true, but how do we come to be mothers in our own right? We may find ourselves reluctant and resistant to let go of the ideal, the image, and even the practice of motherhood, as it has been modelled and sold to us. Our vulnerabilities emerge authentically as we begin to interrogate and challenge the status quo of "good mother" and all that it means, as we let go of normative expectations and unconscious assumptions. As we come to understand ourselves as mothers, we remain open to the

learning and wisdom gained through our own experience in relation to others. When we reflect on experience in context, our maternal stories function as acts of reclamation, reformation, witness, and advocacy for self and other—actions that are at once vital yet precarious: "Our ideas about ourselves are tested in the world and in various social interactions. These interactions, in turn, provide a basis for crystallizing and refining our identity and who we want or believe ourselves to be.... The role that others play in our creation and experience of ourselves is never ending, there can be no final completion" (Stone 46).

Self and identity work—individually and collectively—is an evolutionary process with inherent risks; as we dig in, we are often unsure of what will remain, how far we should go, how much work there is left to do, or how our work will be received. T. S. Eliot, the modernist poet, reminds us, "Only those who will risk going too far can possibly find out how far one can go" (ix).

Through the storied experience of our writers and many others who have come before us, we are encouraged to map our own stories on the landscape of motherhood—a place that has no final destination, no one landing point, and no defined geographical boundaries. Perhaps that is what made the writing of this conclusion such a difficult task—it felt too much like closure, knowing this place as a destination. It is none of this, however, but rather an invitation to explore motherhood as a never-ending process of growth and discovery that is both personal and communal.

We would be less than truthful to tell you that the curation of this collection was easy or that we, as both mothers and editors, were unaffected by what we encountered. Some days were intensely difficult, as we peeled back layer upon layer of experience, memory, assumption, societal pressure, law, cultural misunderstanding, shame, self-criticism, regret, remorse, resentment, and the list goes on. Other days were extremely joyful as we laughed along with our writers or shared in their insight, healing, optimism, openness, and forgiveness. In our ongoing journey as editors, we hear the voices of our writing mothers echo, and we regularly pause to give thanks for their collective maternal wisdom, now resting in our bones.

Weaving together words and ideas of our writers that deeply resonate with us, we invite you to see your selves reflected in our poetic act of solidarity.

Writing Mothers: A Poetic Act of Solidarity

Just hear the beauty. Really listen—with your mind, with your body, with your heart.

We have bared our secrets to you in the hopes that you will share yours—
our beginning, our being, and our becoming;
our uncertainty and promise of an open future;
our not knowing, yet wanting the very best;
our joy and celebration;
our impermanence, doubt, and shame;
our gnawing ache for care, nurturing, love, acceptance, forgiveness;
our regret, remorse, and resentment;
our connection, our validation, our shared vulnerability.

Our stories of motherhood.

What is a mother?
Do we have what it takes?
Why can't we have it all?
Do we know how to be cared for? Are we willing?
Why did things not go as planned?
Have we loved them enough?
How will our care rest in our children's bones?
Are we open to the idea of loving our selves enough?
Are we good enough? Are we enough?
Will we be there? Where is there? Are we there yet?
And what of our children? Will our words ever shock them? Might they
challenge us one day around the dinner table?

It's like Little House on the Prairie, until it's not—
we are exhausted by the demands of motherhood;
we are paralyzed by the ideal that exists only in our minds;
we struggle to find our bearings—we are nowhere but everywhere;
we try not to take it personally (even when it is);
we surveil—ever vigilant, ever watchful—self and others;
we judge, and are judged, as failed or wicked or negligent mothers;
we are trapped by the unthinkable, the intolerable, the less than
acceptable performance of motherhood;
we multitask, we focus, we are the last line of defence, the last resort;
we long for lost pasts, lost selves, and mothers we never had;

we live lives of quiet desperation;
we will time to speed up.

It may be cold outside, but it is warm inside—
we value care as meaningful—for self and other;
we make sense of events that appear random and disordered;
we realize that we are not alone in this self-doubt;
we embrace every scratch and imperfection as authenticity;
we bear witness to ourselves and to others;
we accept public confessions of difficulty alongside celebrations of success;
we treasure the trivial alongside the memorable;
we look to support and feel supported;
we honour difference and the right to be;
we laugh, we rant, we build community, we seek solidarity;
we read, we write, we reflect, we reimagine, we rewrite;
we feel supported, loved, validated;
we dwell in aggressive optimism;
we will time to slow down.

We shed the skins and cloaks; relics of past lives that no longer serve—
the picture-perfect family that perpetuates a public-private duality;
the racialized, cultural, hegemonic, and heteronormative assumptions that endanger us;
the social, cultural, and institutional narratives and rituals that limit our potential;
the happily-ever-afters and false illusions and impossible standard of 'good mother'.

We are strong and resilient.
We have independence of mind.
We have each other's backs.
We do what it takes.
We are true to ourselves.

Our moontime and our ability to give life are sacred.

As mothers with children to live for—
we can bear with almost any how;
we see that the shadowy secret behind the miracle is the redemptive power of mothering;

we respectfully recognize the agency of mothers;
we see mothering as empowered practice of resistance and
salvation;
we shield preservative love and care from the judgment of others;
we take back the story of motherhood
in all its possibility, openness, humility, and freedom.

And perhaps some day, in the near or distant future,
we, too, will wear Blundstones with a cocktail dress.

Remapping Motherhood: A Call to Communal Resistance

As writing mothers, we can resist custom, we can reimagine and reread self in text, and we can rewrite our selves, as well as the social, cultural, and institutional narratives that have shaped the landscape of our becoming. In our freedom to write and be published without fear of reprisal, scandal, or exile, we recognize that we are privileged in ways that other mothers may not be. Vulnerability is often experienced by mothers in the comfort of their own home, with families they have nurtured and protected and children whose paths have been smoothed by the very act of mothering. For some, the daily grind of running a household and carpooling is a burden that may obscure the time and freedom necessary to reflect or pursue personal goals. Although this oppression by way of maternal expectation is real, there are mothers who face more tentative futures—those who have been forced into exile and are powerless to be understood; mothers who are held to unattainable or racialized standards; those who have no choice but to raise their children in circumstances of precarity; and those who are forced to raise themselves. Although we may not be able to change the experiences of these mothers, our writing can offer alternative worldviews and challenge censorship. By sharing the diversity of our experiences, we challenge standards of care imposed by governments and cultural hegemony. Our collective voice advocates for mothers who are silenced, and we willingly speak loud enough that others may hear. The more we share our stories, the greater resonance we find with other mothers; through story, we reclaim our right to reimagine and reshape the personal and social contexts of our lives; collectively, we have the power to rewrite a future open with possibility.

Restoring Mother: A Creative and Complex Act of Self-Care

At its core, this collection is an act of nurture; by virtue of reading, you have entered into a relationship with other mothers. You may have shed tears as you willed aggressive optimism, openness, and possibility to Miller, Goldsmith, and Parr. Perhaps you felt a deep sense of outrage at Brauer's or Hall's less than ideal childhoods, Leddy's racialized experience in the NICU, or Sadler and Carreño's tale of precarity. You may have actively engaged by baking banana bread with Martin, brunching with other mommas as Mandell did, or planning an unscheduled day with Jolles. You might have taken up Bailey's challenge to claim room and space, or, in a found moment, you may have settled in to read one of the stories explored by O'Reilly.

Our adventurous writers have inspired us, as editors, to embrace the totality of the mother we are in the present moment; they have also evoked a realization that in our evolution, we must embrace the uncertainty of our becoming. Their stories offer wisdom but also the courage and encouragement to endure the more difficult terrain of motherhood. Through all of our experiences as mothers, if we are open to the opportunities for learning, we slowly come into consciousness of ourselves. And when we come to truly know ourselves, when we accept our right to love and be loved, give nurture and be nurtured, forgive and be forgiven, and when we can mother ourselves in the ways we long to mother our children, we gain the confidence to open ourselves to others, daring to be authentic—sharing our vulnerabilities and our stories. It is here that we find something as valuable as identity: we find comfort and solidarity in the collective; we come to see ourselves in relation to the world in which we live (Hopper), and we no longer feel quite so alone.

As mothers, we need to be awake to possibilities; we need to embrace care as the source of redemption, and we need to recognize that care begins with ourselves. When we extend empathy, compassion, and understanding to our selves, we are changed for the better. Maternal self-care and self-advocacy, along with a firm grasp on reality, have the potential to open the landscape of mothering for us and for other mothers.

This geographical space of motherhood is far more complex than the physical land beneath our feet. Like any adventure, motherhood requires that we face ourselves, understand our own strengths, test our limits,

and examine our perceptions and assumptions. Socrates was credited with saying, "the unexamined life is not worth living." We suggest that the act of mothering requires far more than examining; we must also reflect, reimagine, and rewrite in an effort to demystify motherhood; we must remap our mothering spaces to make the familiar strange and the strange familiar. It is in this process of seeing and reseeing, as if for the very first time, that the possibility of everything resides.

Narrative Acts: An Invitation to Journey with Us

So, dear readers and mothers, we finish this collection with one final affirmation and challenge. Your story is significant and valid and welcome—in fact, the most important story is yours. Find yourself a quiet (or not so quiet) space, cue up a playlist, watch a movie, flip through a set of photos, find a quotation or two, reread a birthday card, revisit your child's calendar of memories or baby books, open a conversation with other mothers, talk to your mother, or take your reflections outside into the natural world. Write a story or poem (the appendix has a practical guide!), draw a picture or make a collage, fill a journal with your thoughts or recollections, or share stories from your family history with your children. Inspiration is everywhere; we are only ever limited by our own imagination and our willingness to engage.

Let yourself wander through the landscape of your motherhood. Savour those precious moments you may have set aside when the demands of motherhood kicked in—call back the first flutter of movement, the first day of school, the last day of high school. Reach deep: What did it look like? What did it taste like? What did it smell like? What did it sound like? Could you touch it? What did you hear? What did you not hear? How did you feel? What did you do? Who was there? What did they say? What did they not say?

Call forward the memories that in the midst of living may have been tough, made you giggle with excitement or smile with pride, or those that generated intense feelings of joy, struggle, satisfaction, or shame (Hopper). Allow yourself time and space and luxury—no strike that— the permission to reflect on the way these emotions and experiences have shaped your being. It is only by awakening our authentic selves that we can truly know others, develop the empathy and compassion

necessary in today's world, and reimagine the landscape of motherhood.

Remember, though, that it is not enough to tell and retell our stories in isolation. Whisper your stories in the breeze, shout them from the mountaintops, paint them on the sky, ground them in sacred dance, or share them orally with your children. We invite you to feel and join the "echoes of mothers everywhere—across the canyons of race and place and time" (Garrigues 4).

Creating Space: A Promise of Truth

"Tell all the truth but tell it slant," says Emily Dickinson. Don't be afraid of your imagination. Recognize that the truths we live are complicated and often subjective. Be kind and gentle with yourself; explore your truths in the spirit of understanding. If you are feeling vulnerable, share only what makes you feel comfortable. Fiction is protective, so use it as needed. Recognize that the truths you capture on paper are ultimately negotiated with a thinking-feeling-imagining reader. Choose your readers well: look for those who are empathetic, noncritical, and nonjudgmental, but also those who will challenge you. Know that imperfection in our understanding, in our writing, and in our transformation are opportunities. Breathe in gratitude for the privilege of being a mother in this very moment. Let go of who you think you are supposed to be and embrace your imperfection (Brown).

If we have learned anything in this journey, it is this: motherhood is a vast landscape with limitless mountains and unfathomably deep valleys. It cannot be explored or discovered in a day, a week, or even a year; the road will meander through twists and turns, unpredictable setbacks and successes. Not only do we need to trust our own inner compass and guiding force, but we also need to trust in our capacities as storytellers and writing mothers. Our lives and our stories are always in progress. What we make of the stories we encounter is entirely up to us. You carry the stories of our writing mothers with you; they are now part of your story. Do with them what you will. Share them with other mothers. Tell them to your family. Tuck them away for a rainy day. Let them inform your day-to-day acts of mothering as well as the very fabric of your life in a way that enriches both your experience and story. And perhaps, in the near or distant future, the story you share and the voice you hear will be your own.

Endnotes

1. *Writing Mothers* is a found poem. We have selected words, phrases, and ideas from each of the stories in this collection. We have merged thoughts, rearranged ideas, and written what we imagine to be the ideal act of solidarity.

Works Cited

Brown, Brené. *The Gifts of Imperfection: Let Go of Who You Think You're Supposed to Be and Embrace Who You Are*. Hazelden Foundation, 2010.

Dickinson, Emily. "Tell All the Truth But Tell it Slant." *The Poems of Emily Dickinson: Reading Edition,* edited by Ralph W. Franklin, The Belknap Press of Harvard University Press, 1998. Poem 1263.

Eliot, Thomas Stearns. Preface. *Transit of Venus: Poems,* by Harry Crosby, Black Sun Press, 1931, p. ix.

Frank, Arthur W. *Letting Stories Breathe: A Socio-Narratology.* The University of Chicago Press, 2010. Kindle Edition.

Garrigues, Lisa. *Writing Motherhood: Tapping into Your Creativity as a Mother and a Writer.* Scribner, 2007.

Hopper, Kate. *Use Your Words: A Writing Guide for Mothers.* Viva Editions, 2012.

O'Reilly, Andrea. *21st Century Motherhood: Experience, Identity, Policy, Agency.* Columbia University Press, 2010.

Plato. *Plato in Twelve Volumes, Vol. 1* translated by Harold North Fowler; Introduction by W.R.M. Lamb. William Heinemann Ltd, 1966.

Stone, Michael. *Yoga for a World Out of Balance: Teaching on Ethics and Social Action.* Shambhala, 2009.

A Travel Guide for Your Journey

As mothers, writers, and editors, our lessons learned are far greater than the stories gathered in these pages. We have learned that to brave the wilderness of motherhood, we need multiple layers—diverse perspectives informed by varied opinions and experiences (as these make the difference between singing in the rain or struggling just to survive). We accept that she who wanders the country of motherhood is not always lost and that times of ambiguity offer us opportunities to self-orient, get our bearings, and navigate in our direction of choice. We need to travel in a spirit of wonder, with faith in our own powers of navigation, but without fear of asking for direction. Although we may encounter fellow travellers, we also need the confidence to travel solo, as blazing trails is often solitary labour. We need to stay organized and focused but also flexible. We need only carry forward the advice, wisdom, and memories that ease our way. We have also learned that sometimes the best way to avoid a difficult situation is to keep our distance, but in the landscape beyond our fears, we are called to surrender to the possibility of everything. Through experience, we learn that while uncertainty and ambiguity are daunting, humility and faith are our greatest assets.

Drawing from the work of Lisa Garrigues in *Writing Motherhood: Tapping into Your Creativity as a Mother and a Writer* and Kate Hopper in *Use Your Words: A Writing Guide for Mothers*, we offer the following set of writing supplies to support our (novice and current writing mothers') navigation through the complementary processes of reflecting, reimagining, and rewriting.

Keep a Mother's Notebook

Our notebooks are a messy but most sacred place for writing, "where we can write down *our* experience in our voice—where we can write it in between the lines of experience, where there are shadows and silences and white spaces" (Hopper 22). Include quotes, newspaper clippings, love letters, emails, or cards from our children, pictures, artwork, lyrics, rants, and bits and pieces of our days (and sleepless nights!) that may otherwise be forgotten.

Start with Mother Pages

Set aside time each day, or designate a number of pages each day, to write down one moment of motherhood. Begin with a "writing start"—a word, a detail, a scent, an image, a sentence, a quote, a half-filled page, a photo, a song, a rant—and then just write. Write what you know for sure and "write what you don't know for sure" (Hopper 23). Allow yourself to brainstorm, to list, to free write. Leave the inner critic behind and resist the urge to revise and edit as you go. There is lots of time for that later.

Write the Hard Stuff

Explore how having children changed your life, your relationships (with self and with other). Look back on some of the tougher times with humour and sarcasm; does that ease the pain and hurt? Are there tensions between how you parent and how you co-parent? What are your times of struggle, your times of perceived failure? What experiences come up over and over? What do you mull about, revisit, retell, obsess over, not let go of? What defines you as a mother, as a woman, as a human being? Where does your mind go when you give it permission to not think? Where does your heart go when you give it permission to accept yourself fully? Explore the experiences from which you'd like to shield you children, the kinds of choices you have made to protect your children. What fears and worries do you have for your children? Where do these come from? (adapted from Hopper)

Take to Heart the ABCs of Writing Mothers

Awaken to the moments of motherhood; **B**e a writing mother; **C**hoose our tools; **D**ate our mother pages; **E**ase into it; **F**orget the rules; **G**enerate a list of writing starts; **H**ave faith; **I**gnore the critic; **J**ot down a writing start and start writing; **K**eep our feet on the ground; **L**et our writing go; **M**eet other writing mothers; **N**ever let writing become another chore on our list; **O**wn our stories; **P**ractice patience; **Q**uestion freely; **R**ead like a writer; **S**ave our mother's notebooks; **T**ell the truth; **U**se our imagination; **V**enture out of the notebook; **W**rite to discover, not to be discovered; **X**-out doubt; **Y**ell less, write more; **Z**oom in on our lives (Garrigues 32-37).

Establish a Holistic Writing Schedule

Explore how our lives unfold week to week and choose a time to write: be nonnegotiable, reasonable, yet flexible and compassionate. Find a time that works best. There are days when we all ask whether we really have the time, but we challenge you to see that we cannot afford to give this time up—this work is too important.

Find a Room of Your Own

Borrowing from Virginia Woolf (and Bailey), we need to claim a writing space that is uniquely ours (or make it our own); it need not be an entire room, but it does need to be a sacred space—a bit of territory, a tiny piece of the country of motherhood that is our own.

Take a Time Out

We tend not to set aside time just for ourselves, or if we do, we feel guilty. We are often taught that nurturing or caring for ourselves as mothers is selfish, feeling that our time is not our own. Take time away from children, responsibility, and chores. It's not about punishment, restraining, or taking something away, but about replenishment, restoring, and giving back. Think "indulgence, not diligence—and certainly not duty" (Garrigues 52).

Schedule a Playdate

Whereas a time out is all about solitude, selfhood, being quiet, recharging, and reclaiming your inner self, the playdate is about socializing, friendship, being boisterous, and having fun. Mothers need companionship, friendship, and support; schedule a brunch (or cocktail hour) with other mommas and find time to laugh! Share your stories and relish the comfort of community.

Works Cited

Garrigues, Lisa. *Writing Motherhood: Tapping into Your Creativity as a Mother and a Writer.* Scribner, 2007.

Hopper, Kate. *Use Your Words: A Writing Guide for Mothers.* Viva Editions, 2012.

Notes on Contributors

Victoria Bailey is currently completing a PhD in Creative Writing, she has an MA in Women's Studies and her writing has been included in a variety of academic, creative and non-fiction publications.

Mandy Fessenden Brauer has a doctorate in clinical child psychology and a master's degree in organizational social work. She moved to Gaza with her husband during the first *intifada* and then spent a year in Armenia. She has been a professor of psychology and a Fulbright scholar in Egypt; she also gives workshops about children and has published books and articles for and about children in Arabic, English and Vietnamese. Recently, she and her husband have divided their time between Egypt and Indonesia. Dr. Mandy is fond of cats and feels pets can teach children and adults much about love, responsibility, consistency, and caring.

Alejandra Carreño is a Chilean social anthropologist. She works at Universidad del Desarrollo (Chile) in the field of transcultural psychiatry, medical anthropology, migrations, mental health, and motherhood. In 2013, she obtained her PhD in anthropology at the University of Siena with a thesis about mental health and indigenous migrations in the Andean area (the Chilean, Peruvian, and Bolivian border zone). She has worked in Italy (Centro Franz Fanon) and the Dominican Republic (Liceo Científico), focusing her research on migrant families, motherhood, and education about border construction. Contact: acarreno@udd.cl.

Daena J. Goldsmith is Professor of Rhetoric and Media Studies at Lewis & Clark College. Her research examines how communication (face-to-face and online) enacts identities, sustains relationships, and builds communities. She is currently writing *Polyphonic Resistance: Blogging Motherhood and Autism,* a book about how blogs by mothers of autistic children challenge dominant narratives of intensive mothering and provide alternative ways of understanding autism.

Cassandra Hall is a crip, femme mama, writer, and doula. Cassandra is a doctoral student in women, gender, and sexuality Studies at Oregon State University. Her current work is an ancestrally cocreated project that traces care's manifestations in formalized and embodied archives. She lives on unceded Chinook territory (Portland, OR) with her partner and three children.

Marjorie Jolles is an associate professor of women's and gender studies and director of the Honors Program at Roosevelt University. Her research is in the area of feminist philosophy, with an emphasis on embodiment, ethics, style, and narrative theory. She is coeditor of *Fashion Talks: Undressing the Power of Style* (SUNY Press, 2012) and the author of numerous articles and chapters in the fields of philosophy, women's and gender studies, and cultural studies. She earned a PhD in philosophy, with a graduate certificate in women's studies, from Temple University.

Lianne Leddy (*Anishinaabe kwe*) is a citizen of the Serpent River First Nation and grew up in Elliot Lake, Ontario. She is an associate professor of Indigenous Studies at Wilfrid Laurier University's Brantford campus. One of her main areas of research is the history of Indigenous-settler relations in what is now Canada and, in particular, she is interested in gender and environmental issues as well as historical methods. Her SSHRC-funded research looks at *Anishinaabe* women and nation building in Ontario as well as the gendered experiences of colonialism; another project focuses on Indigenous peoples and northern contaminants. Her work has appeared in the *Canadian Historical Review, Oral History Forum, Herizons,* as well as several edited collections.

Hinda Mandell is an associate professor at the School of Communication at RIT in New York, and is the author of *Sex Scandals, Gender and Power in Contemporary American Politics* (2017), coeditor of *Scandal in a Digital Age* (2016) and a coeditor of the proposed anthology *Nasty Women and Bad Hombres: Historical Reflections on the 2016 Presidential Election.* She researches news coverage of scandal, and her essays on the topic have appeared in the *Los Angeles Times, Chicago Tribune, USA Today, Boston Herald, Palm Beach Post, Politico,* and in academic journals, including *Women's Studies in Communication, Visual Communication Quarterly,* and *Explorations in Media Ecology.* Mandell is a regular contributor to *Cognoscenti,* the commentary site for Boston's NPR station, and a

contributor to the *Huffington Post*. Mandell's website is omghinda.com, and she's on Twitter: @hindamandell

BettyAnn Martin is a narrative scholar interested in the reconstruction of experience through story and the ways in which creative engagement with memory transforms individual consciousness. She graduated with an MA in English from McMaster University. She went on to complete a bachelor of education from Western, after which she began to teach and raise a family. She is currently enjoying a long hiatus from teaching but continues to participate in the growth and education of her five children. She returned to academe in 2012, and recently completed a PhD in educational sustainability from Nipissing University. In addition to several peer-reviewed articles and book chapters, her most recent publication is a coedited book entitled *Taking the Village Online: Mothers, Motherhood, and Social Media* (2016). Through her own experiences of mothering and through a growing literature theorizing motherhood, BettyAnn continues to research and write about motherhood and its implications for identity. She currently resides in Brantford Ontario, with her husband and three school-aged children. Contact: thenarrativeconnection@gmail.com

Michelle Hughes Miller is associate professor in women's and gender studies at the University of South Florida, where she studies constructions of motherhood within law and policy and violence against women. In 2017, she published two coedited volumes: *Bad Mothers: Representations, Regulations and Responses* and *Addressing Violence Against Women on College Campuses*.

Michelann Parr is professor in the Schulich School of Education at Nipissing University. She holds a BA, BEd, and MEd from Nipissing University; her PhD work was completed at McGill University. As the first-born Italian granddaughter of immigrants, she learned how the world worked in a large extended family and consistently had maternal models to guide her through childhood, support her through the successes and struggles of being mom to three, and celebrate the wondrous moments of being nana to two healthy grandkids. In the spaces between actively and intensively parenting and grandparenting, Parr is the Elizabeth Thorn Chair in literacy, focusing on literacy-based community outreach and family engagement; she also teaches and supervises at the graduate level. Though not new to mothering and academe,

she is relatively new to motherhood studies; she first explored the reciprocal relationship between motherhood and academe in "Baby Steps: That Was the Way To Do It!" which appeared in *The Parent-Track: Timing, Balance, and Choice within Academia* (2016).

Andrea O'Reilly, PhD, is a full professor in the School of Gender, Sexuality and Women's Studies at York University, founder/editor-in-chief of the *Journal of the Motherhood Initiative* and publisher of Demeter Press. She is coeditor/editor of twenty books including *Feminist Perspectives on Young Mothers and Mothering* (2019). O'Reilly is also the author of *Toni Morrison and Motherhood: A Politics of the Heart* (2004); *Rocking the Cradle: Thoughts on Motherhood, Feminism, and the Possibility of Empowered Mothering* (2006); and *Matricentric Feminism: Theory, Activism, and Practice* (2016). She is editor of the *Encyclopedia on Motherhood* (2010) and coeditor of *the Routledge Companion to Motherhood* (2019). She has presented her research at over one hundred conferences and has authored eighty articles and chapters. She is twice the recipient of York University's "Professor of the Year Award" for teaching excellence and is the 2019 recipient of the Status of Women and Equity Award of Distinction from OCUFA (Ontario Confederation of University Faculty Associations).

Michelle Sadler is a Chilean social anthropologist, with a master's in gender studies (University of Chile) and an MSc in medical anthropology (University of Oxford). She is currently working on her PhD dissertation in anthropology (Universitat Rovira i Virgili) on the topic of childbirth models in Chile. She is a fulltime teacher and researcher at the Faculty of Liberal Arts, Universidad Adolfo Ibáñez, Chile; and director of the Chilean Observatory of Obstetric Violence (OVO Chile). Inspired by Emily Martin's work, among many other scholars and activists, her work seeks to make visible the gender metaphors which sleep in science. Contact: michelle.sadler@uai.cl.

Irena Zenewych's work as an art therapist is winding down. She has enjoyed this work immensely. She has learned so much about other people's lives and about human nature. And everything she has done in the past has informed her practice, including interior design, cultural geography, museum display and gallery curatorship, paralegal practice, qualitative research and, most importantly, motherhood. But now, the future is open to her, and she really welcomes the unknown.

She would like to see her country, travel down the Mississippi River, and have grandchildren.

Dara Herman Zierlein is a graduate of Pratt Institute and has an MA in art education from Columbia University. She has taught art for over twenty years in the public school system and is an exhibiting and published artist. Dara is a political artist and continuously uses her art to advocate awareness in the world. Her paintings of current issues concern social justice, women and equal rights and plastic pollution. Dara's large watercolour paintings, writings, and collaborations have been published internationally. She has been interviewed on several themes focusing on motherhood, climate change, and the environment. When Dara is not painting, exhibiting, writing grants, teaching, creating posters, illustrating, working and submitting her art, she lives at home in Western Massachusetts with her husband, three cats, two dogs, and their teenage son entangled in the complications of being an artist.